THE
DRAWING
BOOK

Leonardo da Vinci
Plan for Casting the Sforza Monument, c. 1493

THE DRAWING BOOK

a survey of drawing: the primary means of expression

edited by Tania Kovats

Black Dog Publishing

CONTENTS

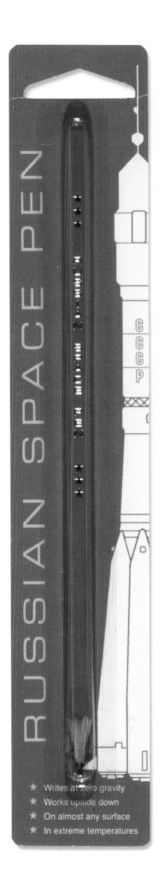

TRACES OF THOUGHT AND INTIMACY

Tania Kovats

When NASA first started sending astronauts into space, they realised that the ballpoint pen would not work at zero gravity. A million dollar investment and two years of tests resulted in a pen that would write in space, upside down, on any surface and at any temperature from below freezing to over 300 degrees centigrade. When confronted with the same problem, the Russians used a pencil.

I was given the 'Russian Space Pen' by a friend at the very beginning of compiling *The Drawing Book*. I think this story may well be apocryphal but I can't think of a better place to start than with an astronaut and a pencil in space. *The Drawing Book* is a cosmology of drawing. By this I mean that the drawings in this book describe and trace a vast tract of experience. Constructing a visual narrative with this collection of drawings situates these traces into a possible order. This is not a chronological or geographical order, but it is a conversation between the drawings made by artists, scientists, designers, engineers, filmmakers, illustrators, children, architects and other visionaries.

It is also appropriate to start this book with a story, whether true or not. Any book has an implicit narrative to it. It also has an inside and an outside— not all things have this, images don't. You can enter a book. There is a time before and a time after a book and a sequence to the time you spend with it. The intention of *The Drawing Book* is to take you, the reader, on a journey. What drawings do, as well as what drawings are, is one of the subjects of this journey. Drawings are not simply things to look at; they are a direct form of positive communication. Part of the reason they communicate so directly is that drawing belongs to everyone. Acts of drawing occur all the time—someone applying eyeliner, doodling whilst on the phone, or making someone a map on the back of an envelope. We are all mark-makers.

The Drawing Book has found its structure from a literary model that peaked in the Renaissance—the 'commonplace book'. This is a book where passages were collected, usually arranged under general headings or indexed thematically. They were a reader's companion at a time before books were easily accessible but when the world was exploding with information and signs. You could negotiate your own way through all this new information by making a book of your own. Commonplace books sanctioned the selection of passages made significant by personal experience; they were personal anthologies, a forest of thinking governed by the objective chance of autobiography, or what memory might look like. The commonplace book continued as a form way beyond its peak in the Renaissance. Francis Bacon, Ben Johnson, John Milton, and John Locke, to name a few, compiled some of the most treasured commonplace books. More contemporary examples exist, such as WH Auden's *A Certain World*, 1970. Recently the form has found a new lease of life in hypertext versions on the internet.

The Drawing Book is a commonplace book of drawing that exists as a depository for memory, commentary, and possibilities. It is a storehouse, an archive of images that attempts to define the nature of drawing in current times. Some of these drawings are remembered drawings, others have been discoveries. Every conversation I have had with anyone about this book during its evolution has prompted suggestions as to what should be in it. I would hope the book continues to promote these speculations and the endless compiling of the drawings that we all seem to have placed in our own storehouse and see in our mind's eye.

The Drawing Book is a travel narrative. Perhaps all narrative takes us from one place to another. Our starting point is *Measurement*. Before we go anywhere we need to know how to map the space we travel over, the formlessness of space and time would prove too overwhelming otherwise. The drawings start in the poet's study; William Blake's drawing is of a man locked in a room, in the throes of a vision. There is a great deal of space around this figure, allowing for many possibilities. Systems of primary forms, simple architectural containers, and grids are introduced to chart the territory. Having established these tools we use them to chart *Nature*. What exists in spite of us is observed, sampled, speculated over. The next location is the *City*, the site of culture, a mass of interconnected communication and signs, a living organism, but constructed. Within these vast systems the individual has to find a place to withdraw. *Dreams*, and the nets cast to catch them, describe this withdrawal. Sometimes we tenderly watch the sleeper. At other times a drawing describes what the dreams have dragged up, visions and possibilities, or poisonous nocturnal emissions. When the dreamer wakes, they are left with the corporal reality of the *Body*, the site of love, sex, intimacy, disease and death. With death and extinction we are back where we started, formless and dispersed.

If confronted by something that has no form, no language, or no place, a familiar analogy steps in; we use one thing to describe another. When we do not have the words to say something, drawing can define both the real and unreal in visual terms. This is a positive act of displacement, and is one of many reasons that drawings are made. When we look at drawings we often position them very close to their maker. We are witnessing something being created at no further than arm's reach, and can often see the moment passing or thought emerging, right there on the page.

The analogy of the first drawing is that of Pliny's shadow. The classical Greek story describes an act of tracing by the potter Boutades' daughter. She is distraught that her departing lover is about to set sail, perhaps never to return. Whilst he sleeps, she watches, and draws around the shadow his face casts upon the wall with a burnt coal that she takes from the fire. The first drawing is made, a trace, a shadow, an act of love and grief—an attempt to fix a moment in time using a marker from the source of light and shadow itself. Her father then makes a clay form that fits into the profile and places it in a shrine. The moment is memorialised and made sacred.

Encapsulated within this analogy are many of the keys to unlocking the act of drawing. Here we have an immediate act, a kinetic tracing, the concept of a contour, an act measuring space, distance and emotion. A choice of ground—in this case the wall, and marker—a charcoal from the source of the shadow. Also we see the first drawing generates a form—her father makes an object from the initial outline. This drawing is also an acknowledgement of failure; the drawing cannot replace her lover or stop his departure. It can only provide a substitute or replica. What the drawing can do is describe and articulate her pain.

In Walt Disney's *Peter Pan*, the 1953 adaptation of JM Barrie's novel of a journey to and from Neverland, a shadow provides the meeting point for the sweethearts rather than the moment of parting. Peter first meets Wendy while searching for his shadow, which he has lost. In Disney's brilliant animation Peter finds his shadow but it tries to escape him, only eventually being caught after much tumbling through the drawn space of the nursery. Peter tries ineffectually to re-attach himself to his shadow by rubbing soap on the soles of his feet, the most obvious point of contact between 'figure' and 'ground'. Wendy had been looking after his shadow during this period of separation from Peter and had folded it up neatly and put it in a drawer. She is woken up by all the noise and very sensibly decides the best way to re-attach the shadow is with some stitches. Animation is a triumph of drawing, offering a world in which anything is possible if it can be drawn.

The task of producing feature length films made up of drawings is perhaps as complicated as drawing can get. But set against that is the basic compulsion to make a mark. This compulsion exists in spite of the majority of people who, if asked, would say "I can't draw". Making a mark, where one can first exercise some sort of visual control over it, occurs at about the age of 18 months. Serge Tisseron, in his essay "All Writing is Drawing", charts this process, suggesting that at this stage the eye is following the hand but without much control over it. By 24 months the eye is guiding the hand. He suggests that the act of drawing, the mark back and forth, away and towards the child's body, describes and traces the physical and psychic distance between the body of the child and that of its mother. Thus he places drawing as part of our collective psychic history: "The earliest drawings are not guided by a visual exploration of space but by an exploration of movement. At its origin, graphic expression is blind." [1]

The relationship between writing and drawing is something pressing down heavily on me as I write this introduction. The Greek word *Graphe* doesn't distinguish between drawing and writing. The manuscript, or the notebook, diary, or rough copy is a site where the writing process can be seen to spill over into other spaces of the page—crossings out, arrows redirecting sentences, margins filling up with more thoughts or instructions for later. My profusion of notes for this introduction stare up at me and I can look at them in the way I would look at one of my drawings. But I know an

ordered printed version of these scribbles is the aim. This blurring between writing and drawing is another reminder of the cursive mark-making activities that we habitually engage in.[2]

By extension, then, of where *The Drawing Book* started, you are invited to 'read' the drawings. The drawings are in a sequence, thematically grouped in chapters. As well as its place within this unfolding narrative, each individual drawing has a time line built into it. Philip Rawson, in his seminal work *Drawing*, 1969, encourages what he calls the "habit of attention". He states that any drawing resists the pressure to convey its whole impact at a first glance, and that because of the fundamentally kinetic basis of drawing, the eye should try to follow the traces of the drawing point—whatever the instrument of that drawing might be—to unravel the drawing.[3] You are being asked to locate the way into a drawing, its kinetic make up, how it opens and closes.

In the 'drawing' *Sweetheart come (Letter to her Husband)*, 1909, Emma Hauck writes and rewrites her message, until the words become a mass of tangled knitted line. Unravelling this continuous line is also an act of unpicking context. This 'drawing' is a letter. It is part of the Prinzhorn Collection, assembled by the German art historian and psychiatrist, Dr Hans Prinzhorn, from various patients of psychiatric institutions in Europe from the preceding 40 years.

Hauck's drawing recovers the pliancy of writing, how the written word can be worked upon, and reworked, until an exquisitely painful scribble is achieved. The scribble takes possession of the space of the page, filling up the margins, written by a simultaneously running and trapped hand. On the track "One Line", PJ Harvey sings: "I draw a line/ to your heart today/ to your heart from mine/ and pray keep us safe."[4] Here again is the tracing of a contour or connection, a line drawn describing the space between lovers. It could also be the same line that Boutades' distraught daughter draws, as she captures shadows to set against the absence of her loved one; or the line of Wendy's stitches, a continuous line threaded into an obsessive act of disappointed attachment.

Draw in the sense of delineation—to trace by drawing a pencil or pen or the like across a surface—is the first and simplest definition of the word. There are a host of secondary meanings attached to the term, however, and its etymology can be usefully employed to expand on certain themes of drawing.

Draw meaning to take in is where I find myself next. The process of giving so much thought and time to this compilation leads me to think of drawing as a primary act of creativity, like breathing. Experience and thought is taken in or inhaled into the lungs of consciousness, and then via drawing, exhaled onto the paper. This breathing process could be anything from meditative and repetitive, a deep sigh, a whisper, or panting, full of energy and exertion; regular breathing, a breath held in anticipation, a shallow last breath or a death rattle.

Rachel Whiteread's drawing *Untitled (Torso)*, 1990, is a sculptor's drawing. Many sculptors consider drawing to be an extension of the process of making, more about construction than visualisation. The sculpture it refers to is from a series of works in which Whiteread made plaster casts of the inside of hot water bottles. These casts are like the solid smooth torsos of fat babies, armless, headless, legless. The drawing itself is very simple. Four contours are laid over each other. From the way the lines break and stutter slightly it seems that Whiteread has drawn around several of these hot water bottles or their casts. These are beautifully phrased lines. It is as if the form is breathing, inhaling and filling, exhaling and deflating. The form lives. The lines touch their subject, embracing and defining it.

One of the curious qualities about a line is that it has no three-dimensional value. And the problem is even more complicated than that, as Rawson points out: "No one ever actually sees a black outline, or the line which separates one plane from another."[5] This then begs the question of how it is that we are able to understand an outline, or a contour, and see how it can demark areas, space, and volumes. The act of drawing is associated with the act of seeing but the two things are not the same—nothing looks like a drawing. Drawings are their own visual reality and we have the capacity to look at them because of the analogising faculty of our minds. Our ability to recognise form and give it its appropriate name or analogy is what makes our experience communicable; this is the basis of comprehension and language. The same faculty allows us to understand the line drawn on a page, or read the shape of the hot water bottle.

A drawing can also occupy a gap between these acts of certain translation, where things aren't so clear. Here we might imagine the breath on a pane of glass or mirror, misting over what was previously clear. Drawing is often thought of as a very private activity, many drawings are made and never meant to be seen, erotic sketchbooks, exorcising the night's thoughts or demons. Because of the directness of drawing, experiences or thoughts most difficult to express can be rescued from a place where they would otherwise be left inert.

The mental state when making drawings is most commonly one of total absorption, a withdrawing and removal of attention from anything other than the drawing; the sense of draw meaning to extract. The world is reduced to the piece of paper and becomes a depository for thought, speculation, observation and projection. There are numerous grounds utilised throughout history: the cave wall, bark, skins, pottery, fabrics, papyrus, papers, notebooks, backs of envelopes, and coming full circle, returning to the cave in the direct use of the gallery's white wall. Cave drawings were drawn directly on to a part of the world; there are no coordinates or edges here, only a mark that adapts itself to the surface. The chosen ground for a drawing conditions the work. Each piece of paper has a size, as does the scale of any marks you put on it. The edges have to be negotiated, and as a rule, so do the four right angled corners of the paper; there is middle, top and bottom, and a back to the paper. The range of grounds in this publication include graph paper, notebooks, ruled paper, newspaper, photographic paper, ceramic, and hand crafted art papers. There is a comparable diversity of materials. Our reading and unravelling of a drawing is informed by the detailing of these choices.

To quantify what constitutes a 'good drawing' is a thankless task, but one measure of success could be a perfect alliance of style and subject—the how and the why are harmonised. Paul Noble's *The Sea*, 1996, is a good example. This is an expansive drawing, the sea laid out to the ultimate infinite landscape—the horizon line. The horizon line bends slightly, and happens at the edge of one piece of paper, so that it correlates with the edge of the world of the drawing. The drawing is made with a descending scale of forms that make up the broken surface of the sea. The sheen of the polished graphite captures the wetness of the sea, made with hard pencils and painstaking tissue paper polishing. This is the cold

strong North Sea at Whitley Bay in the North East of England, where Noble would sit with his friend, wondering how best to represent it.

Drawings are either wet or dry. Materials used to make a drawing form an infinite list but can usually fall in with either of these distinctions. It is their wetness that calls on another sense of the word draw—to cause to flow, to draw water or liquid, or drain from a source. Drawing has many fluid aspects. The dipping of a brush into ink emptied from the sacs of an octopus is a centuries old occupation. Here the shadow becomes mobile; tone and areas of darkness, built up in washes, can black out the white of the paper, saturate the light, leak or bleed, concentrate and condense. Colour is most easily introduced here, allowed at last to swim in liquid seas of watercolours or gouaches. And of course there is the spill, the drip or the blob. This is the hazardous introduction of a medium that may behave in an unpredictable and unrepeatable manner. Embracing this emblem of uncertainty has been an inspiring beginning for many drawings. Alexander Cozens famously utilised the inkblot as the initiator of a system of landscape motifs. This liquid knowledge floods and informs the work of many artists in this book, Eva Hesse, or Lucia Nogueira to name just two.

Albrecht Dürer's *Vision in a Dream*, 1525, is a drawing which emerges from the dissolve between waking and sleeping. The drawing was made after the night of 7 June, 1525. Dürer had written, ten years earlier in his notebooks, "How often do I see great art in sleep, but on waking cannot recall it: as soon as I am awake, my memory forgets it." [6] But this dream is not forgotten—it is not "great art" he has seen but a great disaster approaching. The text beneath the drawing describes a tremendous flood: "many great waters fell from heaven. The first struck the earth about four miles away from me with terrific force and tremendous noise, and it broke up and drowned the whole land." Over the brown dry landscape hugely destructive weights of water descend. These pendulous forms of liquid destroy the land and trouble Dürer enough to wake him from his dream trembling. The drawing and the dream are remarkable. The drawing was made at a time of great religious uncertainty and there had been much talk of a catastrophic flood being imminent. The Flood was still the orthodox reading of why the world appeared as it did. We were all inhabiting a world that had suffered one such deluge as a result of God's displeasure and were living in the chaos left behind when the waters finally subsided. Here the waters are coming again, in a second wave of disapproval, dropping like bombs and laying the world flat and submerged. Once again, the drawing succeeds because of the congress between mark, medium and subject. The drawing is itself subjected to this deluge from above, the washes entering from the top of the paper, their icy blue flooding the brown dry landscape, threatening to dissolve all form, wash it away, and unravel the cursive lines of script that speak of this particular apocalypse.

Alfred Wegener's drawing illustrating the movement of the earth's continents allows us to visualise a different moment of drama on a vast global scale, and lends itself to the examination of another sense of the word draw. Here the meaning is to move—either towards or away, gradually gain on something or draw something towards you in a magnetic sense, or draw together, or cause to happen. Harry Robin, in his introduction to *The Scientific Image: From Cave To Computer* describes movement generated through drawing: "Images trigger an internal motion: the deliberate perusal of the elements in a picture. By seeing into a picture, the viewer transforms the static image into an active intellectual experience." He goes on to consider the many scientific realities that can only exist in the mind, black holes or the structure of subatomic particles, and it is here that the visualisation of these thought experiments through illustrations and drawings can give concrete expression to otherwise abstracted hypotheses or orthodoxies. These images, then, exist and chart the evolution of our thinking.

Wegener was born in Germany in 1880. He was an explorer, trained in astronomy and meteorology, but his thinking lead him into geophysics, climatology, volcanology, magnetism, oceanography, hydrography and glaciology, rendering the distinctions between these sciences somewhat redundant. His theory of *Pangaea*, the Greek for all land, draws upon proof offered by many of these different sciences. But it is through the visual manifestation of his thought, his drawings and illustrations, that his speculations became accepted. Wegener had been dissatisfied with the theory that land bridges had once existed between the continents as the explanation for the concurrent similarities in the fossil records around the globe. His breakthrough was to visualise how the continents once fitted together. When trying to explain this, he famously said "It is just as if we were to refit the torn pieces of a newspaper by matching their edges and then check whether the lines of print run smoothly across. If they do, there is nothing left but to conclude that the pieces were in fact joined in this way." [7] This global jigsaw puzzle is now an accepted orthodoxy, something a child might explain to you. When Wegener published his *Origins of Continents and Oceans* in 1915 it was a significant re-imaging and re-imagining of the earth's history.

Contemplating the immensity of geological narratives forces you to face the eventual total collapse of the present in a way that is both exquisite and horrifying. Harry Robin quotes Albert Einstein to usefully illustrate this kind of encounter: "The most beautiful and most profound emotion we can experience is the sensation of the mystical. It is the sower of all true science. He to whom this emotion is a stranger, who can no longer stand rapt in awe, is as good as dead." [8] John Ruskin was also amongst one of the first thinkers to appreciate the fluidity of the earth's make up. "Of Mountain Beauty" was published after many years of pacing the Alps. His drawings reveal his own reading of the landscape, which was based in his understanding of the absences in landscapes as well as what is present, to appreciate the mountains that had been there before and were now eroded as well as the mountains that remained. Mountains revealed their fundamental form of organisation to be the curve, not the angle; "the great silent waves of the blue mountain" is how Ruskin describes it, and also how he chose to draw these landscapes. Like waves, these mountains are prone to movement, cast up by colossal forces and still in motion. This thinking is encapsulated in Ruskin's drawing *Aiguilles de Chamonix*, c. 1850. The landforms are described in marks and lines that flow and merge; these are not lines that fix the form, instead they describe its slow movement. Rather as Ruskin says, he "shall adopt the order, in description, which Nature seems to have adopted in formation". [9]

The drawings by James Clerk, commissioned by the geologist James Hutton for the publication *Theory of the Earth*, 1799, depict an analytical hand at work capable of a radical act of representation that moved towards abstraction. Here is a significantly different means of visualising landscape: a cross-section. Hutton's geological theories inexpressibly deepened the earth's history, resulting in the late eighteenth century expansion of the realm of time, just as two centuries earlier the telescope had expanded space, and

the microscope had extended the realm of the visible. Susanne B Keller, a historian of science, points out the significance of drawings like these:

> The medium of visual representation played a crucial role in the Enlightenment project of taking intellectual possession of nature, and of dominating it. Pictures helped to categorise the various natural phenomena, to disseminate knowledge about their appearance and capture them. By translating their theoretical considerations into the abstract forms of geological sections, these natural philosophers moulded a new visual language for seismology and earth history. The reading of a geological section implies complex visual conventions that have to be learnt.[10]

Rules of representation or drawing, then, have to be capable of a slow kind of expansion or alteration to accommodate the evolution of what is being communicated.

There are many such evolutions of understanding included in *The Drawing Book*. Boccioni's *Study for States of Mind (Those who Go)*, 1911, could easily be an equivalent example. The kinetic energy of this drawing embodies the Futurists' understanding of the radical changes taking place at the start of the twentieth century, how the pace of life was irreversibly being speeded up, powered by technological advances and industrialisation. Any drawing is a static object but contains the trace of actions carried out in time. The pace of Boccioni's hurried repeated marks store up and symbolically record the changes taking place around him.

One remaining consideration of the word draw is available as we retrace our steps, from drawings by geologists to artists, to letters from an asylum, dream drawings, and a sculptor's speculations. This is the sense of draw meaning to pull out, extend, stretch or draw tight. Visualise a continuous line allowed to flow through this book, a thread of activity weaving its way through time and space through the thoughts of naturalists, filmmakers, engineers, and map makers. It is worth reiterating that drawing does not belong to artists, it belongs to everyone. The net used to catch these drawings is full of holes, and many aspects of drawing as well as drawings that I would have liked to include here have fallen through—computer generated drawings, pre-Renaissance drawings, comics, Aboriginal drawings, applied drawings, and drawings from China and India, to name but a few. To create a context for drawings is to accept standing before an avalanche and knowing you only have a small box to put your rock samples in. Drawers of plan chests open and have to be shut again with only a tiny fraction of work allowed out, collections dipped into, institutions and libraries sifted through. Locating a drawing is a complex process. Drawings are often hidden, the traditional conservator's assertion that drawings are too sensitive to light making them disappointingly likely to be left in the dark.

The 'how to draw' section of the book shop is always much bigger than the section for books full of drawings. *The Drawing Book* may educate, but only through example, rather than an imposition of rules, celebrating the diversity and commonality of drawing, and expanding the form endlessly. It is an invitation to its reader to make their own commonplace book of drawing. This element of the book is in keeping with the democratic nature of drawing. Everyone carries their own archive of images that are meaningful to them, that demonstrates what they think drawing is. As you read these drawings, others will come to mind. This is the way the story could read, as a conversation between this storehouse of images and yours. One mark made against another. TK

1 Tisseron, Serge, "All Writing is Drawing: The Spatial Development of the Manuscript", in *Boundaries: Writing & Drawing*, M Reid, ed., New Haven: Yale University Press, 1994.

2 There are obvious illustrations of this union between image and letter, not necessarily present in this book. The illustrated manuscript, the hieroglyph, Persian and Chinese calligraphy are just some that come to mind. The comic strip attempts to bring the two back together again but it is as a form often relegated to the world of children. More recent developments in the form of the graphic novel continue to dynamically direct this collision.

3 Rawson, Philip, *Drawing*, Oxford: Oxford University Press, 1969.

4 Harvey, Polly, "One Line", *Stories from the City, Stories from the Sea*, Island, 2000.

5 Rawson, *Drawing*.

6 "Nourishment for Young Painters" was an unpublished collection of writing by Dürer written about ten years before this drawing was made, c. 1515.

7 Wegener, Alfred, *Origins of Continents and Oceans*, 1915. First English edition of German fourth edition, New York: Dover, 1966.

8 Quoted in the introduction by Harry Robin in *The Scientific image: From Cave to Computer*.

9 Ruskin, John, "Of Mountain Beauty", *Modern Painters IV*, London: Smith and Elder & Co., 1856. Charles Lyell's *Principles of Geology* had been published in 1833 and had been fully absorbed by Ruskin by this time.

10 Keller, Susanne B, "Sections and views: visual representation in eighteenth-century earthquake studies", British Journal for the History of Science, June 1998, p. 31.

INVESTIGATING THE STATUS OF DRAWING

When Marcel Duchamp drew a moustache on a reproduction of arguably the most famous painting, and indeed face, in the world–the *Mona Lisa*–he articulated a universal human compulsion to make a mark, and for that mark to make a statement. A baby uses its finger to draw a line through food, a teenager scrawls a 'tag' on a brick wall, a young adult perfects a unique signature to access the world of personal finance. Each act of mark-making is a form of drawing and for this reason drawing is the most accessible and versatile of mediums. Nearly all artists draw, whether as a research tool, a private mode of expression, or as a public statement. In addition, all artists have their own personal 'drawing book' of images that hold significance and inspiration for their practice. *The Drawing Book* takes us on one artist's journey through some of the most captivating and seminal drawings in the history of art. The selection is justifiably varied and subjective; for each inclusion there are dozens that Kovats has considered. One could endlessly debate additions and alternatives; to think about and compile our own drawing book. In parallel to Kovats' visual thesis, this text aims to investigate the state of drawing practice today.

To do so, it would be useful to take a brief look at how the boundaries of drawing and indeed all artistic practice have been challenged in the post war era. Drawing was somewhat out of vogue among the avant-garde in the 1940s as it was seen as a skill that needed to be acquired. The Abstract Expressionists believed that it was unnecessary to draw and yet managed to incorporate characteristics of drawing into their paintings, and thereby put it on an equal footing with painting. In the late 1940s and 50s, figuration was left behind and the line was used as evidence of raw emotional expression. In these paintings the scale of drawing is blown up and line operates between description and non-description. In 1953, Robert Rauschenberg requested a drawing from Abstract Expressionist painter Willem De Kooning and erased it, framing the blank sheet of paper as his own work of art. It is significant that he opened up the arena for art activity by deliberately erasing a drawing–the symbol of artistic authenticity–declaring that a work of art could be an act of negation, and the direct hand of the artist was no longer necessary. During the 1960s, artists like Agnes Martin and Sol LeWitt celebrated the purity and simplicity of drawing in the name of abstraction. At the same time, drawing's obvious link with technology and industrialisation was exploited by Pop artists like Andy Warhol and Roy Lichtenstein to serve the needs of representation. As the object dematerialised throughout the late 1960s and early 70s, drawing became a way of recording an action or intellectual statement. It became the medium of choice, alongside writing, for expressing art as idea, and has remained at the core of this enduring strand of contemporary practice. At the same time it was released from the page, as artists declared that art could be a performance, a temporally-constrained event. Drawing became a line made by walking in a field or cutting through a house. In the 1980s, painting and sculpture became more dominant as artists returned to object-based practice. By the 1990s, an artist working with video or sculpture was not necessarily directly involved in producing their work, as new technologies in fabrication and new media were employed. Yet during this decade certain artists began to champion drawing, attracted once again by the direct creative experience it offered.

Yet why should drawing be isolated and discussed separately? There is a sense of 'rescuing' the medium in order to re-evaluate its status. Drawing is simultaneously fundamental and peripheral, central and subsidiary. In its more traditional role as preparatory sketch it has had a steady if somewhat marginal role. Drawing has often been treated as the much loved but neglected, poorer cousin of painting. The recent interest in drawing was partially revived by artist-curated exhibitions such as Deanna Petherbridge's *The Primacy of Drawing*, 1991, Michael Craig-Martin's *Drawing the Line*, 1995, and more recently Avis Newman's selection from the Tate Collection for *The Stage of Drawing: Gesture and Act*, 2003. All three acknowledged the importance of drawings of the past and present to the development of contemporary art practice. Struck by the 'modernity' of drawings of the past, Craig-Martin has suggested

> that this is because qualities we have come to value most highly in art in the twentieth century have always been present in art, but usually in the past have characterised only modest and 'secondary work'; that is, drawings. These characteristics include spontaneity, creative speculation, experimentation, directness, simplicity, abbreviation, expressiveness, immediacy, personal vision, technical diversity, modesty of means, rawness, fragmentation, discontinuity, unfinishedness, and open-endedness. These have always been the characteristics of drawing.[1]

This re-evaluation of the special attributes of drawing and their application to all manner of working methods is key to the changing and elevated status of the medium. Artists have always highly valued drawings and sketches; as Erika Naginski has noted, Leonardo da Vinci understood drawing to be "part of a process which is constantly going on in the artist's mind; instead of fixing the flow of imagination it keeps it in flux".[2] On the other hand, the influential American Modernist art critic Clement Greenberg failed to recognise the value of da Vinci's drawings, which he saw as "sheer rumination, reverie, wish-fulfilment, thinking [that] amounts to works of art only in the limited way that isolated passages of verse do—or even less, because their presumptive wholes never saw existence."[3] Artists have worked hard to reassert that special quality of drawing, described by Stephen Farthing as follows: "the best drawings create a sense of limbo, a conceptual space where ideas can be stored in an untraceable state... the information just sits there, it doesn't go away".[4] In her text for the book *What is Drawing*?, Naginski suggests that it is this dimension of drawing that has been incorporated into the practice of particular contemporary artists—"drawing as an activity that exemplifies an imagination in flux".[5]

The Museum of Modern Art in New York has mounted a series of exhibitions themed around drawing, including *Drawing Now*, 1976, *Allegories of Modernism: Contemporary Drawing*, 1992, and *Drawing Now: Eight Propositions*, 2003, a unique attempt to track the development of drawing practice over the past 40 years. The first of these exhibitions was mounted at the height of Minimalism, a movement that brought together the logical, diagrammatic aspects of drawing and the concerns of three-dimensional objects, as well as Conceptualism, which promoted the aforementioned dematerialisation of the art object. The expansion of the field of sculpture, in particular, was seen as key to the re-alignment of drawing. Richard Serra was one of the main

practitioners in this expanded field, articulating the importance of drawing for his generation, finding process to be everything. "Anything you can project as expressive in terms of drawing—ideas, metaphors, emotions, language structures—results from the act of doing", which is to say, as Serra famously went on to declare, "Drawing is a verb."[6]

The Museum of Modern Art's exhibition of 2003, *Drawing Now: Eight Propositions*, turns full circle and in its selection showcases the work of artists whose drawing practice is related to that of their nineteenth century predecessors, who favoured the polished, finished article over the working document. Yve-Alain Bois has described this as "projective" drawing; that is, it depicts something that has been imagined before it is drawn. This shift heralds above all a new attitude towards drawing by contemporary artists; the status of drawing is no longer under question. As Laura Hoptman points out in the catalogue accompanying *Drawing Now*, "With all respect to Serra, for many artists today drawing is not a verb but a noun."[7]

Today, what constitutes drawing is being revisited as artists exploit the infinite potential of the discipline. In this book we find artists who draw on vases, on globes, on found materials, or who 'draw' using the entire three-dimensional space of the gallery. In contrast to the predominantly detached stance of the 1990s, contemporary drawing celebrates the artist's touch, as the process of 'crafting' an object is once again valorised. Labour intensive processes, carried out by the artists themselves (with assistance in some cases), are an important and integral component of the work of the artists discussed here. This interest in craftsmanship seems to have a moral and ethical dimension and could be perceived as a reaction against Modernist and Postmodernist attempts to undermine these aspects of art making. It is now possible to adopt a personal subjective stance, especially as this is not perceived to be mutually exclusive with a conceptual approach.

Artists do not work in a vacuum, and the market has a role to play in any art trend or shift in focus. With the prosperity of the 1960s, art became a lucrative commodity and commercial galleries opened new spaces in more affluent areas to exhibit maquettes and drawings of large-scale works. The deliberate rejection of the consumable object inherent in environmental, conceptual and minimal art was in part a reaction to these new economic interests. In Britain, a wave of small and experimental commercial galleries is once again promoting drawing as a way of supporting the new enthusiasm amongst emerging artists. Drawing is particularly accessible and affordable to collectors, offering them at the same time the element of the hand made, the exquisiteness of touch, and a sense of intimacy. The 'personality' of a drawing reflects the personal taste and interests of an individual collector. Unlike works in print, video or film, that require documentation to authenticate the work, the uniqueness of a drawing provides evidence of the artist's hand and the artist's signature as validation of its originality. Encouraged by the commercial success of artists who predominantly draw, many younger artists continue drawing once they have left college or incorporate it into a multi-disciplinary practice.

The support structures for art practice are also reassessing their treatment of drawing. In Britain, there are now a number of established graduate courses that focus solely on drawing, and drawing fellowships attached to academic institutions. New forums for celebrating contemporary drawing have been initiated, such as the International Biennial of Drawing in Pilsen in the Czech Republic, which began life in 1996 as a local event then expanded to take in Central European countries, and in 2004 took on an international remit; or the Montreal Biennial which has focused on drawing in recent years.

Institutions have always collected drawing—the importance of the medium in the 1970s led to the establishment, by The Museum of Modern Art in New York, of a separate Department of Drawings in 1971. Up until that point, drawings were collected to enhance viewer's understanding of the Museum's primary collections of painting and sculpture. In the context of a museum, drawing, more than any other medium, calls into question whether the primary function of the institution is to conserve a work of art for longevity, or make it available for public display. As works on paper fade as a consequence of exposure to light, they have often been shown separately to paintings or sculptures, so that light levels can be kept low. This has resulted in a sense that drawing is a subsidiary discipline, suitable only for the secretive plan chest or the chapel-like, dimly lit gallery. This debate has still to be resolved, as new conservation techniques are researched, and as institutions are continually challenged to accommodate the evolving practice of artists.

The Drawing Centre opened in New York, in 1977, to provide opportunities for emerging and established artists to demonstrate the significance and diversity of drawings throughout history. 25 years later, in response to a renewed commitment to drawing by artists which was not accommodated by a dedicated public space in Europe, we established The Drawing Room in London. The space continues to provide a framework in which ideas around drawing are developed and made visible in the public domain. Other initiatives have successfully promoted the medium, such as the Centre for Drawing at Wimbledon School of Art, London.

This text shall examine individual artists' practice to demonstrate the varied ways in which drawing is employed in contemporary practice. By necessity the different styles and approaches to drawing cannot all be represented or discussed in this book, and therefore only a small number of the post war artists illustrated within the selection and working within the field of fine art are discussed below. In order to give structure to the sheer diversity of drawing practice, this essay is divided into sections. The first section will look at four artists whose practice merges drawing and painting; the second will examine 'spatial' drawing, and the third will discuss the importance of drawing for five sculptors. The fourth will examine the practice of artists who predominantly draw and the final section will investigate the role and status of drawing within the practice of multi-disciplinary artists.

DRAWING INTO PAINTING

Distinctions between drawing and painting became irretrievably blurred when Jackson Pollock started to paint with line in the late 1940s.[8] Writing about his work in *Drawing into Painting* in 1979 Bernice Rose stated "Perhaps, then, it would be more precise to say that there is no real dividing line between painting and drawing in his work... Obsessed with drawing, Pollock erased the distinctions then pertaining between drawing as a discipline and drawings."[9] In his paintings the scale of drawing is blown up and the line operates between description and non-description. By pouring paint onto canvas in an act of raw emotional expression, Pollock severed the anatomical connection that had traditionally linked the artist's hand, brush and canvas. Pollock's work marked a shift away from representation and towards abstraction that prioritised the act and the manipulation of materials.

What does separate painting and drawing? The dictionary definition of drawing suggests that it is inextricably linked with line: "the art of representing by line, delineation without colour or with single colour".[10] However, this line can be realised in paint as well as graphite (or as a line of stones, as an absence, and so on). Walter Benjamin suggested that when a drawing entirely uses or covers its supporting ground it can no longer be called a drawing. Perhaps it is better to leave it more open and to acknowledge that "In an age where painting aspires to the condition of drawing, that is, where spontaneity, fragmentation and immediacy are privileged, the designation *drawing* seems only a matter of degree."[11]

The four artists in this section—Marlene Dumas, Ellen Gallagher, Louise Hopkins and Chris Ofili—each have a conceptual agenda, and liberated by their predecessors, incorporate qualities traditionally associated with drawing into their 'paintings' in order to maximise the formal potential of their chosen materials.

Louise Hopkins
Untitled (the,of,the), 2002
ink on newspaper
60 x 74 cm

Marlene Dumas

Drawing is a vital part of Marlene Dumas' oeuvre; by drawing with the tools of painting her works on paper and the oil paintings echo each other. Her paintings are quite unlike those of her contemporaries who during the 1980s revisited the figure in Neo-expressionist work that favoured intoxicating colour. Dumas uses paint as a subversive, anti-conventional means of expression and the figure as her vehicle for achieving these ends. Her figures—culled from magazines, postcards, books and her own Polaroid photographs—come from a wide range of sources including art history, fashion and pornography. The resulting works are about the effect the image has on her—the feelings, memories, ideas and associations that they bring about. This effect is transmitted in a very direct, visceral way through the means of their execution. Dumas treats the surface of paper or canvas as a skin; the pictorial body is made radically, shockingly flesh. The power of the images comes from the directness of approach, which is informed by the immediate gesture of drawing. There is a fluidity that suggests that the work has been executed in a short, frenzied, space of time. A tension is created because we recognise what is depicted and yet we are not entirely sure about its meaning; we are compelled to decipher our complicated reaction to it. Dumas' titles redirect the way we see the work; they are not meant to secure the meaning of the image but to show how loosely tethered meaning really is to image. While her work frames serious political and ethical questions about apartheid, race, gender and sexuality, her insistent ambiguity keeps things open and questioning.

In *Simplicity*, 2003, the model's vulva and anus are thrust into our face, as if tempting us to reach out and touch. In the translation of the image into ink on paper the peripheral elements have been left out or reduced to washes of ink while the orifices are rendered in heavy blotches. The bleeding, smearing and soaking washes, which stray from demarcated lines, simulate bodily functions.

Ellen Gallagher

Ellen Gallagher is usually described as a painter, yet drawing is integral to her working process. It has been suggested that her 'paintings' are better described as the "aggregation of materials", which include pigment, paper, pencil, watercolour, oil, enamel, plasticine and rubber. She often draws with penmanship paper, the lined paper associated with learning how to write, using its strict lines and off-white colour to provide a basic structure. The motifs that are applied to this field are graphic symbols culled from many different sources and eras and carry multiple meanings. She uses racially encoded signs—popping eyes and hotdog lips associated with a minstrel's mask, flipped wigs from advertisements in old issues of *Ebony* magazine, long tongues—as shapes, and so strips them of their original associations. These symbols are individually drawn, often in ink, mutating like cells across her canvases. Gallagher has used the analogy of a growth when describing the way her forms emerge from within the work; she is not interested in producing images that sit on the surface of the canvas. Like Dumas, she wants the work to be 'felt'—like skin—"tattooed and scarred by new possibilities". [12] She is "interested in the way materials manifest meaning. In the paint, the lines, the ink, the drawings". [13]

In the large-scale piece *Purgatorium*, 2000, Gallagher has worked up a portion of the penmanship paper into a beautiful patchwork of marks, rendered in blue ink. The woven texture is created through the repetition of the outline of 'hotdog' lips, which sit on dotted lines. Cartoon-like tree forms interrupt the surrounding purity of the picture space and the blond flipped wigs are rendered in yellow plasticine. In *Bubbel*, 2001, popping eyes create an amorphous blob. These motifs resemble frogspawn and vary in size and density to create subtle variations within the cell-like form. The fat lips, rendered in splotchy blue ink, resemble platelets that are mutating out of control. These large works are made on the floor and involve a painstaking amount of labour; this physical exertion is a crucial part of the process and end result.

The *Watery Ecstatic* drawings, begun in 2001, relate to Gallagher's fascination with the unreachable depths of the sea and its imagined life. These delicate drawings are based on known marine forms filtered through the language of fantasy and science fiction. They are rendered on heavy watercolour paper and employ a range of materials. The series includes delicate drawings of fantastical sea creatures, using little colour, mappings of obscure islands, and more heavily worked drawings in which she has carved the paper into an intricate filigree of fins, gills and tentacles. Many of the drawings incorporate plasticine to mould the forms of the creatures, as if they are rising up out of the paper. Her chosen motifs—in particular female heads with flipped wigs—have found their way into some of the *Watery Ecstatic* drawings—and have become entwined with the sea creatures.

Louise Hopkins

Louise Hopkins' work hovers on the boundary between drawing and painting. She describes herself as an artist who uses paint, rather than a 'painter'. Hopkins' approach rejects the traditional approach to 'picture-making'; she never starts with a blank page or canvas. In an early series of paintings she worked instead on chintzy, classically 'English' fabric. This was stretched, reverse side out, and then prepared with glistening layers of translucent gesso. Areas of the pattern were worked up in oil with small brushes, in shades varying from off-white to dark sepia. Other areas were left unpainted, and behind their layers of gesso tended to recede, creating a strange spatial tension.

In *Untitled (the,of,the)*, 2002, Hopkins has taken a broadsheet newspaper and systematically drawn over every single key word and image, leaving only the connecting words, the glue that binds the phrases and sentences together. The words become isolated signs denied their referents. And yet, what is left remains a language, with its undeniable pattern, rhythm and form. In a related work, *Goodbye*, 2003, all but the treble clef, the ties, rests, repeats and slurs in a sheet of music have been inked out—the signifiers are there but not the notes with which to realise the tune. This process has created a different kind of rhythm, played out by the white circles and lines framing the musical notations. Hopkins' approach is not merely repetitive or perfunctory; she has made the aesthetic decision to highlight specific points within the page and thereby compose her own tune. These works have a strong temporal element—we trace the white shapes from left to right, working steadily down the page, just as we would read the notes on a stave.

This method appears to be painting or drawing in reverse—existing material and images are systematically covered up. The more ink or paint she adds, the more information she takes away. There is a parallel here with Robert Rauschenberg's drawing *Erased de Kooning*, 1953. For Rauschenberg this was a conceptual gesture that posited the idea

of art as negation. He did not value this work for the process involved and while Hopkins shares his clear conceptual starting point, her works inescapably display the method by which they are made. The changes she makes are made by hand, meticulously, one stroke at a time. For her the process of erasure is creative rather than reductive, opening up possibility for new connections, associations and meanings from supposedly definitive information sources or power structures. She is questioning the authority of her chosen printed material by drawing out its very core, while Gallagher is recreating her own hand wrought versions of clichéd advertising material. For both artists, the process of making the work is crucial; in Hopkins' case drawing attention to what she has taken away, and in Gallagher's creating new possibilities for stereotypical images.

Chris Ofili

Chris Ofili has described his works as coming out of a love affair with painting. His approach to painting is characterised by a desire to experiment with the traditional confines of the medium. He has done this by layering a wide range of materials—paint, transparent resin, sequins, blobs of bright lacquer, map pins and even elephant dung. His imagery is drawn from a similarly diverse range of sources which reflects his wide ranging interests in everything around him including jazz and hip hop, the Bible, the work of William Blake, sport, and street culture. He incorporates snippets cut out of pornographic magazines, heads of black models and sports stars, photocopies of Op art patterns and dots from ancient cave sites he visited in the Matopos Hills of Zimbabwe. This layering of culturally and historically exclusive entities is comparable to the sampling, scratching and rapping of the hip hop tradition in which he is immersed. The unfolding of dots in a spasmodic pattern also echoes the improvisational characteristics of jazz. While his work inevitably acknowledges his race, he "tr[ies] to bring all that I am to my work and all that I experience. That includes how people react to the way that I am—the prejudice and the celebrations," what he chooses to include in his work is driven by formal concerns rather than a desire to discover his cultural roots. [14]

Drawing forms a significant part of his working process. The line which is so important to his painting is traced in dots, collaged heads and map pins. His earlier, abstract paintings are driven by psychedelic swirls that gradually gave way to more figurative imagery, all of which is clearly delineated, even as it fuses with increasingly geometric patterning. The drawings, rendered in pencil, usually have just one layer and are ingeniously and painstakingly constructed. *Afrovoid*, 1998, and *Albinos and Bros with Fros*, 1999, resemble dot-to-dot drawings, as the images are constructed from tiny dots or balls. On closer inspection these are revealed as tiny 'afro heads', each one painstakingly drawn in pencil. The Afro hairstyle can be read as a symbol of pride and unity, serving to highlight the individuality of each face it adorns, and as a means of sucking all that individuality out, sustaining the cliché that all black faces look the same. In *Prince among Thieves with Flowers*, 1999, Ofili has introduced the layering of divergent imagery characteristic of his paintings. The image is familiar within his repertoire—a stylised head of a bearded royal. However, more unusual are the faded, delicately drawn flowers in the background, which evoke a very different era and place.

The four artists discussed in this section make substantial and ambitious works of art. Deanna Petherbridge has noted that drawing lacks materiality in comparison with painting, which is one reason why it is often undervalued. [15] By incorporating elements of drawing into their work and by making distinct drawings that employ the methodology and exacting techniques of their paintings, these four artists have made a contribution to the elevated status of drawing.

SPATIAL DRAWING

The drawing is seen as a field co-extensive with real space, no longer subject to the illusion of an object marked off from the rest of the world. The space of illusionism changes, merges with the space of the world, but by doing so it loses its objective, conventional character and becomes subjective, accessible only to the individual's raw perception.[16]

This was an observation made by Bernice Rose in 1976 in the catalogue to accompany the *Drawing Now* exhibition at The Museum of Modern Art, New York. Jodi Hauptman has suggested that the expansion of the terms of drawing started a hundred years earlier:

Since the 1880s, artists have sought to interrupt these seemingly unbreakable links between mark, hand and imagination, and to unseat the sacred status of paper. Defying long-held traditions of drawing and rejecting traditional materials, modern artists invented a host of practices, altering not only the field of drawing but art-making more generally.[17]

The collages and assemblages of the early part of the twentieth century extended the field of drawing to include materials from the world around them which by nature had a temporal element. These were added to the 'sacred' clean sheet of paper—"no longer limited by the four sides and four corners of the white sheet, this newly unbounded field expands up, down, left, and right and even out into the space of the viewer".[18]

During the 1960s and 70s the parameters of drawing were extended further. "The expansion of scale and the isolation and concentration on line as subject in itself had the effect of catapulting drawing, formerly relegated to a minor supporting role in art, into a major, autonomous role".[19] Drawing became a line made by walking in a field, or a cut through a house. The notion of an expanded field was used to describe work that had dispensed with the object and took the form of alterations to a site.[20]

This section looks at the work of Sol LeWitt, Richard Long and Gordon Matta-Clark, who contributed to the release of drawing from the page in the 1960s and 70s, and at the work of Diana Cooper who continues this legacy today.

Diana Cooper
Swarm, detail, 2003-2005
corrugated plastic, ink, acrylic, foam-
core, photographs, velcro and map pins

Sol LeWitt

Sol LeWitt's first drawing directly on the wall of the Paula Cooper Gallery in New York in 1968 was an attempt to dissolve any distinction between a drawing and its support. It took the form of different permutations of four squares and was realised in graphite. LeWitt chose drawing as his medium here, as he felt that line was the foundation of all works of art. Early studies after the Old Masters introduced him to the medium of drawing and to what were to become the building blocks of his work. In his studies of the work of Piero della Francesca he discovered a distillation of visual information into basic geometrical shapes: "released from the necessity of being significant in themselves, they can be better used as grammatical devices from which the work may proceed".[21] Perhaps his earlier experience as a graphic designer with the architect IM Pei gave him an eye for such information. Another revelation was that an architect can retain their artistic integrity without having to carry out the building work. This realisation formed the basis of his "Paragraphs in Conceptual Art" of 1967, which included the following radical statement: "In conceptual art the concept or idea is the most important aspect of the work. When an artist uses a conceptual form of art, it means that the planning and decisions are made beforehand and the execution is a perfunctory affair... the idea becomes a machine that makes the art." LeWitt wasn't the first artist to articulate such ideas. Ten years earlier Ad Reinhardt had decreed "No sketching or drawing. Everything, where to begin and where to end, should be worked out in the mind beforehand."[22] Bernice Rose has suggested that LeWitt's "Paragraphs" contained ideas which "when applied to drawing changed attitudes towards that discipline, transforming it from a minor medium to one that played a role equal to that of painting or sculpture".[23]

LeWitt's approach to making wall drawings was radical for a number of reasons. To begin with, it was not necessary for the artist to carry out the drawing himself. Instead, a set of instructions, which then became the title of the work, were written out so that any competent draughtsman could execute the drawing. For example: *Within a six foot square 500 vertical black lines, 500 horizontal yellow lines, 500 diagonal (left to right) blue lines, and 500 diagonal (right to left) red lines are drawn at random*, 1970. Crucially for the medium of drawing, it displaces the authority of the artist's hand, since his touch is not vital to the authenticity of the work. LeWitt's *Folded Drawing*, 1971, which is just that, a drawing made by the action of folding a sheet of paper and then flattening it out again, was another attempt to prioritise intellectual content over the authorial gesture. At the same time his wall drawings moved from being framed by the wall, to incorporating an element of time, and then treating the entire gallery as a total artwork.[24]

LeWitt had from the start an interest in liberating the medium of drawing and in exploiting the simplicity of the drawn line. Lawrence Alloway sees his wall drawings as "a brilliant reconciliation of the two senses of drawing... LeWitt's drawings propose a new relation between drawing as touch and drawing as intellectual content".[25] It is interesting that by adhering to the two-dimensionality of traditional drawing he embraced its three-dimensional possibilities: "Any idea that is better stated in two dimensions should not be in three dimensions."[26] By eschewing illusionism and drawing directly onto the wall in the most two-dimensional way possible, he created a drawing that was integral to the wall and the three-dimensional space. LeWitt's move away from the materiality of the object happened in tandem with that of his contemporaries but takes quite a different direction and embraces a unique form of spiritualism.

LeWitt's wall drawings, reduced to the 'absolute' and addressed to our immediate perception rather than to our conventional responses, preserve the contemplative and rationalising functions that were always the special privilege of drawing, asserting them as a real part of the world.[27]

Richard Long

Richard Long's drawings engage with the real world in a very direct sense. His footsteps across the land mark out predetermined routes that explore his interest in relationships between time, distance, geography and measurement. In his first work of this nature, *A Line Made by Walking England 1967*, he trod in a line back and forth across a field, wearing down the wild grass, his path creating a trough of mashed, pressed blades. Subsequent walks have taken place in many parts of the world and have left behind a temporary trace of the artist's presence—footsteps etched into the dust, or stones thrown down as markers. Sculptures have been created during some walks using materials found along the way—stones or twigs, usually arranged in basic, universal patterns—lines or circles. Again these are by their nature transitory. Long has recorded these walks and sculptures in the form of photographs and text works. He has also traced the routes he has taken onto maps, the pen repeating what his feet had done on a very different scale.

In another body of work Long has used natural materials such as mud and stones as drawing tools, using his hands to draw with the mud directly onto gallery walls. In 1970, at the Dwan Gallery in New York, Long walked a spiral on the floor with boots muddied from the soil of his homeland. This gestural element of his work brings it closer to the bodily traces of Pollock's lines and drips.

His work manages the complete annihilation of the traditional separation of object and subject, and in so doing achieves a purity sought by many of his contemporaries. Although he is often grouped with American 'land artists', he claims:

> ... it was a very different philosophy from my own work, which was almost invisible, or made only by walking, or used the land in a free way, without the need for possession or permanence.
> Especially with hindsight, I see my work as having as much to do with conceptual art, de-materialisation, or even Arte Povera... you can think of *A Line Made by Walking* as a classic Arte Povera work, sort of simple and artless and made out of nothing.[28]

It could be said that Long's work allows nature to speak for itself, using his body as a conduit.

Gordon Matta-Clark

In 1972 Gordon Matta-Clark travelled to Italy and carried out a series of cuttings on buildings, inspired by the special graphic quality of the Italian walls. He pre-drew the cuts as lines on the walls before extracting the section of wall. In 1974, at John Gibson Gallery in New York, he displayed a photograph of the site of the architectural intervention on the wall and beneath it, directly on the ground, a cut drawing. These cut drawings are stacks of paper held together with nails and screws, incised deeply with overlapping, geometric forms. In these works the graphic line becomes

a cut, more tenuous and ambiguous than a drawn line. Pamela M Lee has suggested that the shadows cast by the stacks of paper serve to 'model' the cut forms so that the works are more like relief sculptures in negative than a drawing marked by the hand. Rather than consolidating form, the lines in these works unlock its relative indeterminacy.[29]

Matta-Clark had trained as an architect but was frustrated by the passivity of contemporary architecture. He was a member of Anarchitecture, a collective of artists formed in 1974 that aimed to explore architectural systems in a radical way, with a focus on the in-between spaces of the urban environment rather than containment. His cut buildings represent an attempt to make the space active and imbue it with human emotion. In *Conical Intersect*, 1975, the cutting took the form of a huge twisting cone, four metres in diameter at the base, through two town houses that remained in the Les Halles area of Paris during its period of regeneration. From within, this cut functioned as a periscope, while people passing by were allowed a view through the building and a glimpse of the Centre Pompidou beyond. Matta-Clark suggested that these cut buildings were like a layered drawing that the viewer could participate in. Spatial exploration was necessary in order to reconstruct the work from a series of views.[30] "As a necessarily sculptural gesture, the cut speaks to that long-held tradition in which drawing and sculpture are understood as parallel art works which appeal to a tactile as much as an optical dimension."[31] The preparatory drawings that he made for these works hover between objective representation and more diagrammatic or abstracting form as if to acknowledge that they may never be enacted. This contrasts with the drawings of contemporaries such as Robert Smithson, which are very precise and objective.

Diana Cooper

Diana Cooper creates works that defy classification as sculpture, drawing, or painting: "I'm occupying a three-dimensional space... but I have a two-dimensional background, even though my work is a cross between painting, drawing and sculpture." *Orange Alert*, 2003 (ongoing), is an evolving room-sized installation that has been described as a 'constructed drawing'.[32] It started out as a wall-based work, which had a strong graphic element in the form of jagged strips of orange, red and yellow that suggested readings on a cardiograph. As the piece evolved the freestanding sculptural elements proliferated, and many of the two-dimensional graph-like forms were swung out from the wall to jut into the space. This is a new departure in Cooper's practice, although as Jon Wood has pointed out, "Cooper consistently complicates her surfaces with ambiguities of line, layer and texture. The layered play between plane, line and cut is crucial."[33] In earlier work, canvas, paper or foam board provided an overarching structure or armature and a continuous, if tenuous and wavering, line could be traced throughout the work. This more tentative line has often been transcribed in doodle-like gestures using felt tip pens or pipe cleaners, which Cooper has described as slightly pathetic and quirky.[34] *Orange Alert*, in contrast, is dominated by straight lines and rectilinear shapes that resemble functional, manufactured things in the real world such as surveillance cameras, monitors, luggage straps and seat belts. These are hand made from highly inappropriate, flimsy and brightly coloured materials such as acetate, felt, foam and photographs, held together with glue and attached to surfaces using map pins. The title of the work was triggered by the US Homeland Security Terror Alert Colour Coding System, which Cooper has said dovetailed with her artistic interests in systems, mapping and colour coding.[35] Strident, brightly coloured foam lines are used to unite and connect the more disparate elements of the constructed drawing. Shadows have always played a role in her work but now serve to double, triple or even quadruple the lines and add to their force and sense of theatricality. The concentration of this visual activity within a confined arena approaches sensory overload and engenders in the viewer a sense of anxiety as they try to negotiate the booby-trapped enclosure.

Cooper describes her process as a little like drawing in space:

> I will draw a shape and then another shape... it's so fluid between drawing and making the work because in drawing I have no problem cutting out something I don't like and it ends up somewhere else in the work or I cut it out and that lip, that disjunction, becomes a part of the language of the piece.[36]

She is interested in the contest between Formalism and Conceptualism that her work enacts in a very physical sense. How can some of the ideas that inform the work, suggested so emphatically by its title, co-exist with beauty and certain kinds of aestheticism? Like Matta-Clark before her, the work makes oblique reference to the current political situation.

How far can artists stray from making marks on a two-dimensional surface and still claim their activity as drawing? LeWitt's large-scale wall drawings are unquestionably drawings. Long's line created through the act of walking across the land is also a drawing, as are Matta-Clark's cuts into buildings and Cooper's strips of foam stretched from ceiling to floor; the artists themselves have described these works in terms of drawing. It seems that artists see drawing as a tool that can overcome distinctions between high and low art and different media. It facilitates the flow of ideas and energy—back and forth between two and three dimensions, layers, solid and shadow—and prevents the artist from stalling. Artists act as the barometers of our social and political climate and make work that reacts to it, however subliminally. Drawing, in its infinite manifestations, is an adaptable tool that enables the artist to do that very effectively. As Avis Newman has suggested, "The fractured, open-ended, and incomplete that are inherent characteristics of drawing practice seem very pertinent as materialisations of our present experience of the world. It is that space of anxiety and fragmentation in contemporary practice that I would say offers a potential of infinite diversity."[37]

IN PARALLEL:
DRAWING AND SCULPTURE

Despite the blurring of distinctions between the different art forms over the past 40 years or so, many sculptors are making drawings that are distinct from their sculptural practice. The artists discussed in this section—Richard Serra, Antony Gormley, Lucia Nogueira, Rachel Whiteread and Tania Kovats—each produce substantial drawings that are created in parallel with three-dimensional works and contribute to its conceptual and physical realisation. The act of drawing keeps ideas flowing while major sculptural works are in the planning and manufacture stage, and at the same time subtly feeds into their origination and refinement.

As Antony Gormley has said, "Drawing is analytical but it's also expressive in its own right, it has a duty to bear witness, not simply by making a representation of something, but taking things apart and reassembling in a way that makes new connections. It is entirely experimental."[38] The process of drawing helps the sculptor synthesise their ideas and feelings; they are in control and contact with the material, which they can modify, correct or discard in a moment. And it offers the freedom to experiment.

Rachel Whiteread
Floor Study, detail, 2001
ink on paper
25.5 x 42 cm

Richard Serra

Richard Serra sees drawing as a critical analytical tool for his practice:

> Drawing is a concentration on an essential activity and the credibility of the statement is totally within your hands. It's the most direct conscious space in which I work. I can observe my process from beginning to end, and, at times sustain a continuous concentration. It's replenishing. It's one of the few conditions in which I can understand the source of my work.[39]

He developed his ideas about drawing at the same time as expanding the field of sculpture.

> In 1967 and 1968, I wrote down a verb list as a way of applying various activities to unspecified materials. To roll, to fold, to bend, to shorten, to shave, to tear, to chip, to split, to cut, to sever. The language structured my activities in relation to materials which had the same function as transitive verbs.[40]

In other words, the act of creating the piece was its most important characteristic—he was not interested in the categorisation of the outcome as sculpture as distinct from drawing.

In the late 1960s and early 70s Serra made two sculptures, *Strike* and *Circuit*, in which vertical plates of steel bisected rooms, causing a substantial restructuring of the spaces. This led him to experiment with drawings that could achieve the same effect, but in a more subtle way. Serra embarked on a series of installation drawings that questioned the terms of drawing, just as he has redefined those pertaining to sculpture. He is not interested in creating images that sit on the surface and make reference to something outside of themselves. He is concerned with the way that the density and volume of the drawings effects the viewer's perception of the space, both temporally and spatially:

> There is a difference between sculpture and drawing installations. Sculptures can change the space both physically and structurally so that the intentionality of the architecture is diminished or reduced if not destroyed. Drawing installations do not interfere structurally with a given context; even though they alter the perceptions of space, they reassert its structural principles in that they only adhere to the boundaries and edges of the architecture or the room, they are located solely on the surface of the container.[41]

The materials he uses to make these installations—canvas and paintstick—are related more to painting than drawing. The drawings are made in the space, the waxy, oil-based crayon layered onto the canvas to create a dense film of non-reflective black. Once he has been in the space for some time he cuts the canvas to the desired dimensions: "To cut is to draw a line, to separate, to make a distinction, to define the specific relationship between the lines of drawing and the lines of the architecture. The cut as line defines and redefines structure."[42]

Serra's installation drawings are most obviously linked to his sculptural practice, although he has made many different types of drawings. His drawings on paper are mostly studies made after sculptures are completed; they help him to assess, analyse and index the structures he has made. He asserts:

> I never make drawings for sculptures. Drawing is a separate activity, an ongoing concern, with its own concomitant and inherent problems. It is impossible, even by analogy, to represent a spatial language. Most depictions and illustrations are deceitful.[43]

Both *Through the Screen I*, 2002, and *Memorial Day*, 2002, are drawings made using a grid as an interface between the artist and the page, a device employed to escape gesture and the signature touch, and to concentrate on the weight and directionality of the line. The page becomes something like a planar site on which to construct a drawing, instead of a virtual space into which a graphic figure is introduced. The mark-making is structural rather than pictorial; Serra is interested in finding a structure for the two-dimensional surface rather than creating an image of structure. He wants the drawing to be what it is, rather than make reference to something outside of it.

Antony Gormley

Drawings have played an important part in Antony Gormley's oeuvre since his first series of large-scale drawings made directly on the wall between 1981 and 1983. These coincided with the first lead figures, cast from his own body, and like the sculptures, explore the human experience of being in the world. These drawings exist in distinction from his 'workbooks' which are more provisional, sketchier and mainly executed in pencil. However, these distinct drawings are not conceived as 'pictures' but as a vehicle to test ideas and materials.

Field, 1984, is a relatively rare example of a drawing closely connected with a sculpture. It is one of a series of drawings in which the figure is set within an architectural space, in this case in the centre, the elongated arms stretching out to reach the walls on either side. It is executed in black pigment, linseed oil and charcoal. In *Through*, 1992, a spatial tension is created as receding swirls of watery black pigment give way to a clean square of paper in the centre of the drawing. The small rectangle of light anticipates the mouth aperture in his *Allotment* sculptures, 1995-1996, while the mottled quality of the drawing echoes their concrete surfaces. *Immersion*, 1993, also seems to relate to these sculptures—a flat black figure is encased in a close fitting, translucent and penetrable notional box. These drawings run parallel to his sculptures and enable him to explore territory that is inaccessible in three dimensions. In his drawings, Gormley is able to explore what lies within the skin—the contradictions and the plethora of feelings and emotions—and his sculptures seem concise and resolved in comparison.

In many of Gormley's drawings the focus is on creation, fertilisation and growth. It is through the drawing process itself that ideas germinate and become, and the surface of the paper is often transformed in the drawing process, as he "pits the materials of the making against the symbolic structures of the imagination, connecting the theme of origin with the embodiment of the idea unfolding upon the paper".[44] A distinctive feature of his drawing is in the choice of those materials:

> It is important to me that the substances I use to draw with are not taken for granted, and lamp black, bone black, casein, linseed oil, milk, semen, blood, coffee, chicory, earth, shellac, varnish all come with their own qualities, extracted from the body of the earth, from the body of plants or from living bodies. In their reactivation, these are not innocent parties.[45]

Gormley treats the surface of the drawing paper as a skin, the strength of which is continually put to the test by the materials to which it is subjected.

Lucia Nogueira

Drawing was a crucial process of discovery for Lucia Nogueira throughout her career. She filled hundreds of notebooks with images, texts, thoughts, and philosophical writings. Her drawings in ink and watercolour on separate sheets of paper were a distinct part of her practice, but intimately bound up with her sculptures and installations. Nogueira was born in Brazil and moved to England in 1975 to attend art school. Her earliest sculptures were slight and subtle interventions within the gallery space. These works resulted from the accumulation of all manner of objects and curiosities—test tubes, thermometers, wind-up toys, plugs, crates, bouncy balls, and discarded furniture—in her studio. Nogueira perceived the emotive and symbolic potential of these objects and in her sculpture and installations enhanced these qualities through subtle juxtapositions and transformations.

In some ways Nogueira's drawings, all untitled, appear more coherent than the three-dimensional work, but that is probably because the activity is contained within the confines of the page. The drawings are full of ideas and inventions and above all, convey the open-ended nature of her work in all dimensions. Opaque in many ways, some drawings do give away the secrets of their final state. In one very dark drawing, *Untitled*, date unknown, the ground of the drawing is lightly distorted by its liberal soaking of black ink, on which floats a simple line drawing of a ladder, slightly off centre, rendered in gold crayon. A second vertical line has been drawn in, step by step, as if while making the drawing she enacted the unsteady, slow climb up the ladder. This drawing might be linked with *Smoke*, 1996, an interactive work and film for the Berwick Ramparts project, the components of which—ladder, kites, umbrellas, kiosks, and bench—were all black.[46] Nogueira returned to the same objects again and again in both her drawings and three-dimensional works. Nonetheless, some of the drawings do seem to have a more direct relationship to the sculptures, in particular those where the ground is left bare and objects are arrayed, usually in pairs or groups, on the page, sometimes suspended on wavering graphite lines.

> The feel she had for drawing... and for how things are placed on a page is very similar to the way in which she would place an object or burrow into the floor to bury a piece of fur into the gaps between the floorboards... her work had a connectedness—between her own body and a sense of touch... there was a continuity.[47]

A lot of the drawings involve the containment of objects or creatures, an interest echoed in the sculptures. Talking about her work in 1993 she referred to this fascination for what is hidden, for enclosure, containment, which causes a pressure to build up.[48]

Nogueira's use of laboratory equipment came out of an interest in transmutability, impermanence and change. *Untitled*, 1992, demonstrates an interest, like Gormley's, in experimenting with different materials. The admixture of different inks and paper has produced a complex, hot, coppery surface. Plus and equal signs fashioned out of correction tape waver across the page, a link with chemical formulas and her interest in making visual "life's vicious circle—there is no beginning and no end... and no permanent solution is ever found".[49]

Other drawings are more abstract and seem to relate to thoughts and psychological states and suggest notions impossible to visualise by any other means. In some of the drawings she made towards the end of her life, when illness compelled her to use her left hand, the distinction between writing and drawing becomes blurred. In *Untitled*, 1998, the page is painstakingly filled, from edge to edge, with wavering lines resembling staples, the gaps having been filled even at the cost of reducing the programmatic size of the repeated mark. Now and again she has added intense colours over the pencil lines, as a child traces over letters to learn the alphabet.

Rachel Whiteread

The importance of drawing within Rachel Whiteread's practice has increased in step with the ambition of her sculpture. As an art student in the painting department at Brighton Polytechnic, her employment of drawing drove her to ignore the edges of the paper or canvas and move into the space of the room, an early indication of her sculptural interests. Her first sculptural works relate to the body and are modest in scale—a wax cast of her back, a plaster cast of her leg, both 1987, combined with surprising materials—copper or carpet—to create disquieting objects. She moved on to objects that have a visceral connection with the body, casting the space within a hot water bottle, inside a wardrobe and, in *Shallow Breath*, 1988, beneath a bed.

The transition from works on a relatively modest scale to the room-sized work *Ghost*, 1990, is dramatic, only to be eclipsed, three years later, by *House*, 1993, the cast of an entire house. This ambitious work took three years to come to fruition and during this gestation period drawing became a crucial tool. Some of these drawings take the form of architectural drawings, a marriage of her photographic and drawing skills.

> I was thinking about trying to make something that wouldn't necessarily require me to destroy the house. I had the idea of making the piece and moving it. I didn't know that I could ever have the possibility of destroying a building in the cause of sculpture. I thought about it very obsessively. I would take these photographs and then look at them at home and fantasise about making it. So that was the function of all these drawings.[50]

In order to refine her ideas for the piece and realise it in some form, she experimented with redrawing entire buildings using correction fluid. In *Study for 'House'*, 1992-1993, the surface is not quite opaque, allowing a glimpse of the features beneath, just as the plaster or concrete surfaces of her sculptures pick up the contours, in reverse, of a room and all its lived-in traces. These are not working drawings, but an attempt by Whiteread to conceptualise and visualise a building in negative, an interest that could be related to Gordon Matta-Clark's exploration of positive and negative space.

Whiteread's most prolific drawing output occurred during the eighteen month period she spent in Berlin from 1992-1993. Drawing is often the medium that artists turn to while away from their studio. This is partly due to practical considerations—they are away from their tools and equipment, yet paper and graphite can be found and transported anywhere. During this time Whiteread created a body of drawings that did not relate to a specific sculptural project. She made many drawings of the parquet floor in her Berlin flat. Some of these are rigorous line drawings on graph paper that could be working drawings for sculptures. Others are uneven and fill the paper entirely: "I sometimes look away from the drawings whilst I'm making them, playing with an element of chance. I also make other drawings that are meticulous. It depends on my mood."[51] Many of these drawings are created using correction fluid, which shares the substantial, powdery

consistency of her favourite sculptural materials. During the process of hardening lines and contours are drawn in with ink. Watercolour is sometimes added later. The ink lines have to be drawn in quickly and the stage of the drying process determines the quality of the mark.

Whiteread had been drawing flights of stairs for eight years, puzzling out their forms in a mental rehearsal before her first opportunity to realise them as sculptures in 2001. This project posed a number of problems, as she wanted to cast a staircase without destroying it. Drawing helped her to tackle this challenge and address formal, practical and material considerations. *Untitled (House)*, 1995, seems to be dealing with all these concerns and gives an insight into how she approaches her ambitious sculptural projects.

Tania Kovats

Drawing has become increasingly important in the practice of Tania Kovats. During the 1990s she made a series of sculptures that dealt with conceptions and experiences of landscape, in particular, coastal landscapes prone to erosion. At this stage Kovats was using drawing as an aid to realising her sculptures, rather than to create distinct works. She is interested in the way our experience of landscape is culturally mediated and has made detailed studies of geological formations in order to understand the origination of landscape, independent of our effect on it. This interest has led to sculptures based on precise renditions of land forms – some taken directly from nature and others fabricated. These geological formations emerge from white plinths, creating a sense of theatricality and reminding us of their artifice.

In a series of drawings entitled *Breath*, 2001, Kovats dripped a blob of ink onto graph paper and then blew through a straw to disperse it. The results are intriguing amoeba like blobs that evoke ancient life forms or jelly fish. The process by which they are made is particularly interesting. The ink has not been pushed around by pen or brush but by air; its final condition is determined by the material quality of the ink combined with a strong element of chance. The process is far from analytical, as the scientific graph paper on which they are made might imply.

In *British isles*, 2004, Kovats charts every one of the more than 2000 islands that lie off Britain's shore, painstakingly copied from a road atlas. This involved tracing round all those parts of the British Isles that have broken off from the mainland and blotting them out in black ink. The resulting 60 drawings were then superimposed over each other, up to six deep, and pinned together as a set of ten works. This layering has rendered these 'accurate' cartographic drawings functionless. Despite the logic of the exercise she set herself, the drawings have an obsessive, emotional dimension, possibly caused by homesickness—she made these drawings during an 18 month period spent in Los Angeles: "I found myself sitting five thousand miles away, tracing my way around Dungeness and Ramsgate; becoming a British landscape artist thanks to a trip to America."[52] The deep layers of paper in these drawings relate to the sculptures that followed, the white paper functioning as a plinth.

The Giant's Causeway and Staffa are two of Britain's best known areas of marine geomorphology. As well as three sculptural works *Basalt I*, *II*, and *III*, 2004, Kovats' interest in these landscapes also generated a drawing entitled *Basalt*, 2004. Rendered in china ink on paper, this intriguing work is of the hexagonal pillars of basalt formed by the rapid cooling of submarine lava, then pushed upwards by tectonic uplift. On completing this drawing Kovats discovered that it could be read equally satisfactorily either way up. She was delighted with this result; like Richard Serra, Kovats wants to create three-dimensional structure from within the two-dimensional work, rather than an image of three dimensionality.

This concern is further developed in recent drawings that explore the behaviour of liquids on paper. In *bubble drawing*, 2005, she has poured a mixture of acrylic paint and liquid detergent onto the paper and then blown into it, resulting in the formation of bubbles. The result is a thick, lava-like crust; the liquid becoming solid to create an ambiguous surface. In another series Kovats has used materials that generate crystals that seem to grow out of the paper. These drawings are very organic and process-driven in contrast to the analytical and conceptual nature of her map works. They also move towards a fusion of drawing and sculpture. And while her three-dimensional projects have steadily grown in ambition and therefore take longer to realise, Kovats can use drawing to work through all the generative material teeming in her head.

Serra, Gormley, Nogueira, Whiteread and Kovats have each extended drawing's repertoire of materials and visual language. The drawings of these artists make their process of production palpable and provide an insight into the origination of the sculptures. Just as his three-dimensional practice led to a redefinition of the terms of sculpture, Serra's installation drawings have contributed to the emancipation of drawing. These drawings are made on canvas; the paintstick, closer to paint than graphite, covers the entire ground; and the drawings are cut to size on-site. Kovats shares Serra's interest in blurring the distinctions between drawing and sculpture, and like Nogueira and Gormley experiments with a wide range of materials. Drawing plays a distinctive role for each of these sculptors, offering an opportunity for experimentation that informs and works in parallel with their three-dimensional output.

Lucia Nogueira
Untitled, 1995
graphite, watercolour on paper
28 x 38 cm

THIS DRAWING LIFE

In 1966, Philip Guston unexpectedly abandoned abstract painting and turned his attention to drawing. Like Pop artists Roy Lichtenstein and Andy Warhol, he developed a new figurative vocabulary and style indebted to commercial cartoonists such as George Herriman, Al Capp, and Walt Disney that recalled his early training on a correspondence course organised by the Cleveland School of Cartooning in 1925. In a lecture given at the University of Minnesota in March 1978, Guston explained that "The visible world... is abstract and mysterious enough. I don't think one needs to depart from it in order to make art."[53] This dramatic shift allowed him to investigate the seminal political events of the late 1960s that disturbed and activated him, such as the Vietnam War and the Civil Rights movement. His engagement with the 'real' world in a style that is direct, humorous, honest, even uncomfortable, has been influential for subsequent generations of artists. Following Guston's lead, the proliferation and sophistication of comics and cartoons has firmly infiltrated fine art in the work of Raymond Pettibon, Paul Noble and Adam Dant amongst others.

The growing eclecticism of styles in the 1980s gave artists the freedom to appropriate style and form from other disciplines such as architecture, fashion, and scientific illustration, as well as popular culture. During this decade certain artists began to champion drawing again, at first seen as eccentrics, then gradually acknowledged as important individuals. In the 1990s, practices such as Russell Crotty's, which follows in the tradition of scientific illustration, or Toba Khedoori's which employs architectural techniques, began to experience professional and commercial success with an exclusive drawing practice. William Kentridge is the most important artist to emerge from post apartheid South Africa, combining filmmaking—arguably the dominant art form of the 1990s—with his commitment to drawing. For these artists and many others, drawing is the only medium that allows them to fully express their thoughts, ideas and emotions.

Adam Dant
Musée du Louvre (B.I.S.I), 2003
ink and watercolour on paper
25 x 20 cm

CATALOGUE

MUSEE DU LOUVRE

BUREAU POUR L'INVESTIGATION
DE L'IMAGE SUBLIMINAL

Raymond Pettibon

Raymond Pettibon's drawings have a private, sinister quality. They are indebted to the comic book, powerfully juxtaposing unexpected and often provocative fragments of thoughts and quotations that sit alongside an image. Unlike the comic strip, each individual drawing stands alone and instead of working together harmoniously, the figurative elements often jar with the scrawled text. He extracts and exaggerates the comic genre's tendency to violence, taking this theme to a horrific extreme. Pettibon has deliberately selected this unpretentious, 'low' art form that has been a regular part of everyday life in the United States since the end of the nineteenth century to examine the darker aspects of today's American society. Instead of the pleasant, entertaining experience the viewer expects when faced with the recognisable format of the comic, they are confronted with a shockingly aggressive visual commentary. By confining himself to the same humble and stylised method of small-scale drawing, Pettibon can concentrate on exploring his subject matter, producing literally thousands of works since the 1970s.

Like cartoon illustrators, Pettibon has developed his own catalogue of characters, such as the figures Vavoom (from *Felix the Cat* comics) and Gumby (also a comic book character), as well as the surfer, the phallus, the train, the Bible. These sit alongside particularly American themes—Charles Manson, Elvis Presley, the Vietnam War, surfing, or baseball. Like James Ellroy, or Raymond Chandler and the genre of film noir, he investigates unpleasant subjects—violent sexuality, an aggressive misogyny, the futility of religious beliefs, the threat of death. Throughout his prolific output of drawings, motifs recur obsessively as if Pettibon is trying to exorcise these disturbing scenes through their constant repetition.

Adam Dant

Though stylistically very different to Pettibon's work, Adam Dant's drawings are also indebted to a cartoon vernacular and are equally dismissive of the idea of a neat, conclusive narrative. Instead, his drawings possess their own eccentric logic, presenting a group of incidents or anecdotes that are experienced as one might encounter a series of random events in the course of a day. This journalistic instinct resulted in Dant's best-known project, the periodical *Donald Parsnips Daily Journal*, 1995-2000. Capitalising on drawing as a peripatetic medium, for five years Dant wrote, drew and distributed, every day, an eight-page A6 free sheet wherever he happened to be—Paris, New York, London. The individual parts, which comprise literally thousands of drawings, result in a major, unique work that offers a complete alternative universe, populated by Parsnips. Dant is fascinated with presenting alternative systems to existing disciplines or histories. He set up The Bureau for the Investigation of the Subliminal Image (B.I.S.I) in order to investigate alternative art histories. Taking as his model Freud's thesis that Leonardo da Vinci's *Madonna and St Anne* conceals a vulture, he re-examines other great works of art for secret codes and motifs. His findings are presented in a diverse collection of drawings, documentation and pamphlets.

The incredible detail in Dant's larger drawings, made for the gallery wall, demand a similar degree of concentration to those made for the page. The series *The People who live on the Plank* can be seen as a twenty-first century version of William Hogarth's eighteenth century satirical prints, which presented everyday vice and corrupt behaviour for judgement and condemnation. Yet Dant's absurd observations offer no such moral stance.

Interconnected narratives are presented in roundels that diminish in size in each subsequent drawing. These intricate drawings depict human folly in all manner of forms, from the commonplace to the bizarre. In a chaotic chain reaction, one uncommon event leads to another surreal activity that often has a violent or aggressive nature. As the circles get smaller, so the action appears to get more frenzied as we try to follow the curious incidents as they unfold. In Dant's fictional world, as in real life, there is ultimately no end to humanity's capacity to trip itself up, and then get up and start again.

Paul Noble

Paul Noble is another compulsive drawer. Since 1995, he has been creating a series of drawings that together make up a fantastic urban environment called Nobson Newtown. Each large-scale work takes around six months to complete and the meticulous attention to detail is astonishing. He explains:

> The idea of a doodle as an unthinking moment is important to me. I wanted to find an impoverished aesthetic for Nobson Newtown. That's why I treat these lowly drawings in such a monumental and grand manner. I choose to make drawings because I saw it as the most common and least problematic art practice.[54]

So far there are 27 locations in this dysfunctional, peopleless city, which is strangely reminiscent of a post war English New Town. Each building or place is made out of a customised unique typeface, Nobsfont, and spells out its own name—the town centre 'Nobson Central'; the hospital, 'Nobspital'; the squatter camp, 'Acumulus Noblitatus'. Influenced by Chinese landscape painting's incorporation of calligraphy, Noble places language at the heart of this decaying landscape, treating letters as a form of architecture. He uses a technical device called oblique projection, ensuring this three-dimensional effect gives all his drawings a uniform, flat perspective, reminiscent of clunky, early computer games.

Noble admits that the project is itself a struggle to make sense of the experience of urban city dwelling. Moving to London from Yorkshire in the late 1980s, he became politically active, co-running the influential artist-run space, City Racing, in a derelict betting shop and protesting against the demolition of his neighbourhood in the East End for a motorway link road. Around this time Noble started to develop his own alternative town plan:

> The whole body of work is supported by structures of ideas. Town planning sounds like a really boring way of putting it but when you are a poor person you have a very particular experience of a city. You have a peripheral experience, particularly in London. For most of my life in London I've been in squats or short-life housing. In these conditions you tend to be on the front of a new wave of development and live in houses which are about to be knocked down. Most of the places where I've lived don't exist anymore.[55]

Nobson Central, 2000, is a demolished neighbourhood created, according to the specifications of its anonymous inhabitants, to celebrate beauty in the squalor of the modern slum. When asked what the town centre should be like the citizens responded that it should be an "uncentre wasteland". In the *Introduction to Nobson Newtown* published in 1998, Noble explains how "some visionaries remembered the beauty of bombed European cities towards the climax of World War Two and I took this as a working model". So existing buildings at the town centre were destroyed and the debris was scattered to create a place for wildlife and scavenging dogs. The *Introduction* proudly declares of this wasteland, "the only perfect thing is a flawed thing".

Russell Crotty

Russell Crotty draws incessantly in order to record detailed information about the celestial sky that fascinates him. Night after night he gazes at the stars from his hilltop observatory in Malibu, California, committing his astronomical observations to paper. Like a true Californian, he reveres the nineteenth century naturalist John Muir's lifelong struggle to preserve the sublime landscape and its flora and fauna during the rapid urbanisation of West Coast America. He transcribes what he observes into custom bound 'atlases' that can range from a few centimetres to several metres in length. Occasionally he signs these as 'Principal Investigator' (a term still used amongst astronomers), bridging the gap between art and science; indeed he has actually sold drawings of Saturn to NASA. Crotty uses the most ordinary of black ink biros and a technique of cross-hatching to convey the density of the night skyscape. These dark landscapes are often interwoven and overlaid with texts that include snippets of nocturnal radio talk show dialogue, speeches against local ecological intrusions, as well as excerpts from his favourite writers such as HP Lovecraft, Gary Snyder and Carl Sandburg. He uses the same techniques to inscribe large globes made of paper glued to Lucite spheres. The intimidating vastness of the night sky is neatly wrapped onto a sphere, covered with meteor showers, planets and lunar landscapes.

This may seem an archaic means of translating what he sees to permanent record, a throw-back to a nineteenth century occupation. Computers and the camera are now the accepted means of documenting scientific data, yet Crotty's obsessive works take us beyond cold, scientific record. Instead they succeed in capturing the magical allure of the night sky. John Ruskin argued that drawing could be used "to obtain quicker perceptions of the beauty of the natural world, and… preserve something like a true image of beautiful things that pass away, or which you must yourself leave". [56] This sense of capturing an awe-inspiring passing moment is at the heart of Crotty's practice. He describes the experience he is trying to communicate:

> On that ladder alone up there, I actually feel creeped out. I feel like I'm looking at something I shouldn't be looking at. That light, there's something sacred about it. It's travelled so far. It's amazing, like eavesdropping. Looking at a supernova remnant in Cygnus in the summer—it's like a very faint veil of gas. I can't put it into words, but I can attempt to draw it. [57]

Crotty believes that "In drawing there is no distance between the artist and the mark made." [58] He is using the most intimate of mediums to depict the most overwhelming of subjects—the infinite landscape of the galaxy.

Toba Khedoori

Toba Khedoori's wall size drawings have a dream-like quality. Everyday, mundane architectural subjects such as an anonymous room, a set of doors, a brick tunnel, a pedestrian bridge or a train, are presented floating in a vast expanse of creamy white paper. They appear as if a distant memory, out of context and out of reality. This sense of otherworldliness is heightened by the absence of people, or even the trace of humanity. Working exclusively on paper since 1988, Khedoori's carefully perfected technique adds to the ghostlike impression of the work. She prepares a large sheet of paper by laying it on the floor and coating it with wax, most of which is scraped off with a razor blade. During this process particles of dust and detritus settle on the coated paper, embedding physical evidence of time and space within the surface of the work.

Khedoori selects an image from a stock of photographs, then translates the image into a drawing at the heart of this large piece of coated, translucent paper. Traditional architectural draftsmanship is employed to convey a convincing structure, and a sense of three-dimensionality is added by shading with oil paints in a range of soft, neutral colours. Once a mark is made it remains visible, so that the finished drawing bears witness to every gesture. Each large-scale sheet can entirely fill a gallery wall so that the viewer has a sense of being enveloped by the work. The negative space left around the image is just as important as the motif itself. This void creates a sense of the depicted subject being suspended in time as well as in space, removed from the world and presented for quiet contemplation.

William Kentridge

For William Kentridge the starting point for all his work is the insatiable desire to draw. He states:

> Drawing for me is about fluidity. There may be a vague sense of what you're going to draw but things occur during the process that may modify, consolidate or shed doubts on what you know. So drawing is a testing of ideas; a slow motion version of thought. It does not arrive instantly like a photograph. The uncertain and imprecise way of constructing a drawing is sometimes a model of how to construct meaning. What ends in clarity does not begin that way. [59]

Since the 1980s, Kentridge has been creating short animated films by working directly with charcoal and pastel drawings and 16 mm film. For each film, he will usually produce several large drawings, each containing a single scene that is then animated through a process of erasing and redrawing the same sheet, filming each reworking. Kentridge does not necessarily have a storyboard ready formed before he starts; the creative process literally unfolds before our eyes, as does the thought process. He works out from the initial scene, creating the narrative with each subtle change. The effect of layering and erasing to create the film, a process that continually reveals its own history and leaves traces of its past, can be seen as a metaphor for its subject matter. Kentridge makes work about the complex and extraordinary events in his native South Africa over the last 20 years. He depicts ordinary characters in simple narratives to comment on the legacies of post-apartheid South Africa and its effects on industry, racial relationships, politics and domestic life. Yet the works are suggestive rather than conclusive. We are both hypnotised by the quality of the expressive drawing and captivated by the narratives that unfold. It is through the very act of drawing that Kentridge seeks to understand the tragic situation that exists in his country:

> I believe that in the indeterminacy of drawing, the contingent way that images arrive in the work, lies some kind of model of how we live our lives. The activity of drawing is a way of trying to understand who we are or how we operate in the world. It is in the strangeness of the activity itself that can be detected judgment, ethics and morality. [60]

These eclectic and unique practices are united by the compulsion to draw. This instinctive force is directed to allow the artists the possibility of investigating and engaging with the 'real' world around them. Drawing becomes a means of expressing a personal reality, however surreal and eccentric. Often these visions are deliberately stylised, using techniques and visual codes borrowed from the everyday world such as comic books or science journals. There is no attempt to portray a better place; these alternative realities are all dimensions of Guston's "abstract and mysterious" world in which we live.

DRAWING IN PART

In 1978, Rosalind Krauss expanded critical discourse to embrace multi-disciplinary practice, describing how

> ... [w]ithin the situation of postmodernism, practice is not defined in relation to a given medium—sculpture—but rather in relation to the logical operations on a set of cultural terms, for which any medium—photography, books, lines on walls, mirrors, or sculpture itself—might be used. Thus the field provides both for an expanded but finite set of related positions for a given artist to occupy and explore, and for an organization of work that is not dictated by the conditions of a particular medium.[61]

After the breakdown of Modernism, artists became less concerned with the properties of a specific medium itself, instead selecting the medium for its compatibility with their particular thesis or proposition. With the Duchampian principle that art can be made of anything firmly established, artists today often work in a range of media simultaneously. Of course, some artists always went against convention. As Stuart Morgan comments on Louise Bourgeois' work, "For an artist with no fixed style or material or medium, only one rule seems to apply. That is, that there are no rules—no rules at least, which cannot be broken. But perhaps the very idea of breaking them provides the clue."[62] Today artists move without restraint between media or styles, as in the case of Fiona Banner, Tracey Emin, Tacita Dean, or David Musgrave, or to combine them, as in the case of Grayson Perry.

Louise Bourgeois
Untitled, 2002
engraved drawing, thread and collage
on Indian ink prepared board
64 x 149 cm

Grayson Perry

> When I was 12 or 13, I drew a series of short comic strip adventures featuring an idealised male hero. When puberty hit me these boy's own tales became increasingly kinky, involving much cross dressing and bondage. Sadly these reports from my young subconscious were lost in the upheavals of adolescence. 20 years later I drew 'Cycle of Violence' while facing up to becoming a father myself, and once again my imagination became an open wound.[63]

As described in his comic book, *Cycle of Violence*, drawing was the first outlet for Grayson Perry to rationalise his personal experiences and fantasies through art. In a concerted effort to go against good taste and fashion, he turned to ceramics in the mid 1980s, but he brought his skill and passion for drawing to this discipline, merging fine art and craft traditions. The rawness of Perry's drawing style contrasts with the technically sophisticated and accomplished finish of his vases, which use rich glazes, and decorative textures to create seductively beautiful works that disguise their challenging subject matter. Perry is very aware of the power of this subversive strategy, declaring his work has a "guerrilla tactic". He uses the 'pots' as a vehicle to comment on deep flaws within our society, tackling such sensitive issues as sex scandals, missing children and juvenile crime, as well as his own personal history—a miserable upbringing in the heart of Essex; his transvestite alter ego, Claire; and his current happy family situation.

He comments on the graphic element of his work:

> The fact that it is a line is important to me. A hard line somehow captures and owns the image, symbolizes it rather than reproduces the effects of light upon the subject as with shade and tone. I am aware of the impact different nuances of style have on reading an image. Consequently I have adopted a rather naïve and somewhat clumsy manner and my drawing is always teetering between being too slick and too careless.[64]

The confessional nature of his work is reinforced by the direct quality of Perry's drawing, a style that is influenced by Outsider art, in particular the work of Henry Darger. Perry first saw the work of this Chicago hospital janitor at the Hayward Gallery's 1979 Outsider Art exhibition and was immediately drawn to the strange and elaborate fantasy story of seven Vivian Girls who mount a rebellion against the evil adults. He identified with the need to return to the themes of an unhappy childhood: both Darger and Perry depict alternative scenarios and realities as a means of simultaneously escaping and embracing the past.

Tracey Emin

Time and time again, Tracey Emin returns to drawing as the primary means of expressing her abject state of mind and body. Though she employs a vast array of media, such as film, embroidery, sculpture and performance, it is drawing that satisfies her confessional drive the most and has a consistent presence within her practice. Like Perry, she deliberately employs a naïve, child-like drawing style that, combined with the frank, often sexually explicit nature of her subject matter, seems to expose her most private memories and obsessions. Emin's sexual past and present are invariably the subject, and the stylised depiction of herself having sex or masturbating appear to offer her up as 'available'. Yet this act of abandonment is controlled and deliberate; a borrowed feminist device to disarm the viewer who should not be deceived that the 'Tracey Emin' encountered in her art is the same as 'Tracey Emin', the person. Her persona is just as stylised and exaggerated as her drawing style, even if the anxieties are real. The drawings usually take the form of rapid one-off mono-prints, a technique that suits the immediate quality of her work. Yet as Chris Townsend states, this method is "rather a strategy of distantiation, of removing a certain immediacy and directness of gesture which might characterise the drawing".[65] Although the line image is deceptively simple, the process of printing in this manner demands a certain amount of preparation and skill.[66] Writing is also a vital part of the creative process for Emin, and her signature script has the same child-like, urgent quality of her drawings. The text is, or appears to be, unpremeditated, a stream of consciousness in which mistakes are simply scribbled out and spelling errors ignored. Scrawled statements often accompany the drawings, directing our interpretation of the image.

Louise Bourgeois

Emin is indebted to Louise Bourgeois in her attempt to make sense of her childhood traumas though the process of drawing. Bourgeois unwittingly speaks for her younger contemporaries when she states:

> Some of us are so obsessed with the past that we die of it. It is the attitude of the poet who never finds the lost heaven and it is really the situation of artists who work for a reason that nobody can quite grasp. They might want to reconstruct something of the past to exorcise it. It is that the past for certain people has such a hold and such a beauty... Everything I do was inspired by my early life.[67]

As with Emin and Perry, it is useful to know something of Bourgeois' personal history to gain insight into the occupations and motifs that appear repeatedly in her work. Leaving her native France at the age of 27 to follow her husband to New York, Bourgeois repeatedly reworks her memories of those early years; her training in her parents restoration workshop of sixteenth and seventeenth century tapestries; her betrayal by her father in having an affair with her English governess; and the confusing response of her mother who turned a blind eye. Sewing or dress-making, a traditionally feminine occupation, recurs as a theme in Bourgeois' work, as it does in Emin's practice and the act of sewing, like drawing, for both artists can be seen as a process of emotional repair. Her enigmatic drawing is a constant reconstruction of herself, her emotions and her memories. She says "Drawings have a feather-like quality. Sometimes you think of something and it is so light, so slight that you don't have time to make a note in your diary. Everything is fleeting, but your drawings will serve as a reminder; otherwise it will be forgotten."[68] Though she is seen primarily as a sculptor, Bourgeois' drawings exist in parallel, yet independent to her three-dimensional work. She draws incessantly, obsessively covering every surface available to her to create a multitude of shapes and motifs. Yet for a long time these works were kept mostly hidden, only celebrated publicly when there was a renewed interest in her work during the 1980s. In the late 1940s and early 50s, she developed the *Femmes-maisons (House-women)* drawings, strange, surreal sketches that unite the female body and the architecture of the home and betray her preoccupations of that time. In contrast other drawings are purely abstract, intensely worked formal images that have a powerful visceral presence. Created automatically, these drawings offer as much of an insight to her psychological state as do the figurative works. Some drawings can be understood as allegories of geological formations, hilltops or map contours. Yet they could also be read as bodily protrusions, breast-like

or phallic. Other drawings are more geometric, constructed with crosshatched lines that are reminiscent of weaving. Bourgeois has said that she prefers the abstract drawings, commenting, "geometry is a safe thing that can never go wrong, a guarantee. It offers a reliable world, a reliable system, and an unchanging frame of reference that will not betray you."[69]

Fiona Banner

Fiona Banner is compelled by language: both the visual qualities of text and its capacity to negotiate imagery that she finds too powerful or complex to process in any other way. Since 1994 Banner has created handwritten and printed texts—'wordscapes'—that retell in her own words entire feature films or particular scenes in meticulous detail. At six and a half metres wide, *Apocalypse Now*, 1997, is as overwhelming as the film itself: the vast scale echoes the cinematic format of the wide screen. Written as a blow-by-blow description of the violent action on screen, Banner's personal interpretations of popular war films expose how these highly subjective, even fictionalised accounts have had an indelible effect on our understanding of recent history. In direct contrast to these relentless outpourings of language, Banner has made a series of drawings and sculptures in which massively enlarged full stops, selected from a variety of fonts such as Slipstream, Courier, Century or Bodoni, are presented as abstract, physical forms. Created as intensely worked pencil marks on paper, Banner has described these drawings as "stripped bare, like totally edited books". Just as the wordscapes expose the ultimate impossibility of articulating a visual experience through words, so the full stops deny the viewer any further insight as their own image is blankly reflected back in the matt sheen of the graphite.

In more recent work Banner has tackled the traditional subject of the nude, revisiting the now almost antiquated discipline of the life drawing class. Once again she turns to the written word to offer a means of representation. Writing directly on the wall, the idiosyncrasies of Banner's handwriting make it hard to read the description of the naked figure, yet snatches of words and sentences communicate the artist's struggle to capture the elusive and seductive qualities of the human form. Banner's dexterous use of language reveals the humanity of the model as the imperfections of the sitter's body are related in meticulous, yet sympathetic detail. The visual quality of the text is just as important as its meaning: Banner's personal scrawl is a form of drawing, offering a direct index of the artist's thought process. In *Striptease*, 2004, Banner offers a frank account of the performance. We follow her experience in 'real-time', as each calculated act of undressing is described to us. In this way the work goes beyond mere representation of a human form, but succeeds in simultaneously conveying what the artist is experiencing whilst capturing this intimate portrait.

David Musgrave

Like Banner, though deploying completely different means, David Musgrave investigates the most basic artistic dilemma, the act of representation, continually subverting and exploiting this age-old theme. His understated works demand concentrated scrutiny as each layer of deception and illusion set up in the process of making the image is unravelled in the process of perception. Manipulating the drive to recognise the human figure wherever possible, he offers up anthropomorphic forms that are invariably translated from an unseen original. Works are created in a variety of media—

pencil, paint, acrylic or aluminium—yet the connecting principle is that things are not always as they at first appear. *Transparent Head*, 2003, was drawn from observation of a Cellophane record wrapper set against a black ground. The title encourages us to see a skull like shape, yet the 'eyes' are actually just little knots in the Cellophane and the 'head' is merely schematic. The image is created by drawing the dark spaces around and within the material, thus the form itself is transparent, formed by the negative space of the paper left untouched by graphite. *Form in a Bag*, 2004, offers a carefully drawn realistic depiction of a creature-like form that was moulded by the artist whilst in a clear plastic bag. The manner in which the embryonic form is trapped within the bag, becomes a metaphor for the act of 'entrapping' the image in its medium. As in *Transparent Head*, the viewer experiences the form as fluctuating between animate and lifeless object. Drawing lies at the heart of Musgrave's practice, yet he is not attracted to the gestural quality of the medium. On the contrary, he is interested in the precision it allows him to render a pre-conceived idea; as he explains,

> The economy of drawing is something that's very important to me— the potential for elaborating an imaginary world with dust or lines on a surface—but I find terms like 'spontaneity' and immediacy a problem. Conventions of making and reading always precede the act, no matter how it 'feels' to do it. At the same time that's why I tend to take these conventions as the subject of the work, to try to step outside or defeat them in some way.[70]

Tacita Dean

Tacita Dean's films, sound installations, writings and drawings are united by a common preoccupation with the sea. Her seven, two and a half metre square blackboard drawings, *The Roaring Forties: Seven Boards in Seven Days*, 1997, were executed in the course of a week, a feat of endurance akin to sailing through the namesake of the piece, a notoriously perilous area in the southern Atlantic. Each depicts a seascape, inspired by old photographs, which is animated by handwritten captions giving cinematic instructions, such as "Aerial view" and "Out of frame". The drawings betray Dean's instinctive thinking as a filmmaker, acting either as preparatory material for a film, or as a description of a finished work; she "see[s] them as dysfunctional storyboards. They are non-chronological. They do not work in any way as storyboards, they could not function as storyboards. They also have the same quality as post-production stills as well. They are a mixture of the two."[71] These forceful images are at once dramatic and poetic; the vulnerability of the white chalk lines adds to the impact of the scene. The blurred, and partially erased line successfully portrays the continual state of flux of the sea, and in so doing introduces the element of time. This is the closest a still image can get to the movement of film. Yet drawing allows Dean to create a non-linear narrative, where the actions take place simultaneously rather than sequentially. It also permits her to engage directly and immediately with her subject matter, rather than direct the action of others on a shoot that has been planned months in advance. The pleasure of this direct touch is apparent in these fragile yet powerful works, a pleasure that is transferred effortlessly to the act of looking.

In the work of these diverse artists, drawing is an act of investigation, deployed to try to understand a range of concerns. For some, such as Bourgeois, Emin or Perry, these enquiries are highly personal, often dealing with specific histories or incidents and the artists appear to have great investment in reaching some kind of resolution. Yet these works are more

than just visual therapy, they speak of collective experiences and dilemmas that trouble humanity. For other artists, such as Banner or Musgrave, the studies are more objective, though just as relevant to all of us, dealing with the way in which we structure and express our understanding of the world— through language and through visual representation. Each of these artists uses a range of media to explore their defined interests, yet drawing has a constant presence within their varied practice.

Collectively, the diverse example of artists discussed above demonstrates how relevant drawing is to contemporary practice.The question of why artists are continually inspired by drawing perhaps lies in its fertile potential and adaptability, qualities that remain impervious to stylistic or conceptual trends. Artists can draw wherever they are, whatever their physical location or psychological state. Drawing allows complete freedom and spontaneity— the perfect conditions for invention, change and experimentation. It is a great way to harness ideas and synthesise thoughts. And it is the perfect analytical tool. These were always the unique characteristics of drawing, but it was only with the breakdown that Modernism effected that disciplines other than painting and sculpture were regarded as suitable to create 'serious' art. The liberating effect of this questioning of grand narratives led to a radical re-evaluation of the very definition of art during the 1960s and early 70s. Interestingly, this was a time when drawing was at the forefront of avant-garde practice, as seen in the work of Sol LeWitt, Eva Hesse, Richard Serra and Gordon Matta-Clark. As we have articulated, some of the most innovative and influential artists working today are championing drawing once again, whether it is the main part of their practice, complementary to another medium, or an equal part of a varied output. It is perhaps too soon to make definitive conclusions about why this is, but it could be argued that at the turn of the twenty-first century we are again experiencing a re-examination of the possibilities for visual expression. Artists are struggling with the legacy of the previous century, whilst trying to develop an art that articulates the present. Unlike painting or sculpture—or even filmmaking or environmental art—which often appears to bear the weight of its own history, drawing seems to allow for a less self conscious experimentation.

In searching for reasons for this renewed enthusiasm, the fact that drawing is fundamentally a pleasurable activity should not be disregarded. Many artists talk of drawing as something they do constantly as a way of working through and resolving ideas. It is to drawing that many artists turn when they are not sure how to proceed with a particular line of enquiry, or how to realise an ambitious proposal. As Avis Newman suggests, drawing offers the most direct access to the intimate workings of the artist's mind: "I have always understood drawing to be, in essence, the materialisation of a continually mutable process, the movements, rhythms, and partially comprehended ruminations of the mind: the operations of thought."[72] For this reason alone, drawing will always be at the heart of the visual arts. The key shift that has occurred is that drawing as an activity is now believed to be acceptable for public presentation, rather than only suitable for private research or study. This is a recent change in perception, not just on the part of artists but significantly by museums, commercial galleries and critics. Even those artists actively celebrating drawing in the 1960s and 70s, such as Serra or Hesse, were usually better known for other types of work. The fact that Raymond Pettibon is one of the most important

artists working in America today, as is William Kentridge in South Africa and Paul Noble in the United Kingdom, all with an exclusive drawing practice, clearly demonstrates this transformation.

The artists whose work we have discussed, albeit in brief, represent only a few of those working in ways that further develop our understanding of drawing today. This text, and indeed this book, merely serves as an introduction to the breadth and diversity of this humble, yet powerful and lasting medium. **KM AND KS**

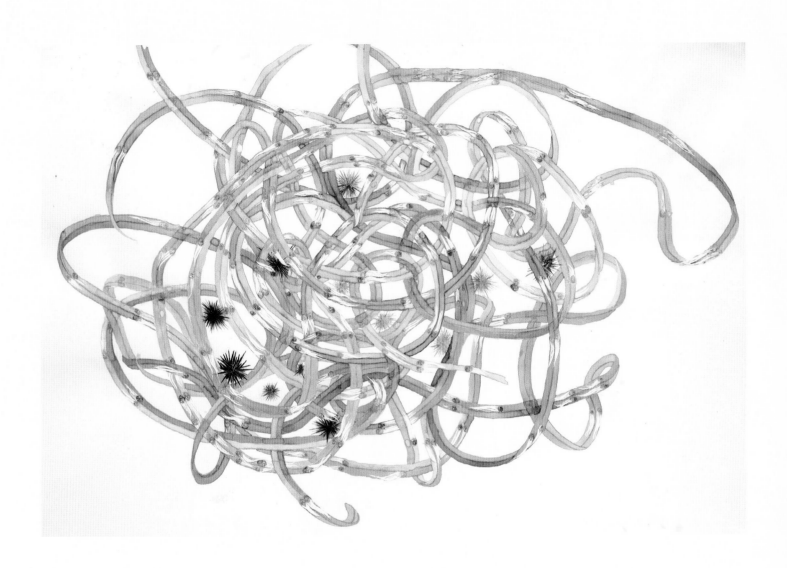

Ellen Gallagher
Watery Ecstatic Series, 2003
watercolour, pencil, varnish and cut paper on paper
69 x 102 cm

1 Craig-Martin, Michael, *Drawing the Line, Reappraising drawing past and present*, London: The South Bank Centre, 1995, pp. 9-10.

2 Naginski, Erika, "Drawing Things In, Sketching Things Out", in *What is drawing?*, London: Black Dog Publishing, 2004, p. 156.

3 Greenberg, Clement, "The Great Precursor: Review of the Drawings of Leonardo da Vinci", in John O'Brian ed., *Arrogant Purpose* 1945-59, Chicago: University of Chicago Press, 1988, p. 110.

4 Quoted from Stephen Farthing's inaugural lecture in the new post of Professor of Drawing at the University of the Arts, London, 2005.

5 Naginski, "Drawing Things In, Sketching Things Out", p. 153.

6 Serra, Richard, quoted in Lizzie Borden, "About Drawing: An Interview, 1977", in Richard Serra, *Writings, Interviews*, Chicago: The University of Chicago Press, 1994, p. 51.

7 Hoptman, Laura, "Drawing is a Noun", in *Drawing Now: Eight Propositions*, New York: The Museum of Modern Art, 2002, p. 12.

8 This could be traced back to the Impressionists, whose short, fragile brushstrokes to describe the effect of light dissolved into drawing. Matisse spoke of "colour by drawing" and Mondrian drew in coloured line in *Victory Boogie-Woogie*, imploding the difference between line and colour.

9 Rose, Bernice, *Jackson Pollock—Drawing into Painting*, Oxford: Museum of Modern Art, 1979, p. 12.

10 *The Concise Oxford English Dictionary*, fifth edition, Oxford: Oxford University Press, 1964.

11 Petherbridge, Deanna, *The Primacy of Drawing: An Artist's View*, London: South Bank Centre, 1991, p. 12.

12 Nichols Goodeve, Thyrza, "The History Lesson—Flesh is a texture as much as a color", in *Parkett*, no. 73, 2005, p. 40.

13 Gallagher, Ellen, quoted in "Curtain Rises", Thyrza Nichols Goodeve, in *Ellen Gallagher*, London: Anthony d'Offay Gallery, 2001, p. 7.

14 Ofili, Chris, quoted in *The Turner Prize, Twenty Years*, Virginia Button, London: Tate Publishing, 2003, p. 142.

15 Petherbridge, Deanna, *The Primacy of Drawing—An Artist's View*, London: South Bank Centre, 1991.

16 Rose, Bernice, *Drawing Now*, New York: The Museum of Modern Art, 1976, p. 14.

17 Hauptman, Jodi, "Imagination without Strings", in *Drawing from the Modern 1880-1945*, New York: The Museum of Modern Art, 2004, p. 17.

18 Hauptman, "Imagination without Strings", p. 33.

19 Rose, Bernice, *Allegories of Modernism: Contemporary Drawing*, New York: The Museum of Modern Art, 1992, p. 13.

20 See Rosalind E Krauss, "Sculpture in the Expanded Field", 1978, in *The Originality of the Avant-Garde and Other Modernist Myths*, Boston: MIT Press, 1985, for more information on this.

21 LeWitt, Sol, quoted in Lucy Lippard, "The Structures, the Structures and the Wall Drawings, the Structures and the Wall Drawings and the Books", in *Sol LeWitt Critical Texts*, Adachiara Zevi ed., Rome: I Libri di AEIOU, Incontri Internazion Ali d'Arte, 1995, p. 257.

22 Reinhardt, Ad, "Twelve Rules for a New Academy", in *25 Years of Abstract Painting*, Betty Parson Gallery, 1960.

23 Rose, Bernice, "Sol LeWitt and Drawing", in Zevi, 1994, p. 270.

24 See Rosalind E Krauss, "Sculpture in the Expanded Field", for a discussion of *architecture* plus *not-architecture* in relation to Sol LeWitt's work—the possibility explored here is the process of mapping the axiomatic features of the architectural experience—the abstract conditions of openness and closure—onto the reality of a given space, p. 287.

25 Alloway, Lawrence, "Sol LeWitt: Modules, Walls, Book", in Zevi, 1994.

26 LeWitt, Sol, "Paragraphs on Conceptual Art", *Artforum*, vol. 5, no. 10, June 1967; reprinted in Zevi, 1994, p. 82.

27 Rose, "Sol LeWitt and Drawing", p. 296.

28 Long, Richard, in interview with Suzaan Boettger, quoted in Suzaan Boettger, *Earthworks Art and Landscape of the Sixties*, Berkeley: University of California Press, 2002, p. 172.

29 See Pamela M Lee, "Drawing in Between", in *Reorganizing Structure by Drawing Through It*, Cologne: Generali Foundation, 1997, for a detailed discussion of Matta-Clark's cut drawings.

30 Gordon Matta-Clark makes these points in *Office Baroque*, a remastered film by Eric Convents and Roger Steylaerts, New York: Persistent Pictures, 1977.

31 Lee, "Drawing in Between", p. 29.

32 Wood, Jon, "Follow the Lines of Cut: Diana Cooper & Hew Locke", in *Diana Cooper & Hew Locke*, London: The Drawing Room, 2004.

33 Wood, "Follow the Lines of Cut: Diana Cooper & Hew Locke".

34 Cooper, Diana, in conversation with Jon Wood, tape recording and transcript in The Drawing Room archive, May 2005.

35 Cooper, in conversation with Jon Wood, May 2005.

36 Cooper, in conversation with Jon Wood, May 2005.

37 Newman, Avis, in conversation with Catherine de Zegher, *The Stage of Drawing: Gesture and Act*. London: Tate Publishing and New York: The Drawing Center, 2003, p. 168.

38 Gormley, Antony, quoted in *Antony Gormley Drawing*, London: The British Museum, 2002, p. 6.

39 Serra, Richard, quoted in Lizzie Borden, "About Drawing: An Interview, 1977", in *Richard Serra: Writings, Interviews*, Chicago: The University of Chicago Press, 1994, p. 52.

40 Serra, quoted in Borden, "About Drawing: An Interview, 1977".

41 Serra, in interview with Lynne Cook, in *Richard Serra Drawings*, London: Serpentine Gallery, 1992, p. 13.

42 Serra, "Notes on Drawing", in *Richard Serra Drawings*, p. 71.

43 Serra, *Notes on Drawing, Richard Serra*, New York: Rizzoli International, 1988, reprinted in *Richard Serra: Writings, Interviews*, p. 181.

44 Moszynska, Anna, *Antony Gormley Drawing*, p. 12.

45 Gormley, Antony, Foreword, *Antony Gormley Drawing*.

46 This project involved artists' commissions and took place on the ramparts of Berwick upon Tweed, on the border of Scotland and England. Participants of Nogueira's piece were invited to take a kite or umbrella from two kiosks, to scale the ladder and look out over the ramparts or sit on the bench and admire the sea view.

47 Searle, Adrian, in conversation with Tacita Dean and Rachel Whiteread about the work of Lucia Nogueira, tape recording and transcript in the Drawing Room archive, 2005.

48 Nogueira, Lucia, in conversation with Bill Furlong, *AUDIO ARTS*, vol. 12, no. 1, 1993.

49 Nogueira, in conversation with Bill Furlong.

50 Whiteread, Rachel, in conversation with Lisa G Corrin, in *Rachel Whiteread*, London: Serpentine Gallery, 2001, p. 25.

51 Whiteread, in conversation with Corrin, p. 25.

52 Kovats, Tania, quoted in *offshore*, Newlyn: Newlyn Art Gallery, 2004, p. 3.

53 Guston, Philip, "Philip Guston Talking", in *Philip Guston: Paintings 1969–80*, London: Whitechapel Art Gallery, 1982, p. 52.

54 Noble, Paul, in interview with John Slyce, March-April 2001.

55 Noble, Paul, in interview with John Slyce.

56 Ruskin, John, *The Elements of Drawing*, 1857, reprinted New York: Dover Press, 1971, p. 25.

57 Weissman, Benjamin, "The many moons of an amateur astronomer", *frieze*, issue 77, September 2003, pp. 70-75.

58 Crotty, Russell, *For the Record, Drawing Contemporary Art*, Vancouver: Vancouver Art Gallery, 2003.

59 Kentridge, William, in conversation with Carolyn Christov-Barargiev, *William Kentridge*, London: Phaidon, 1999.

60 Kentridge, William, in conversation with Carolyn Christov-Barargiev.

61 Krauss, Rosalind, "Sculpture in the Expanded Field", in *The Originality of the Avant-Garde and Other Modernist Myths*, pp. 288-289.

62 Morgan, Stuart, *What the Butler Saw*, London: Durian Publications Ltd., 1996, p. 159.

63 Perry, Grayson, *Cycle of Violence*, London: Atlas Press, 1992.

64 Perry, Grayson, *For the Record, Drawing Contemporary Art*, Vancouver: Vancouver Art Gallery, 2003.

65 Townsend, Chris, "The Heart of Glass", in *The Art of Tracey Emin*, London: Thames and Hudson, 2002, p. 82.

66 Monoprints are made by coating a smooth surface such as glass, or stone with ink, or paint, and placing on top of it a sheet of paper which is then 'drawn on by the end of a brush handle or similar tool. The unique drawing is only revealed once the paper has been peeled back to reveal the inscribed image.

67 Bourgeois, Louise, Marie-Louise Bernadac, and Hans-Ulrich Olbrist, *Destruction of the Father/Reconstruction of the Father: Writings and Interviews 1923-1997*, Boston: MIT Press, 1998, p. 133.

68 Bourgeois, Louise, *Drawings*, Berkeley: University Art Museum, 1996, quoted in *(In Search of) The Perfect Lover, Works from the Sammlung Hauser und Wirth*, Ostfildern (Ruit): Hatje Cantz, 2003.

69 Meyer-Thoss, Christiane, *Louise Bourgeois, Designing for Free Fall*, Zurich: Ammann Verlag, 1992, p. 135.

70 Musgrave, David, Anna Barriball, David Musgrave and Catsou Roberts in conversation, email correspondence, in *Recognition 1*, Bristol: Arnolfini, 2003, p. 15.

71 Dean, Tacita, in *Tacita Dean*.

72 Newman, Avis, in conversation with Catherine de Zegher, p. 67.

MEASUREMENT
NATURE
CITY
DREAMS
BODY

MEASUREMENT

To measure a thing is to tame it, to make it susceptible to your rules. It is calming, in the teeth of a storm, to know whether it's Force Eight or 11, even if the niceties of the Beaufort Scale are unlikely to save you. And so with all measurement, which tries to make an irrational world rational and, by doing so, to master it.

Drawing, too, is a form of measurement, a kind of taming. You take a pencil in your hand, you hold it in front of the thing you're going to draw: you take its measure. There's a flaw to this process, of course, which is that systems of measurement are themselves irrational or arbitrary, drawing included. William Blake recognised at least the first half of this truth in his portrait-drawing of the mathematician, Isaac Newton.

Blake's *Newton*, 1795, is an extraordinary work for all sorts of reasons: its visionary feel, flowing line; its air of slight madness. It is also extraordinary in not being what it seems. Usually taken as an homage to British genius, *Newton* is anything but. Blake's drawing is the portrait of a visionary by a visionary, but their visions are entirely different. We see Newton in two dimensions because that is how Blake saw him; as only half alive. Newton's idea of drawing is scientific, prescriptive, anti-inspirational. He works with a pair of dividers, makes rigid geometric forms: and he does so while looking down at the ground, from light to darkness. Blake, invisible but insistently the second subject of this double portrait, wipes the floor with him. It is Blake's line—inspired, reckless, Romantic—that catches our eye, utterly upstaging the pedant Newton, with his instruments and his right angles and his disbelief in God. (A minor irony is that Newton's actual drawing style is notably freewheeling. It bears much more resemblance to Blake's than to the Euclidean line Blake attributes to him.)

So Blake sets up a *topos*: the Romantic drawing versus the scientific drawing, inspiration versus measurement. This isn't a new idea. You see the same kind of agitation going on in the odd architectural perspectives of Jan Vredeman de Vries, the Dutch Alberti, two centuries before. De Vries' axonometric lines describe an entirely rational world: telling us just who is standing in front of whom, how the picture's recession and foreshortening work. But de Vries' image also tells us that logic is only one part of drawing, and a subservient one at that. His lines and notated numbers do nothing to explain the drama that is unfolding in his logical space: whose is the body lying on the floor? Who is the man skulking darkly in the doorway? Why does the woman, whose eyes mark the picture's horizon and vanishing point, have her arm raised in a classical gesture of horror? As in *Newton*, there are two kinds of drawing going on here, and it is the irrational that subverts the rational.

A shift in this 'inspiration good/intellect bad' formula takes place shortly after *Newton*, in Ingres' *Madame Devauçay*, 1801. The finished picture, in the Musée Condé at Chantilly, is a peerless piece of Neo-classical *chaudfroid*, icily erotic. But Ingres' preparatory drawing has an entirely different feel. If the finished work is corset-tight, this is loose, almost slovenly: and it has the luxury of being so because it's supported by a pencilled grid, from which the artist's line seems to hang in voluptuous folds. The American poet, Robert Frost, famously compared writing free verse to playing tennis without a net. Ingres would seem to agree. Unlike Blake, he doesn't see measurement as imprisoning. Rather the opposite: the grid in his pencilled *Madame Devauçay* comes as a form of liberation, the thing that makes it all possible. And that makes his drawing a very modern work indeed.

A century and a half later, we find Louise Bourgeois exploring a world that is still essentially Ingres'. In her 2005 show, *Sublimation*, the 93 year old Bourgeois showed a suite of felt-tip drawings of grids called *Be Calme*. The formality of the grid in these pictures—its role as a matrix for plotting the figure done away with—gives Bourgeois a language in which every tremor, every imprecision of the pen, registers as a seismograph of her own life. This tension between the personal and impersonal is at the heart of Bourgeois' story as an artist: the battle between childhood and survival as an adult, interior and exterior worlds. It is possible to read all kinds of things into her hand made rectangles (an abusive French childhood, an interest in Lacan), but what Bourgeois is really getting the measure of in this work is Louise Bourgeois.

This isn't gridding-up on the way to something else, in other words, but measurement as an artwork: an impossible elision of the study and the finished image. That, perhaps, is among the greatest gifts the twentieth century has bequeathed art history: the ability to see things that were once regarded as the tools of art—gridding up, taking a measure—as ends in themselves. CD

William Blake
Sir Isaac Newton, 1795
pencil on paper
46 x 60 cm

I must create a system or be enslaved by another man's.
I will not reason and compare; my business is to create.

William Blake

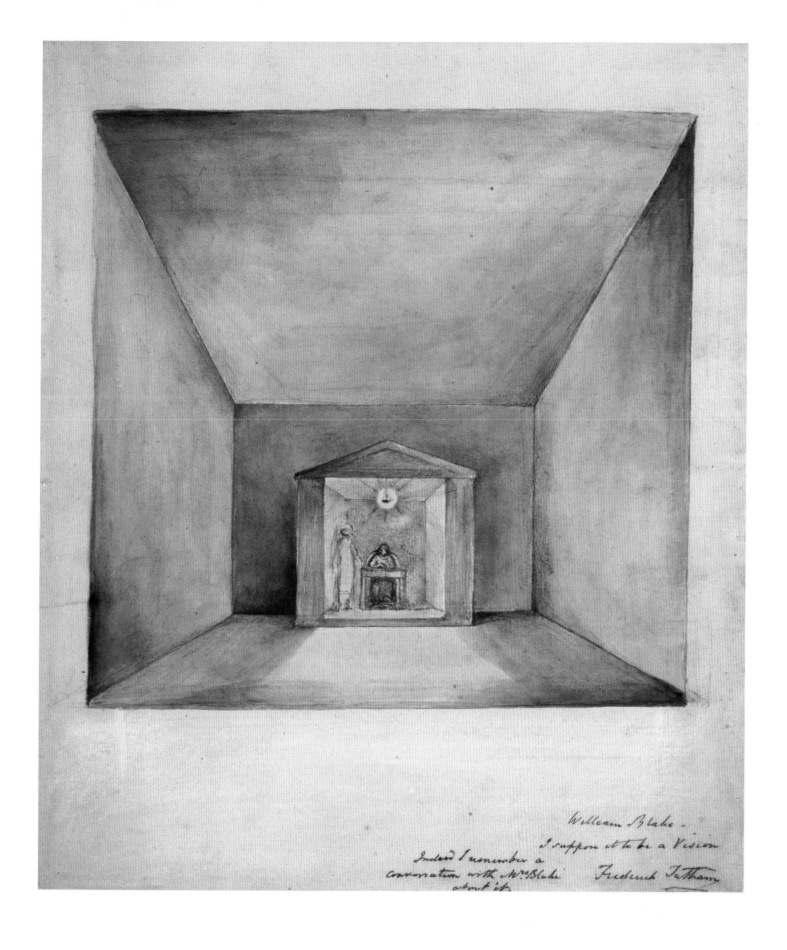

William Blake
Elisha in the Chamber on the Wall,
c. 1819-1820
pencil and watercolour on paper
24 x 21 cm

William Blake's work, as an artist and a poet, represents a meeting point between word and image. In this image, we enter a room within a room through the frame of the picture, leading us into the world of the visionary.

Borders can show where to cross or where to turn back. The border between a drawing and the rest of the world is the edge of the paper, and of course there is a sense in which a drawing's image must turn back when it reaches that edge. The artist's pencil can crowd right up to the last millimeter of paper, yet the more insistently it does so the more clearly it demonstrates the effectiveness of drawing's particular kind of border.

Carter Radcliff, *Drawing Distinctions: American Drawing of the Seventies*

Eva Hesse
Untitled, 1966
ink and pencil on paper
30 x 23 cm

Eva Hesse
Untitled, 1969
ink, gouache and pencil on paper
59 x 45 cm

The work of American artist Eva Hesse in the 1960s utilised primary forms in a manner unique to her; the eccentric abstraction of her simple shapes demonstrates a more intuitive, sensuous approach than that of the more formal experiments of her contemporaries.

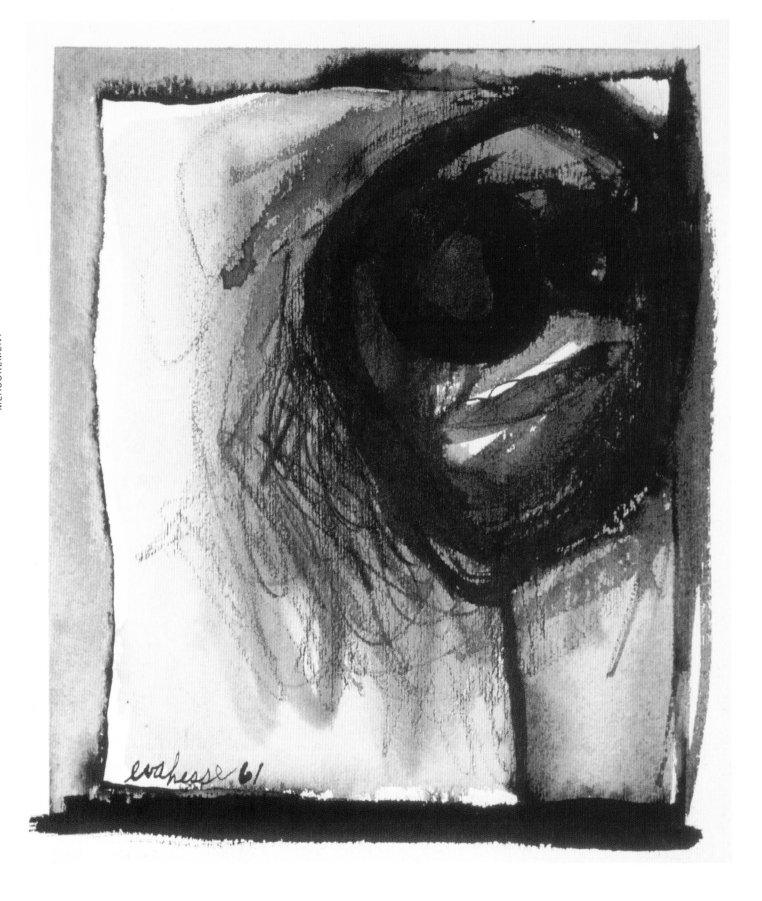

52 Eva Hesse
Untitled, 1961
ink and crayon on paper
26.5 x 23.5 cm

... every corner in a house, every angle in a room, every inch of secluded space in which we like to hide, or withdraw into ourselves, is a symbol of solitude for the imagination.... An imaginary room rises up around our body, which we think well hidden when we take refuge in a corner.

Gaston Bachelard, *The Poetics of Space*

Eva Hesse
Untitled, 1967
watercolour, metallic gouache, and pencil on paper
29 x 39 cm

In conceptual art the idea or concept is the most important aspect of the work.... If the artist carries through his idea and makes it into visible form, then all the steps in the process are of importance. The idea itself, even if not made visible, is as much a work of art as any finished product. All intervening steps—scribbles, sketches, drawings, failed works, models, studies, thoughts conversations— are of interest. Those that show the thought process of the artist are sometimes more interesting than the final product.

Sol LeWitt, *Paragraphs on Conceptual Art*

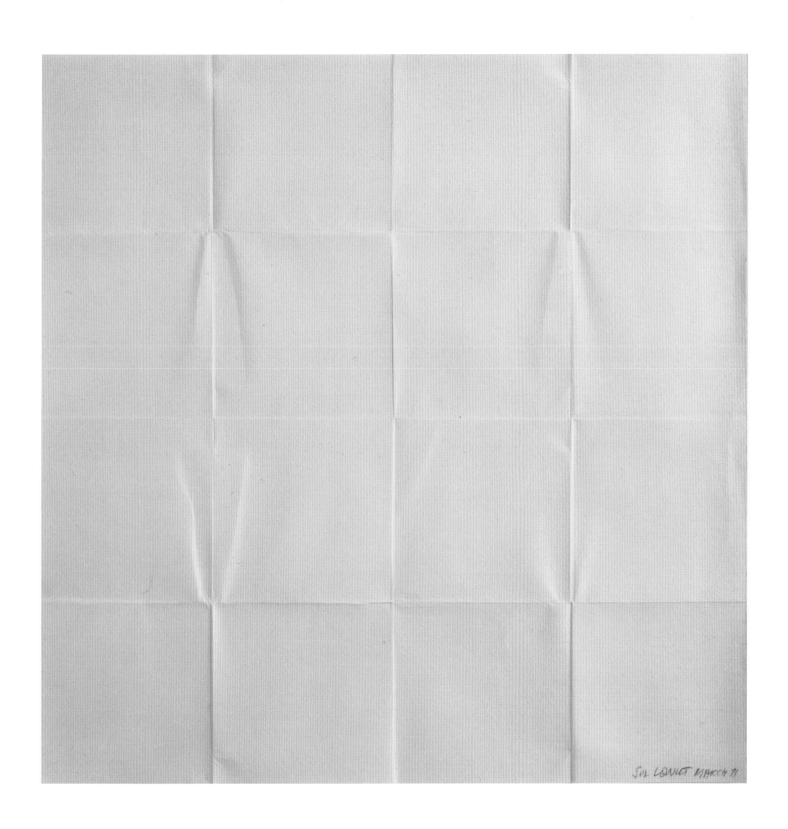

Sol LeWitt
Folded Drawing, 1971
paper
28 x 28 cm

What is this drawing? Why, it is a calf, a square, a flower.... No matter that it is the material deposit, on a sheet of paper or blackboard, of a little graphite or a thin dust of chalk.

Michel Foucault, *This Is Not A Pipe*

Jan Vredeman de Vries
plate from *Book of Perspective*,
1604–1605

David Musgrave
Form in a Bag, 2004
graphite on paper
35.5 x 30 cm

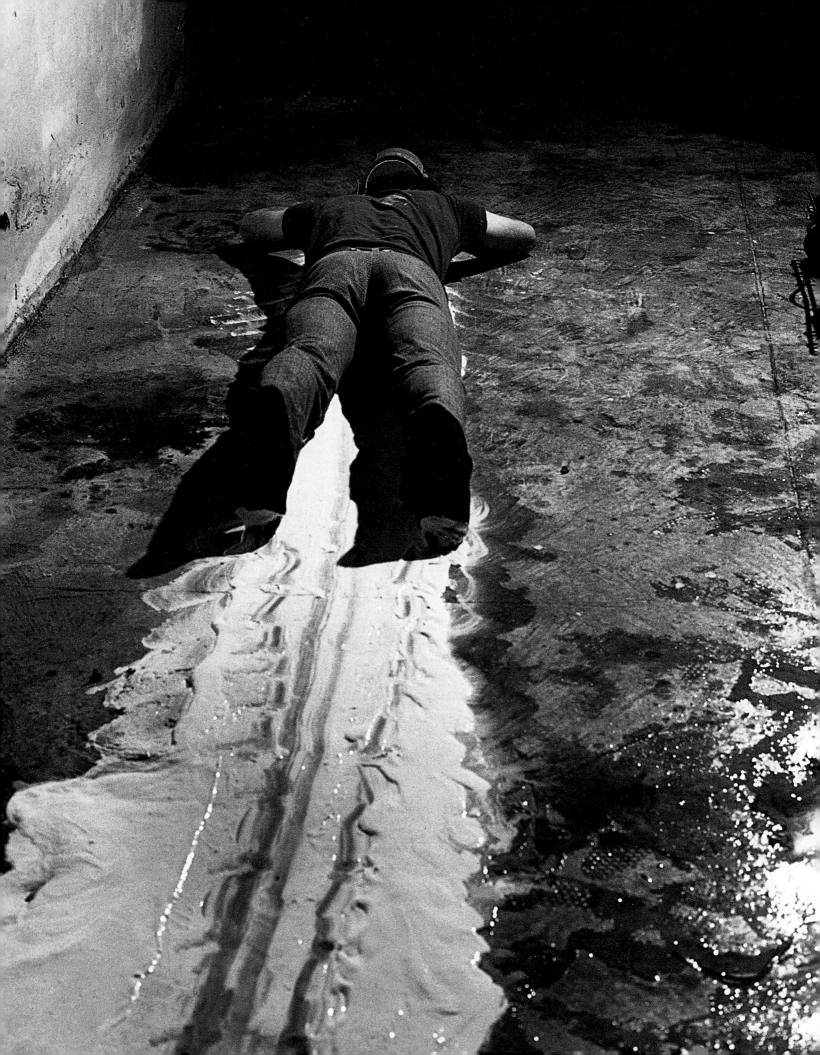

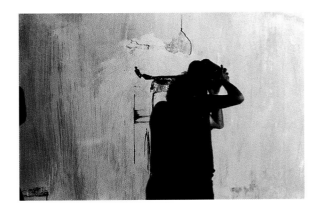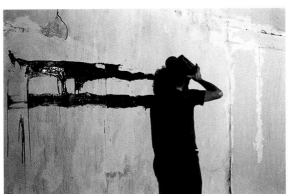
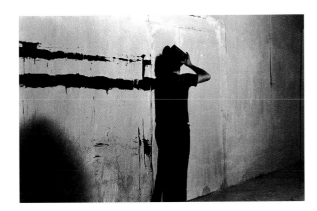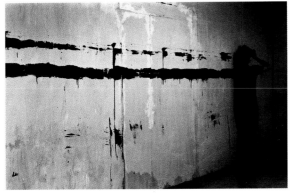
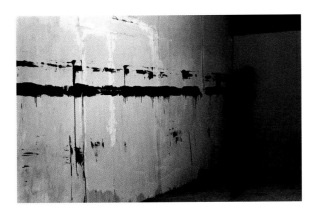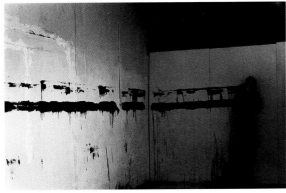

Paul McCarthy
Face Painting—Floor, White line, 1972
performance/video tape,
photographic series

Paul McCarthy
*Face, Head, Shoulder Painting Wall,
Black Line*, 1972
performance/video tape,
photographic series

These archival images of two of McCarthy's seminal 1970s performance pieces show the artist 'drawing' his way around the studio, using his head and body as a marker, either by pouring paint onto himself or dragging his way through it. The field of drawing is thus expanded, with the relationship between figure and ground pushed to its limit as he maps the space around him and his place within it.

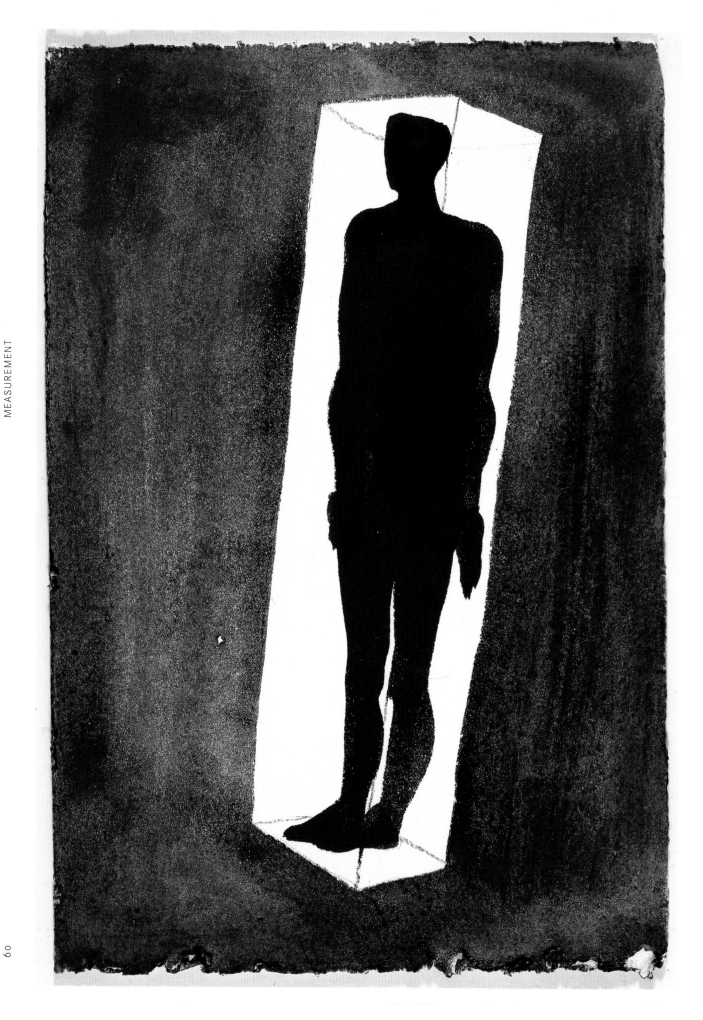

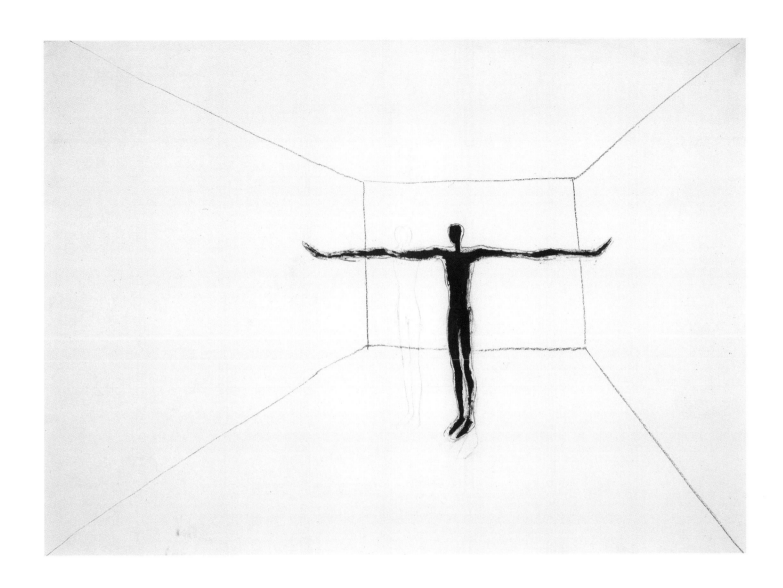

For me drawing is a form of thinking. But it also about medium: using the intrinsic qualities of substances and liquids: a kind of oracular process that requires tuning in to the behaviour of substances as much as to the behaviour of the unconscious, like reading images in tea leaves, trying to make a map of a path of feeling, a trajectory of thought.

Antony Gormley

Antony Gormley
Immersion, 1993
black pigment and casein
28 x 19 cm

Antony Gormley
Field, 1984
black pigment, linseed oil and charcoal
64 x 90 cm

Antony Gormley
Through, 1992
black pigment and casein on paper
14 x 19 cm

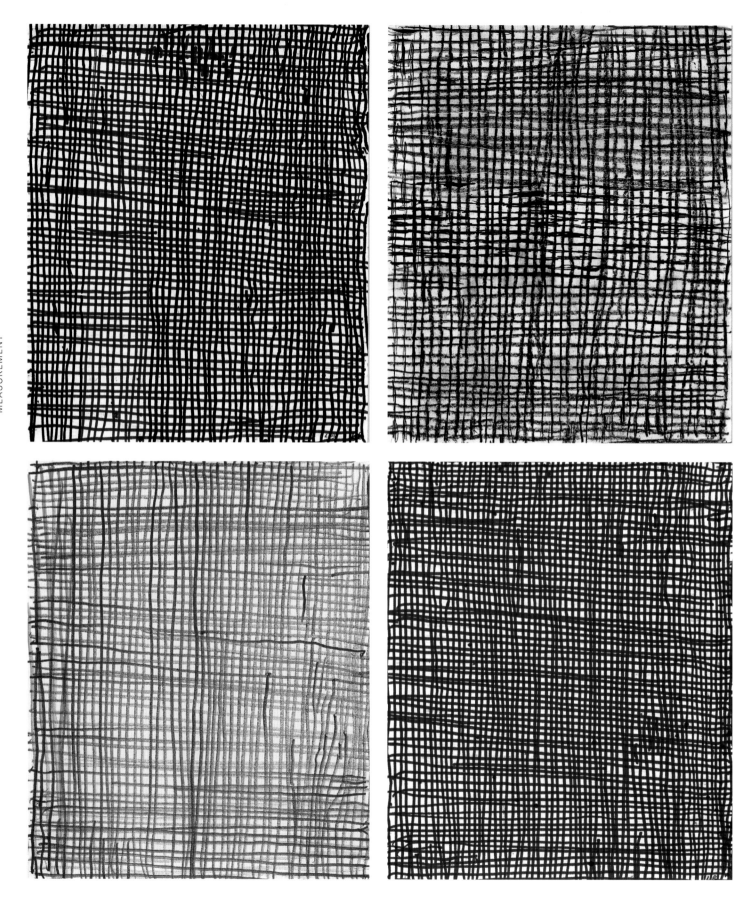

Louise Bourgeois
Untitled (C.I.A), 2004
suite of 49 double sided drawings (nos. 48 recto, 44 recto, 11 recto, 35 recto)
mixed media on paper
24 x 20.5 cm

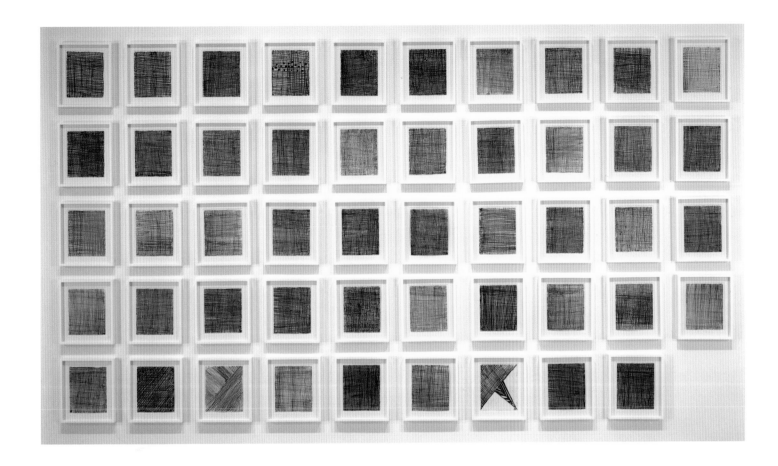

Drawings have a featherlike quality. Sometimes you think
of something and it is so light, so slight, that you don't have
time to make a note in your diary. Everything is fleeting, but
your drawing will serve as a reminder; otherwise it is forgotten.

Louise Bourgeois, *Drawings & Observations*

Louise Bourgeois
Untitled (C.I.A), 2004
suite of 49 double sided drawings
mixed media on paper
24 x 20.5 cm each

Much of Louise Bourgeois' work concerns itself with the body in space; she is an
artist concerned with processes of mapping and measuring herself. These works,
executed at night, represent a record of her activity at that time and place.

Armando Andrade Tudela
Peru Abstracto, 2004
watercolour on paper
33 x 21 cm

Armando Andrade Tudela
Luz Y Mar, 2005
ink on paper
33 x 21 cm

Armando Andrade Tudela
Untitled, 2005
ink on paper
33 x 21 cm

There are drawings in notebooks which are private things,
as well as drawings made to be out in the world. For me it
can be a way of exploring a preoccupation (sometimes leading
to the discovery of another). At other times it is an intense
relationship with the actual materials of the drawing, and the
moment, which brings it into existence. Drawing can be a way
of overcoming fear. At different times it is all these things.

Alison Wilding, quoted in Leeds Sculpture Collections, *Works on Paper*

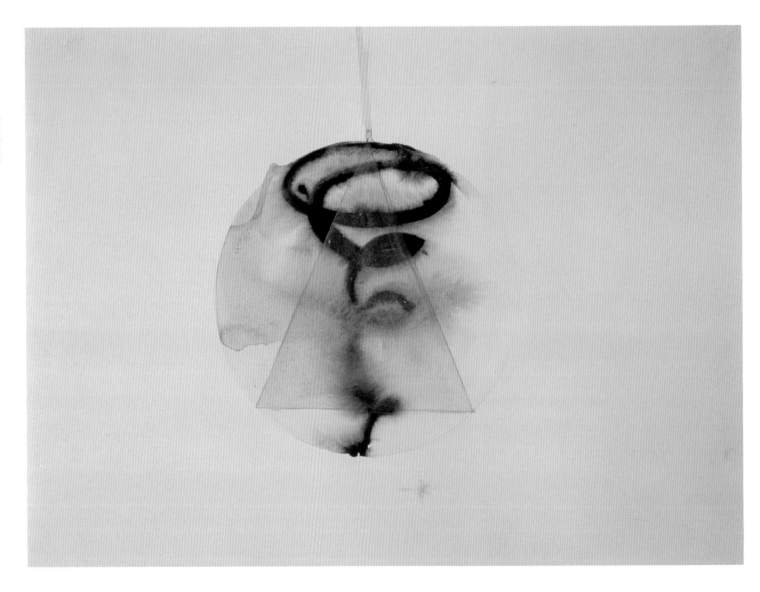

Alison Wilding
Untitled, 1978
pencil, acrylic and water soluble crayon
28 x 38 cm

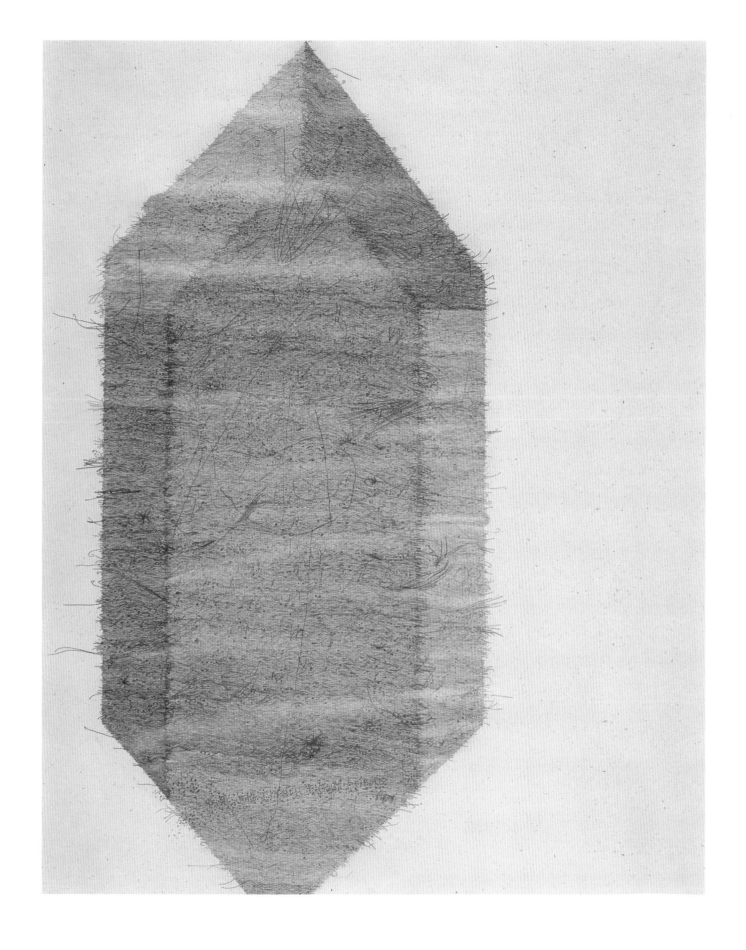

Peter Peri
Crystal 2, 2003
graphite on unbleached paper
51 x 41 cm

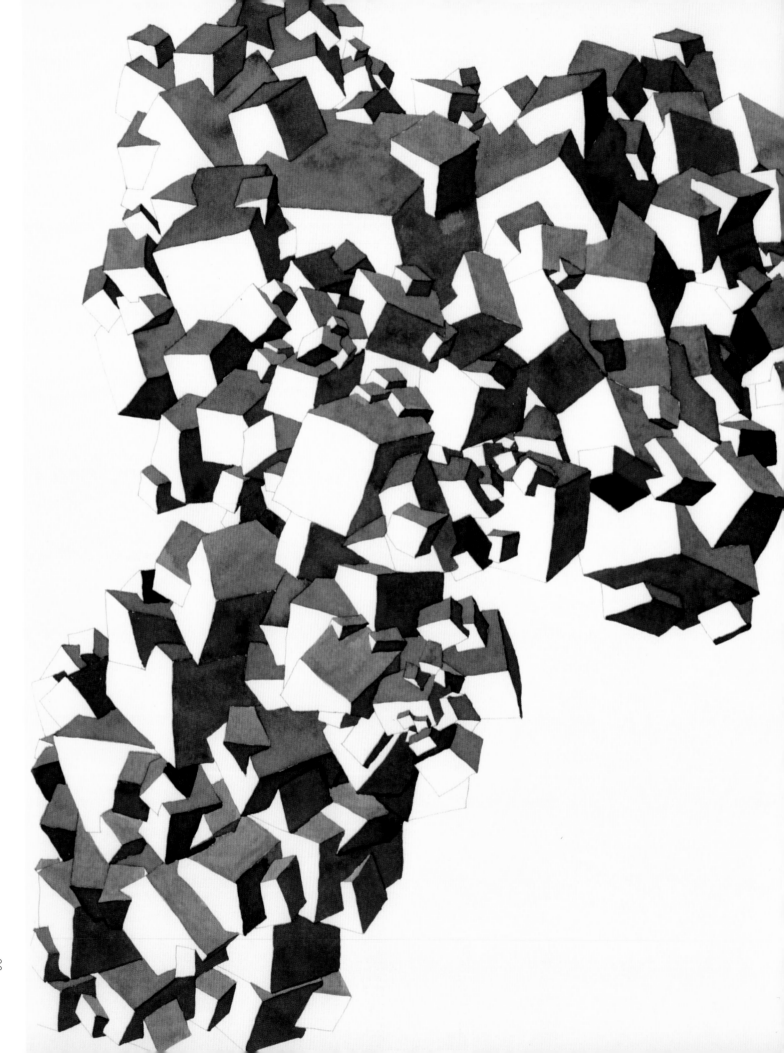

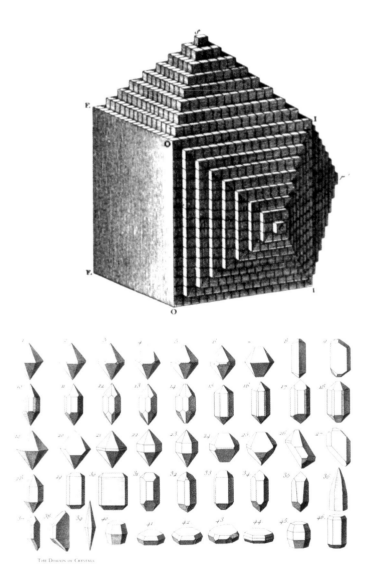

Tania Kovats
Untitled, from *Minerology* Series, 2005
ink on paper
44 x 32 cm

Abbe Rene Just Hauy
from *Traite de Mineralogie*, 1801

Rome de l'Isle
The Domain of Crystals
from *Cristallographie*, 1763

Tania Kovats
Basalt, detail, 2004
ink on paper
64 x 64 cm

Jonathan Lasker
Untitled, 1999
graphite and Indian ink on paper
55 x 76 cm

New York painter Jonathan Lasker has developed a language of mark-making which forms a direct link between his paintings and drawings. His drawing is informed by the compositional rigour of his painterly work, demonstrating a highly developed sense of the picture plane.

Jonathan Lasker
Untitled, 2002
graphite and Indian ink on paper
55 x 76 cm

Jonathan Lasker
Untitled, 2003
coloured pencil and Indian ink on paper
55 x 76 cm

To live is to leave traces.

Walter Benjamin, *Reflections*

Susan Collis
No. 2 (in series), 2004
red glitter and self adhesive vinyl

Susan Collis
Work on it, detail, 2002
new table and adhesive vinyls
73 x 115 x 78 cm

Susan Collis works with the marks left by things, taking the incidental and transient and lending them permanence. She replaces rings left by cups on table tops with brightly coloured, cut out veneers, or fills in her own paint spills with glittery red vinyl, carefully tracing and replacing the original mark with her own. Through these delicate and crafted marks, she maps her surrounding environment.

Sylvia Plimack Mangold
study for *Hallway*, 1969
acrylic and pencil on paper
61 x 45.5 cm

Toba Khedoori
Untitled (Doors), 1999
oil paint and wax on paper
350.5 x 486.5 cm

Rachel Whiteread
Herringbone Floor Study, 2001
pale brown ink on paper
29.5 x 42.5 cm

Rachel Whiteread
Floor Study, 1994
ink and correction fluid on paper
46 x 34 cm

Ellen Gallagher
Purgatorium, 2000
ink, pencil, plasticine and paper on linen
305 x 244 cm

This work, formed of repeated blocks of lip motifs, establishes a softened grid which seems to emerge from the composition, rather than being imposed upon it. Gallagher's work takes on the politics of the African American body and its representation in oblique and abstract ways; her primary shapes begin to leak and soften even as she takes the measure of the human body.

Ellen Gallagher
Bubbel, 2001
oil, ink and paper on linen
304 x 243 cm

Rachel Whiteread
Untitled (Torso), detail, 1990
ink on paper
64 x 90 cm

What drawings have in common is greater than their differences.

Michael Craig-Martin, *Drawing the Line*

Jacob Epstein
Study for the Arms and Hands of Maternity, c. 1910
pencil on cardboard
40.5 x 75.5 cm

Drawing is the truest test of art.

Jean-Auguste-Dominique Ingres

Jean-Auguste-Dominique Ingres
Nude Study for the Portrait of
Baronne de Rothschild, 1848
pencil
21 x 13 cm

Bruce Nauman
Double size head and hand, 1989
ink, pastel and transparent tape on paper
145 x 109 cm

Claude Heath
Head Drawing, 1995
ink on paper
75 x 50 cm

I adopted a deliberately measured approach to this drawing. I was looking for horizontals and verticals and the area that seems to join them, so that a sense of the head's stability and structure could be felt. By using a blindfold I was preventing any knowledge I might have about this plastercast from directly influencing me. The corresponding movements of both hands were aimed at ensuring that each moment of sensing this object through touch was laid down in its own right and according to its own impetus. CLAUDE HEATH

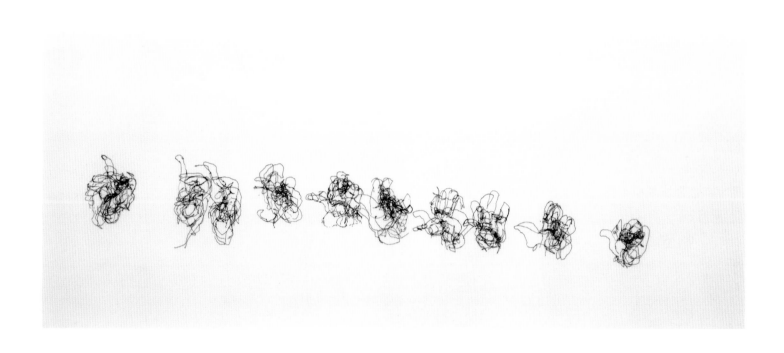

Claude Heath
Epstein's Hands, 1999
ink on paper

Louise Hopkins
Grid (476), 2003
acrylic ink on metric graph paper
21 x 29.5 cm

Louise Hopkins
Untitled (0100), detail, 2000
pencil on partially crumpled paper

Louise Hopkins' work is concerned with visibility and invisibility, with processes
of making and unmaking, and making again. Paper is crumpled, uncrumpled,
and the trace of the folds shaded in pencil; she carefully paints over the grid
of a sheet of graph paper, an act of mapping which is undermined and subverted
by the act of labour itself, as the grid unravels.

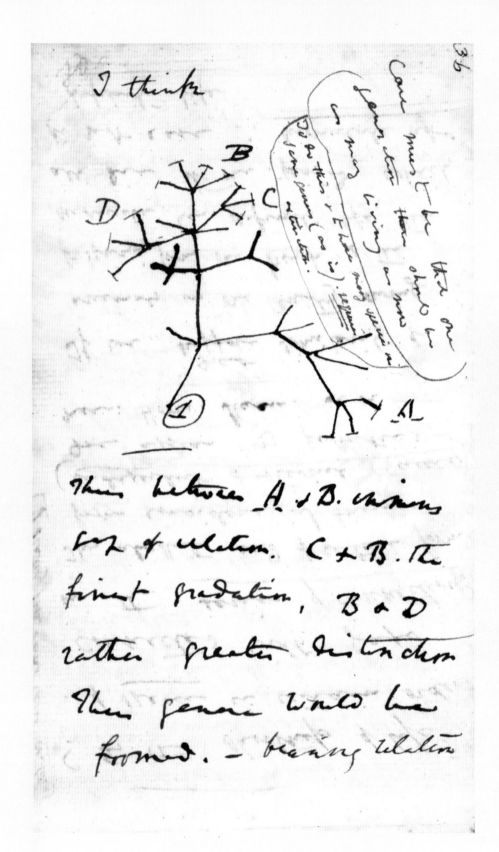

Charles Darwin
Sketch for an Evolutionary Tree,
First Notebook, p. 36, 1837-1838

NATURE

Man's relation to Nature has, mythologically at least, always been embattled. Driven out of Eden, Adam and Eve found a natural world turned punitive: too hot, too cold, needing to be tilled where once it had dropped ripe fruit into the couple's hands. Ever since, Man has sought to re-impose his lost control, and one way of doing that has been to create Nature in his own image: to rule the world by getting it down on paper.

The Fall started with a tree; we might, then, start by looking at Charles Darwin's *Sketch for an Evolutionary Tree*, taken from the naturalist's First Notebook of 1870. As a schema for representing kinship, Darwin's image is hardly new. Mediaeval church walls all over England were painted with family trees charting Christ's descent from David, the fulfilment of Old Testament prophecy: the young Darwin's intended profession had been as a clergyman. Yet Darwin's tree is also particularly vivid proof of the thing he is trying to account for, namely the existence of *homo sapiens sapiens*, or us.

The sketch's traditional formula shows an ability to learn and remember. Its reliance on analogy—families aren't trees, after all—shows a capacity to think in metaphor; to abstract. And the simple fact of its existence hints at the third party in the trinity of human wisdom, namely a talent for getting all of this down on paper: for holding a pencil between two fingers and a prehensile thumb or, in short, for drawing.

In a way he didn't mean it to, then, Darwin's evolutionary doodle sums itself up. It isn't so much a metaphor for humanity as a metonym, an embodiment. His tool-using finches may have been smarter than the average avian, but they could never have done the simple thing Darwin did. European art begins with the story of Zeuxis and Parrhasius, holding a competition to see who was the better painter. Zeuxis' grapes were so realistic that birds flew down to peck them; assuming he'd won, he asked Parrhasius to pull aside the curtain covering his painting only to find that it, too, was painted. It's a nice story, but it's unlikely to be true because birds don't think in metaphor; they can't see fruit in drawings of fruit, evolution in trees.

Bound up in all this is the question of Man and Nature and where they stand in regard to each other. All drawing, being inherently unnatural, inherently asks this question. But the drawings in this section also raise it consciously, one way or another.

The desire to draw nature is also the desire to master it: to show that the non-human world can be contained in the span of a single, Darwinian hand. You can see this in the work of that ultimate natural drawer, Leonardo da Vinci. His *Deluge*, c. 1515, doesn't just reproduce the natural world, it takes it on, on its own terms.

The sweep of Leonardo's pen, apparently teetering on the edge of control, suggests the unstoppable power of a force of nature. But unlike nature, we know that Leonardo's pen is absolutely, uncannily controlled. And just to emphasise that fact, his subject—rocks cascading into water—is emphatically not a slavish reproduction of the truth. It speaks of fantasy, imagination: something more than Nature, an intelligence greater than the merely natural. Like many of the works in this section, Leonardo's *Deluge* finds an analogy between the act of natural creation and the act of artistic creation. And it's a short leap from the desire to describe nature to the impulse to outdo it.

The seismographic print-out in this section—a drawing made at one mechanical remove—seems to sit firmly in the descriptive camp, John Ruskin's topographical sketch, *Aiguilles de Chamonix*, c. 1850, must be placed somewhere rather more vexed. Ruskin, excited by evidence for the Sublime in the statistics of modern geomorphology, is trying to create an accurate representation of nature; yet his work can't be said to be truer to life than the seismograph's, nor any less schematic. His swirling marks set out to convey what he knows about tectonic uplift, the massive forces of mountain-making; but they use a visual shorthand to do so, and they want to create an impression. Like the seismograph's formulaic rises and dips, Ruskin's hatchings and shadings are an accepted code for the things they represent. Both images are abstractions, both fantasies; both are metaphors of the impulse to create.

It's hardly surprising that the abiding measure of Man's cleverness has been his capacity to imagine, nor that nature has been the thing against which that capacity has been most often measured. All drawings of nature are inventions, it's just that some seem more inventive than others. Robert Louis Stevenson's *Map of Treasure Island* and Richard Lydekker's studies of radiolarians look like very different kinds of works—one the creation of the mind, the other of close observation from nature. And yet each is as metaphorical as the other, each as Darwinian. CD

But it moves.

Attributed to Galileo after his recantation in 1632

The wilderness is not a landscape you visit; it is all around you, wherever you are. We persuade ourselves that our taming of the world is profound, we lay water mains and sewers and read thousand year old books, we drive our autobahns through solid rock, we huddle together in caves lit by the incandescence of television screens. We do everything we can to be safe, and still the planet spins, the winds roar, the great ice caps creak and heave, the continental plates shudder and bring cities crashing to the ground, the viruses infect us and the oceans toy with us, lapping against the edges of our precarious land. We are in the midst of wilderness, even curled up with our lovers in bed.

Paul Shepheard, *The Cultivated Wilderness, or, What is Landscape?*

Galileo Galilei
Six Phases of the Moon, 1616

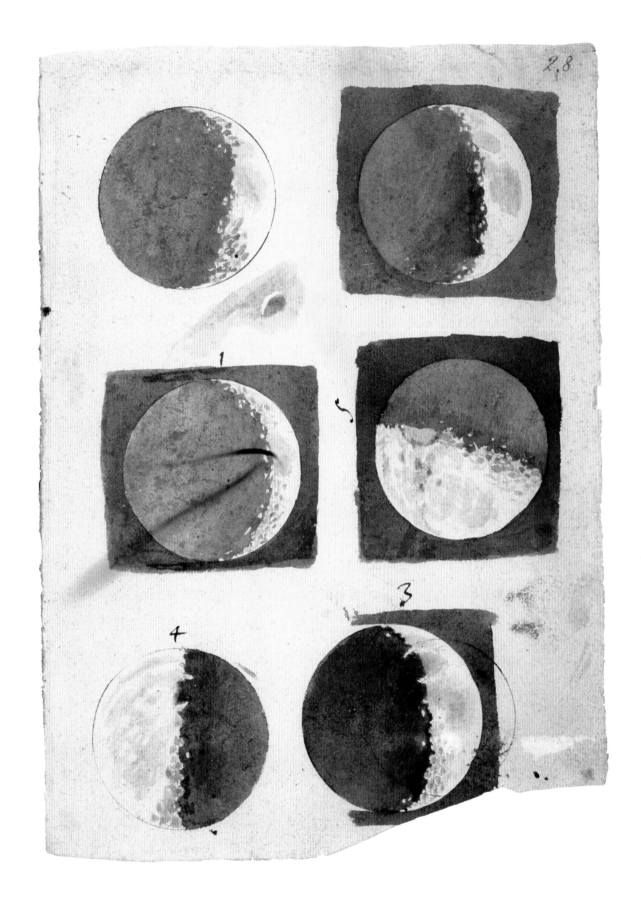

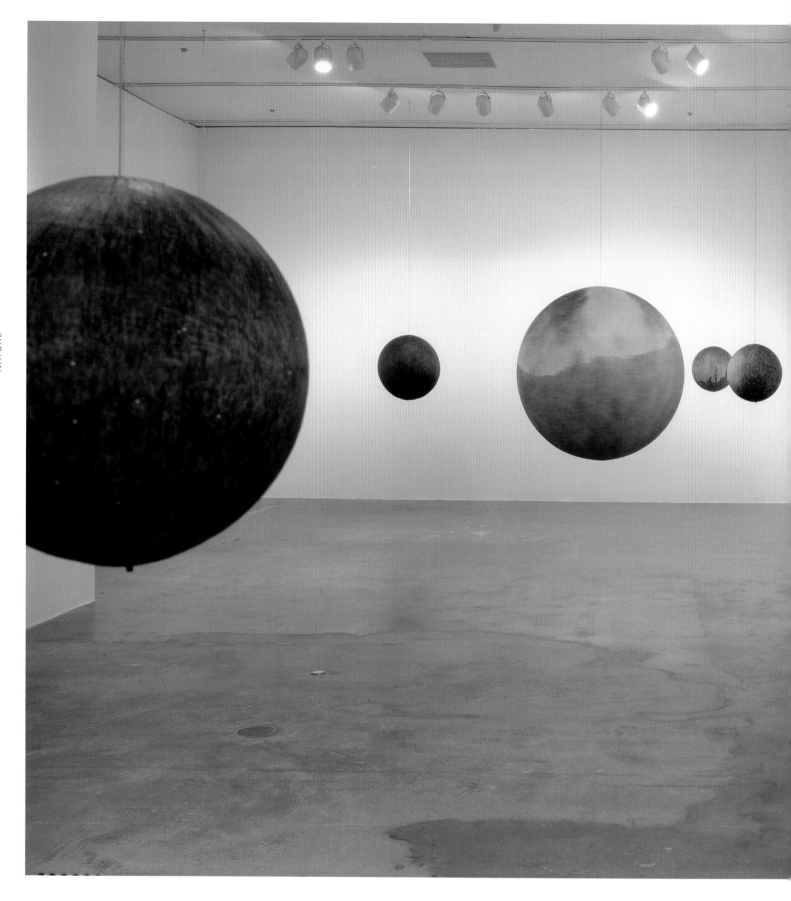

Russell Crotty
Globe Drawings, installation view
Miami Art Museum, 2004

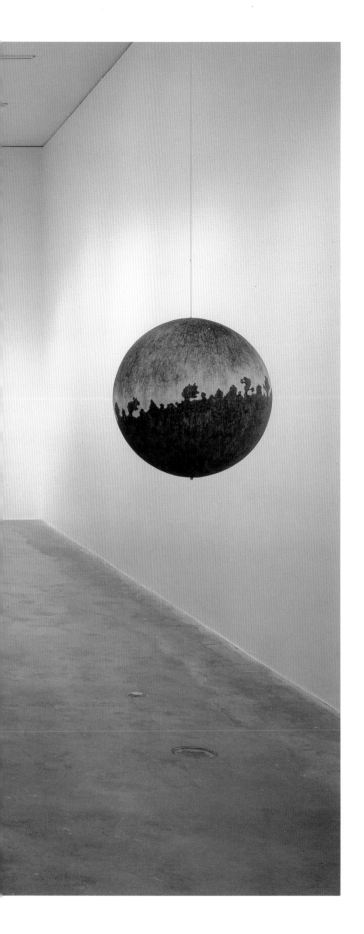

This was how we did the job: in the boat we had a ladder: one of us held it, another climbed to the top, and a third, at the oars, rowed until we were right under the Moon: that's why there had to be so many of us.... In reality, from the top of the ladder, standing erect on the last rung, you could just touch the Moon if you held your arms up. We had taken the measurements carefully (we didn't yet suspect that she was moving away from us); the only thing you had to be very careful about was where you put your hands....

Italo Calvino, "The Distance of the Moon", from *Cosmicomics*

STAR CHAIN

UP ON MT PINOS AT 8,500 FEET
SWEEPING AROUND IN EASTERN CYGNUS
WITH THE 8"F4 RFT (RICH FIELD TELESCOPE)
COLD NIGHT FOR MID JULY... COME ACROSS
A BEAUTIFUL STAR CHAIN NOT FAR FROM
THE VEIL NEBULA... SOMEHOW THIS FIELD
IS STRIKING WITH THE STARS ZIG ZAGGING
THROUGH THE FOV (FIELD OF VIEW) ONE OF
THE DELIGHTS OF USING A WIDE FIELD
INSTRUMENT... THE PINES WHISPER AS
COLD FATIGUE SETS IN... TIME TO SLEEP
UNDER THE STARS.

Russell Crotty
Notable Observations, Summer Milky Way
(page two from a handmade book containing five text pages and five
drawings and a title page), 2002
115.5 x 119.5 x 6.5 cm

Russell Crotty
Notable Observations, Summer Milky Way
(page seven from a handmade book containing five text pages and
five drawings and a title page), 2002
115.5 x 119.5 x 6.5 cm

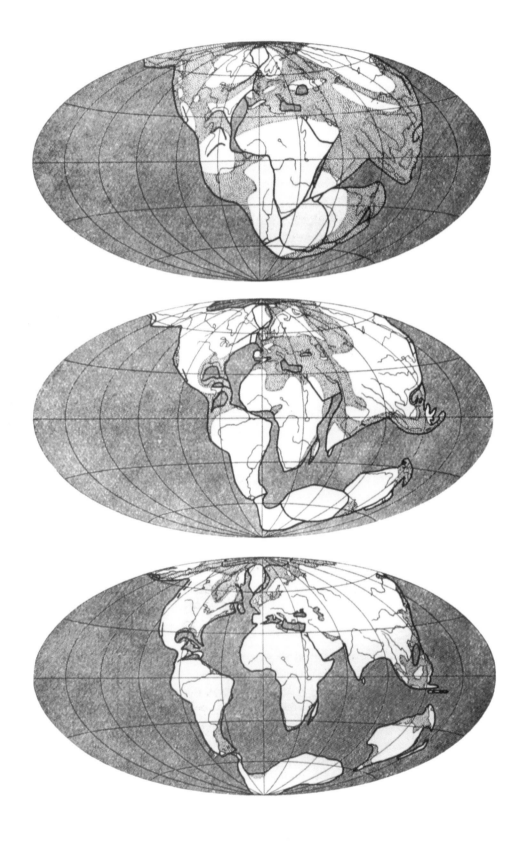

Alfred Wegener
diagrams from *The Origins of the Continents*, 1915

Leonardo da Vinci
Deluge, c. 1515
black chalk, pen and ink
11 x 20 cm

Fig. 2.

A. Bell, Prin. Wal. Sculptor fecit.

A bad earthquake at once destroys our oldest associations:
the earth, the very emblem of solidity, has moved beneath
our feet like a thin crust over fluid; one second of time has
created in the mind a strange idea of insecurity, which hours
of reflection would not have produced.

Charles Darwin, after experiencing an earthquake whilst travelling in Chile in 1835

Seismograph
from Cal Tech Institute

The seismograph is made by human hand, but the drawings it creates are independent of it, made by the movements of the earth. Here the scribbled line becomes a symbol or record of devastation, a measure of the instability of nature. While the

geological drawings of the eighteenth and nineteenth century are an attempt to understand and plot the forces at work on the earth's crust, the seismograph transcribes these forces at the moment of catastrophe.

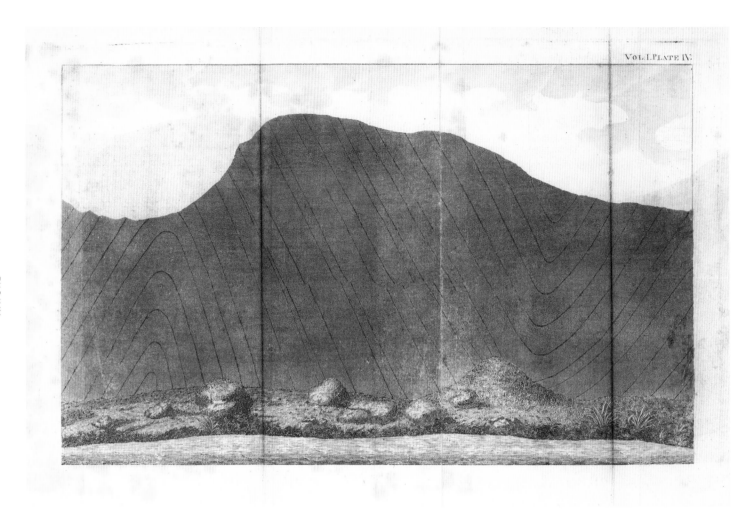

To understand even a little about geology gives you special spectacles through which to see a landscape. They allow you to see back in time to worlds where rocks liquefy and seas petrify, where granite slops about like porridge, basalt bubbles like stew, and layers of limestone are folded as easily as blankets. Through the spectacles of geology, terra firma becomes terra mobilis, and we are forced to reconsider our beliefs of what is solid and what is not.

Robert Macfarlane, *Mountains of the Mind*

John Clerk
drawing for James Hutton's *Theory of the Earth*, c. 1795

John Clerk
drawing for James Hutton's *Theory of the Earth*, c. 1795

Tania Kovats
Crust, 2005
black liquid acrylic on paper
32 x 25 cm

Louise Bourgeois
Dissymetrie is Tolerated if not Encouraged, 2002
ink and correction fluid on paper
30.5 x 23 cm

Louise Bourgeois
Untitled, 2002
engraved drawing and wax pencil
on Indian ink prepared board
67 x 99.5 cm

Drawing is the primal means of
symbolic communication, which
predates and embraces writing
and functions as a tool of
conceptualization parallel
with language.

Deanna Petherbridge, *The Primacy of Drawing*

Sandro Botticelli
Chart of Hell, 1480-1495
silverpoint, crayon and watercolour on parchment

Robert Louis Stevenson
Map of Treasure Island, 1750

I made the map of the island; it was elaborately and (I thought) beautifully coloured; the shape of it took my fancy beyond expression; it contained harbours that pleased me like sonnets... I am told there are people who do not care for maps, and I find it hard to believe.... No child but must remember laying his head in the grass, staring into the infinitesimal forest, and seeing it grow populous with fairy armies. Somewhat in this way, as I pored upon my map of Treasure Island.... ROBERT LOUIS STEVENSON

Robert Smithson
Heap of Language, 1966
pencil on paper
16.5 x 56 cm

Smithson's three-dimensional pieces function on a monumental scale, moving tons of earth to create his forms within the landscape. Drawings and photography provide a way of creating portable work, which the artist can create alone, on a smaller scale. Landscape continues to inform Smithson's works on paper; the graph paper ground for his mountain of and about words referencing the processes of mapping. Although Smithson's work shows a complex relationship with language, it is also consistently material and process based: "My sense of language is that it is matter and not ideas." ROBERT SMITHSON

Richard Long
Untitled, 2004
River Avon mud and black paint on Douglas Fir plywood
122 x 122 cm

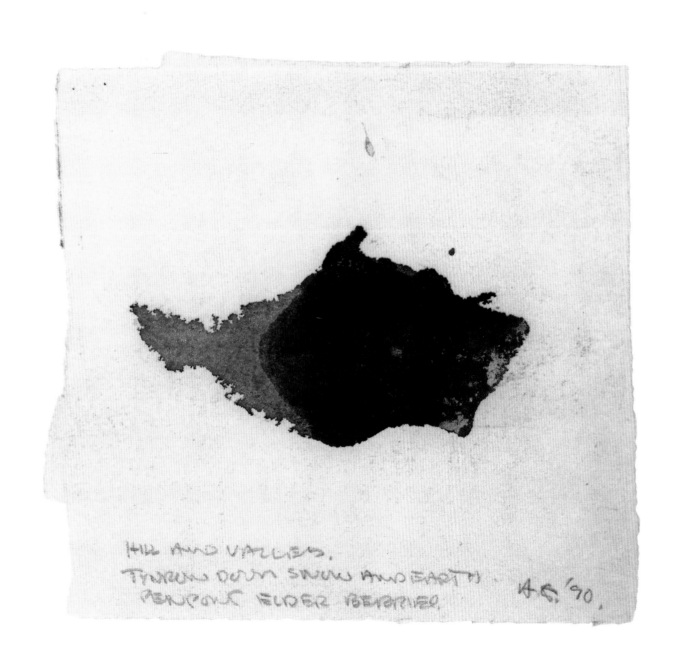

Andy Goldsworthy
Hill and Valley, 1990
berry juice and earth
14.5 x 15.5 cm

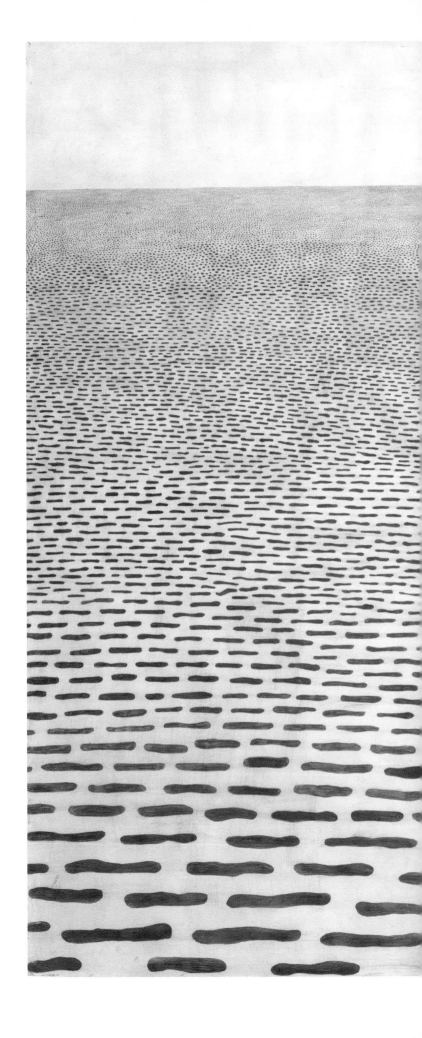

Paul Noble
The Sea III, 1997
pencil on paper
150 x 200 cm

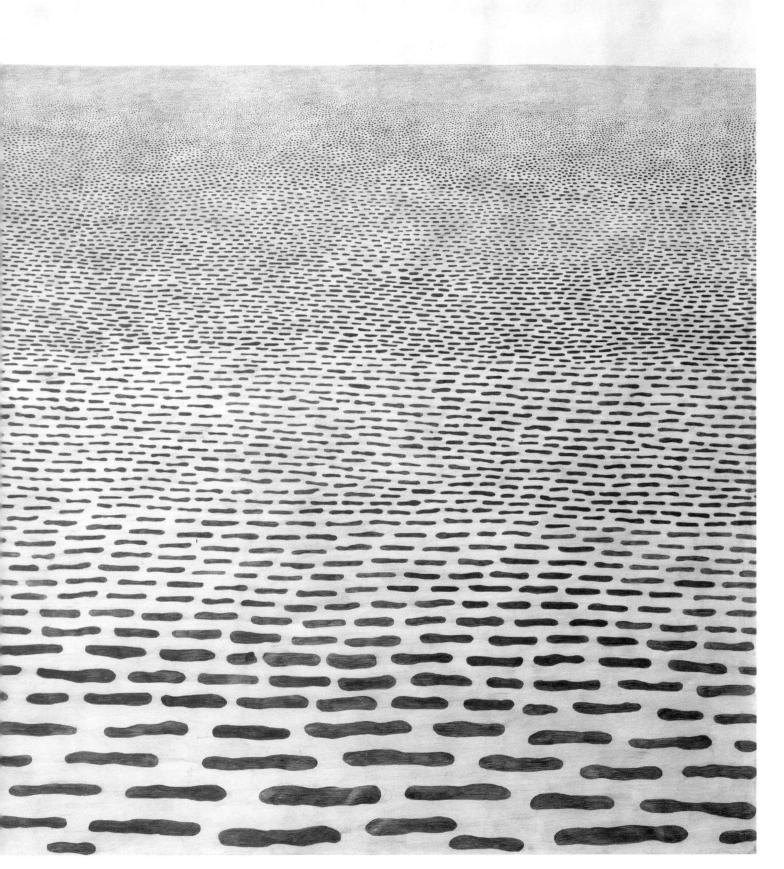

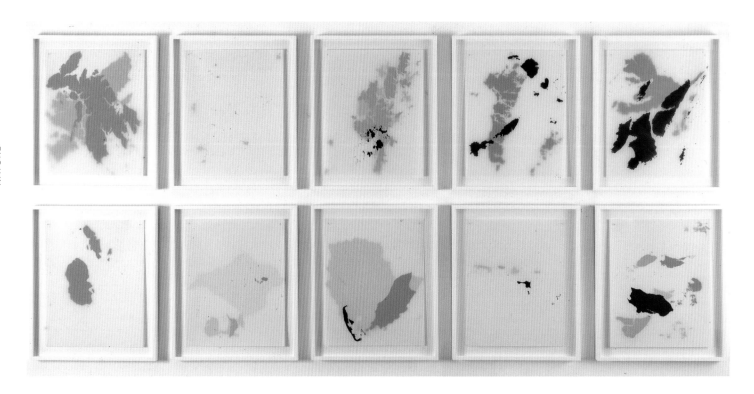

Tania Kovats
British isles, 2004
ink on matt acetate paper, pins
50 x 36 cm each

Tania Kovats
British isles, detail

My drawing is a search for its subject; the techniques I employ have evolved over the years. I like paper as material—it's all surface and shadow, it is ambiguous and hard to read. As a vehicle for drawing it becomes quotidian and the transition from one condition to another is quite important. I am not a draughtsman, neither are the drawings based upon observation, they are more like the sculpture than I previously thought. Of course they are more immediate and more direct although some progress in stages over days or even weeks— rarely but occasionally, years. If they are any good they reveal a lot, perhaps too much. Recent imagery in some of the drawings has surprised but excited me, but whether drawing or making sculpture, work comes from work.

Alison Wilding, *Notes on Drawing*

Alison Wilding
Boulder II, 1996
silicon fluid, pencil and gouache
on two superimposed sheets of paper

Richard Long
Five Stones, 1974
photograph showing the tracks made by rolling five
stones down the side of a volcano in Iceland
51 x 76 cm

Malc Baxter
Tower Face Original from *Stanage;
the definitive guidebook*, 2002

Henry Moore
page one of a ten page letter to Jocelyn Horner, August 1923
black pen and ink
15 x 11 cm

Claude Heath
Ben Nevis, 2003
pen on paper

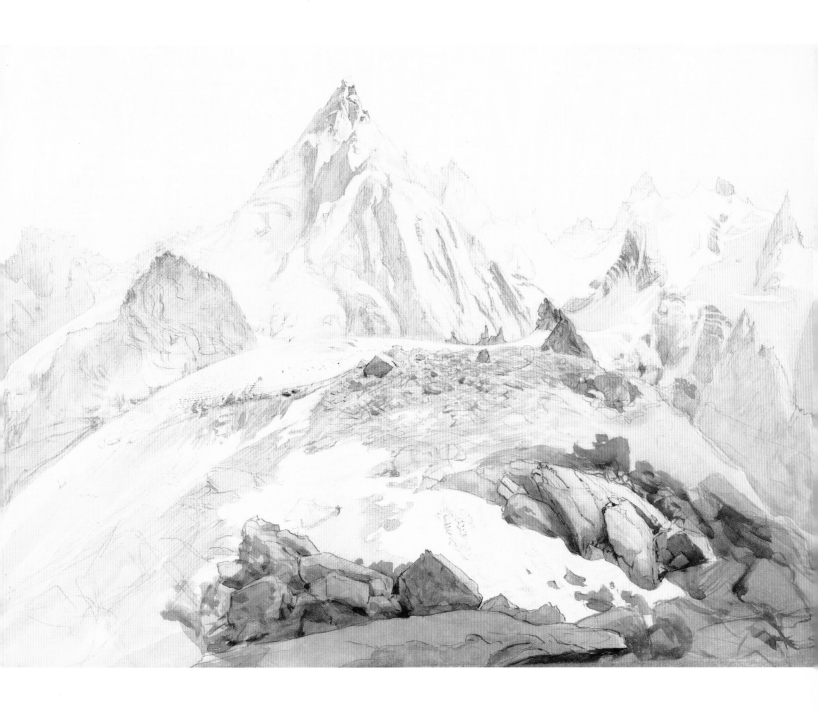

I shall adopt the order, in description, which Nature seems
to have adopted in formation.

John Ruskin

John Ruskin
Aiguilles de Chamonix, c. 1850
pencil, pen, ink and wash on card
25 x 35 cm

Vincent Van Gogh
Peasant Woman, Gleaming, Seen from Behind, 1885
black chalk on wove paper
52 x 43 cm

Even the knowledge of my own fallibility cannot keep me from making mistakes. Only when I fall do I get up again.

Vincent Van Gogh

PLATE 8

NATURE

Elm

Lesson 9

Lesson 11

Lesson 10

Ash

Elm

Lesson 12

JD Harding
drawings from *Lessons on Trees*, 1855

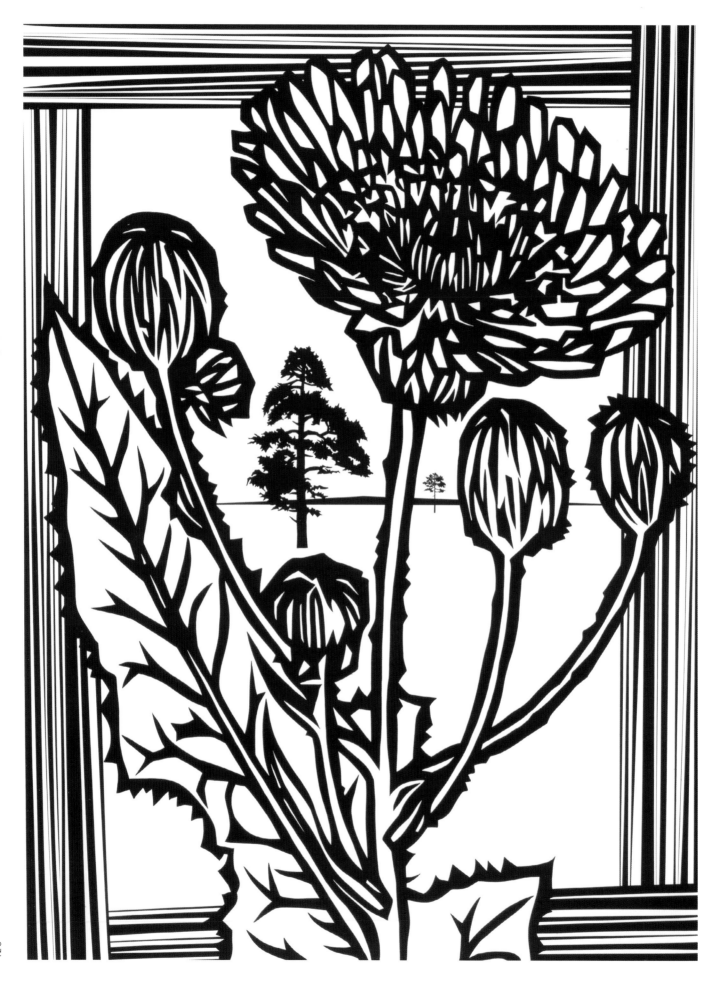

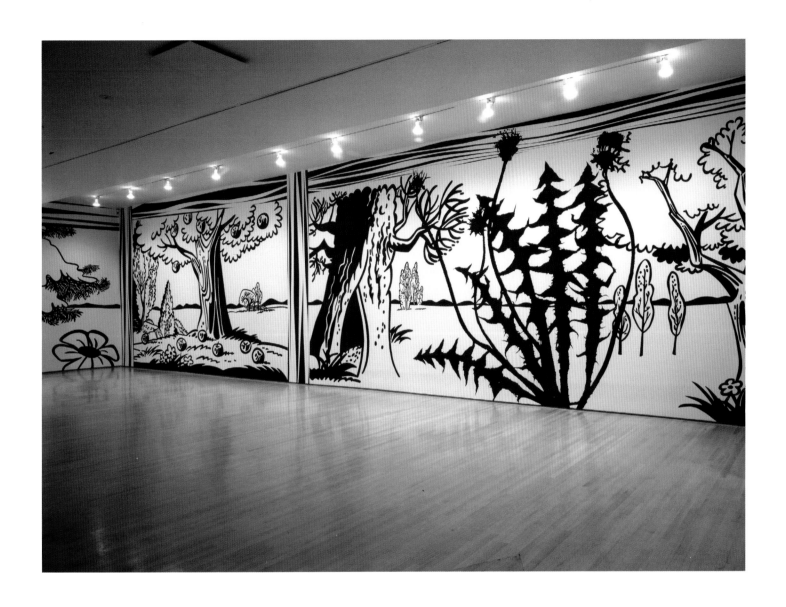

A perfect drawing is one where nothing can be changed
without destroying the essential inner life, quite irrespective of
whether the drawing contradicts our conception of anatomy,
botany, or sciences.

Wassily Kandinsky, *On the Spiritual in Art*

Paul Morrison
Cryptophyte, 2005
acrylic on linen
194 x 145 cm

Paul Morrison
Panorama, 1998-1999
acrylic paint directly onto wall at The Drawing Center, New York
360 degree room installation

TYPICAL BUTTERFLIES.

West, Newman chr a d nat.

Richard Lydekker
Typical Butterflies
from *The New Natural History*, vol. XI,
1880-1890

Michael Landy
Fever Few, 2002
etching
97 x 81 cm

Michael Landy
Greater Plantain, 2002
etching
91 x 80 cm

Bethan Huws
Untitled, 1992
watercolour
21 x 29 cm

Bethan Huws
Untitled, 1995
watercolour
23 x 33 cm

Bethan Huws' grandfather taught her to make tiny rush boats out of a single
blade of grass; this drawing is a record of the object, then, but also traces a fine
line of memory in a single, continuous stroke of the brush. Her sparse, delicate
line captures the nature of her subjects, drawn from the past rather than from
observation, in a return to the Welsh coast of her childhood.

Bethan Huws
Untitled, 1994
watercolour
36 x 44 cm

Bethan Huws
Untitled, 1992
pencil and watercolour
21 x 29.5 cm

Ellen Gallagher
Watery Ecstatic Series, 2004
watercolour, ink, oil, plasticine, pencil
50 x 41 cm

Ellen Gallagher
Watery Ecstatic Series, 2003
watercolour, pencil, varnish and cut paper on paper
104 x 73.5 cm

Richard Lydekker
Glass Sponges
from the *The New Natural History*,
vol. XII, c. 1889-1890

Richard Lydekker
Radiolarians
from the *The New Natural History*,
vol. XII, c. 1889-1890

Both alive and in the form of their skeletons the radiolarians are surpassingly
beautiful. They are all marine, and live in zones from the surface to several thousand
fathoms. Certain species which live in depths below one hundred fathoms, and
whose bodies contain a dark green or black pigment, are probably phosphorescent.
RICHARD LYDEKKER, *The New Natural History*

CITY

For drawing, the City is a site of difference. You sense this in the marks it makes on paper: the straight lines, perfect angles, the algorithms. If, as Man, you're trying to outdo Nature, then inventing a geometry is a good way of going about it: creating a set of artificial forms that make natural laws measurable, prone to harnessing. The City, the embodiment of these forms, is the mark of man's triumph over nature. Drawings of the city compound that triumph, the victory of the built over the formed.

That's the simple version at least, although Tania Kovats's drawings of The Giant's Causeway show the truth to be more complex. The promontory's hexagonal stone columns are known as the work of a vast Ulsterman called Finn McCool, and you can see how the story stuck. It's less to do with scale than with geometry. The evidence of our eyes—until the invention of microscopy, at least—tells us that nature doesn't do straight lines, far less hexagons. "Natural law is God's mathematics" said Euclid, but nature doesn't look mathematical. Something as unnatural as the Causeway must have been built, even if the man who did the building was an unnatural mile high.

Modernist architecture, with its cult of pure geometry, suffers from the opposite problem. Le Corbusier dubbed the house (and, by extension, the city) a machine for living in. Like machines, cities pit geometric forms against natural ones: straight lines and perfect circles are the things that harness gravity or the kinetic force of water to drive Leonardo da Vinci's *Study of Water Wheel* from the mid 1490s. You sense, in the tension between the freehand marks and ruled lines in Leonardo's drawing, a parallel battle between man and nature; the struggle for formal dominance, for power over power.

You also sense something else in this drawing, which is how far geometry has become the measure of Darwin's wise, wise man. Leonardo's water wheel, laid on its side, looks oddly architectural: a precursor, maybe, of the *Ville radieuse* Le Corbusier would draw four centuries later, its buildings radiating outwards like the spokes of a wheel. Curiously, Leonardo's machine also seems habitable, a city in the making. Is this cause or effect? Do cities look like machines or machines like cities? Maybe both are shaped by the same pressures to standardise and replicate. Urban architecture is about ease of navigation and circulation, and the answer to those problems has always lain in defying natural form; in imposing an artificial schema—a grid—on nature's chaos.

And so the city as anti-nature has become the ultimate point of self-reference for man and, by extension, for those who draw. You see this anti-natural form celebrated in the work of the Viennese architect, Adolf Loos. Where art since the Romantics had made a cult of landscape, Loos's dictum that a gentleman had no business looking out of his window turned his houses inwards, made them both the object of their own gaze and its subject. And to signal the arrival this new way of seeing, Loos chose the grid: framed modernity in the straight lines of the city, the right angles of the built.

But that's only half the story. For every Loos who celebrates urban geometry in his drawings, there's a Robert Smithson who questions it. Smithson's famous *Spiral Jetty*, 1970, may be geometric, but its take on the Man versus Nature debate is deeply vexed, intentionally problematic.

Although essentially a drawing—a line in a landscape rather than a line of a landscape—*Spiral Jetty* is anti-human. It is so vast that it can't be seen in its entirety from the ground, as removed from the intimate scale of the hand as it is possible to imagine. Although architectural in the sense of having been built, it defies both urban form and urban scale (and, of course, display in urban art galleries). Seen through the other end of the telescope, in fact, Smithson's jetty reminds us of the nature that underlies all urban forms and structures; and in this Romantic quest it is the unlikely ally of Le Corbusier and his radial town plan.

Le Corbusier's *Ville radieuse* is far from the mechanistic thing its name suggests. His drawing of the circular city doesn't revolve around some abstract geometric axis but around a phallus topped off with an all-seeing, vaginal eye. The point of the *Ville radieuse* wasn't to deny the human tendency to disorder but—*à la* Leonardo—to harness it by making it geometric. At the centre of this most orderly piece of town planning isn't Euclid but Eros; not the superego but the id, the body at its most bodily.

That same realisation underlies the work of Paul Noble, whose massive drawings of *Nobson Newtown*, 1998 (ongoing), blur the line between drawn and built architecture. So vast and slow is Noble's work that it feels architectonic rather than graphic, conceived in the spatial equivalent of real time. And yet Noble's sketches of the letter O in "Nobson" also suggest how urban order inevitably tends to urban chaos. Starting off like an idealised Neo-classical drawing, Noble's O slowly goes back to nature: erodes at the edges, gathers moss. It tells us, in words of one letter, that the logical city is contingent; that its straight lines and angles are only and ever a dream. **CD**

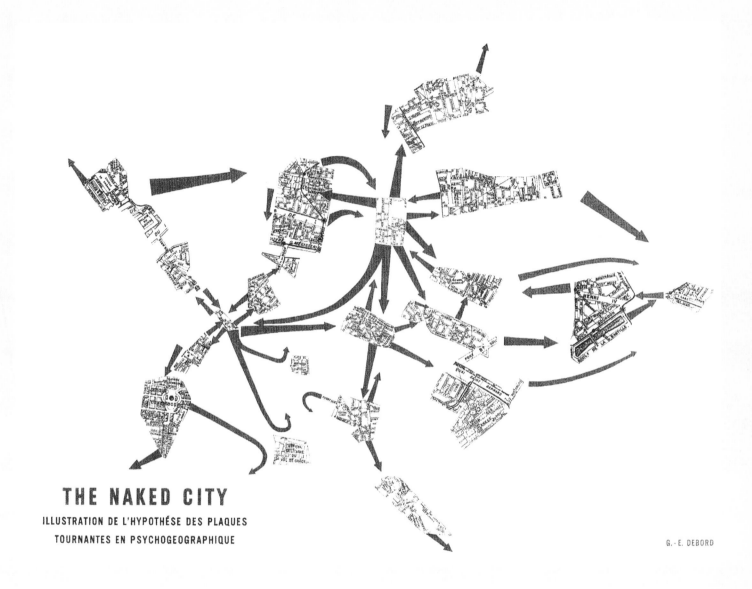

THE NAKED CITY

ILLUSTRATION DE L'HYPOTHÉSE DES PLAQUES
TOURNANTES EN PSYCHOGEOGRAPHIQUE

G. - E. DEBORD

Guy Debord
The Naked City, 1958

If you would see how interwoven it is in the warp and woof of civilization... go at night-fall to the top of one of the down-town steel giants and you may see how in the image of material man, at once his glory and his menace, is this thing we call a city. There beneath you is the monster, stretching acre upon acre into the far distance. High overhead hangs the stagnant pall of its fetid breath, reddened with light from myriad eyes endlessly, everywhere blinking. Thousands of acres of cellular tissue, the city's flesh outspreads layer upon layer, enmeshed by an intricate network of veins and arteries radiating into the gloom, and in them, with muffled, persistent roar, circulating as the blood circulates in your veins, is the almost ceaseless beat of the activity to whose necessities it all conforms. The poisonous waste is drawn from the system of this gigantic creature by infinitely ramifying, thread like ducts, gathering at their sensitive terminals matter destructive to all of its life, hurrying it to millions of small intestines to be collected in turn by larger, flowing to the great sewers, on to the drainage coast and finally to the ocean.

Frank Lloyd Wright

The Plan is the generator.
Without a plan, you have lack of order, and willfulness.
The Plan holds in itself the essence of sensation.
The great problems of to-morrow, dictated by collective necessities, put the question of 'plan' in a new form.

Le Corbusier, *Towards a New Architecture*

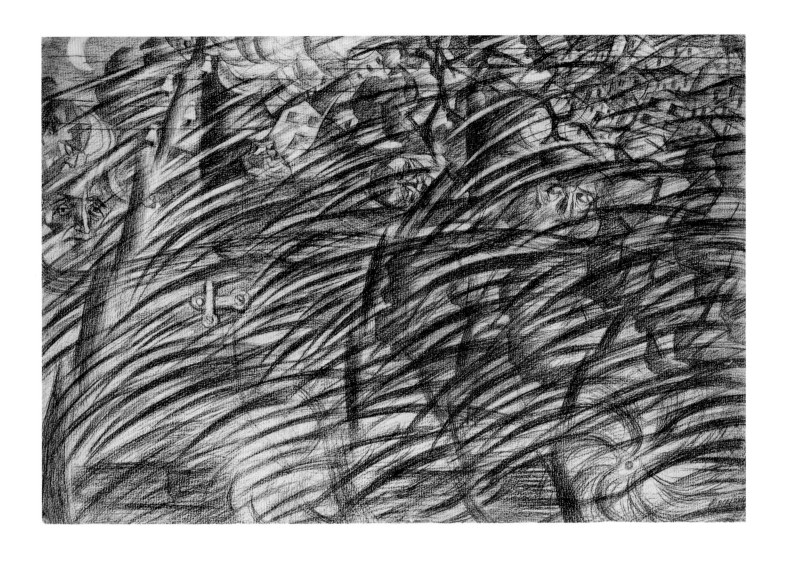

Umberto Boccioni
Study for States of Mind (Those Who Go), 1911
charcoal and chalk on paper
55 x 86 cm

SS 1 4 1

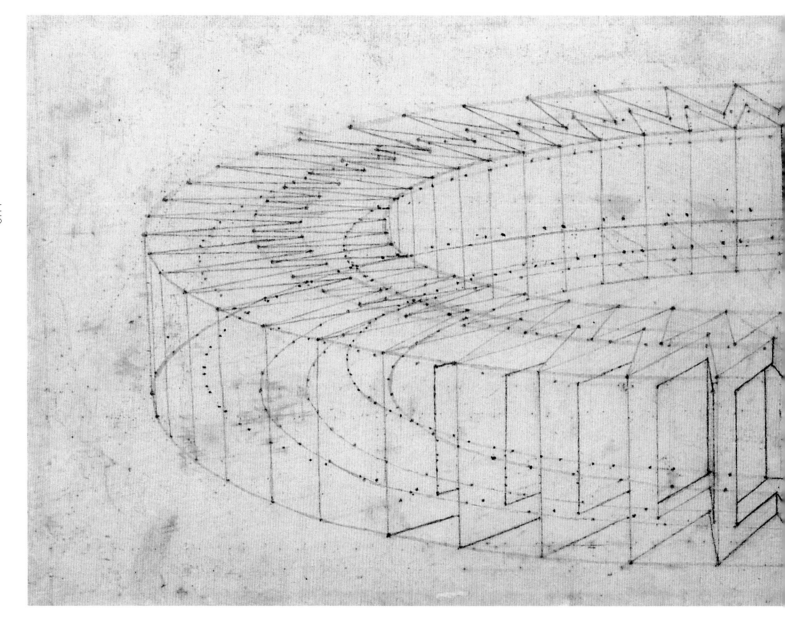

Leonardo da Vinci
Study of Water Wheel, c. 1495

Leonardo's extraordinary geometric drawing
demonstrates his understanding of hydrodynamics,
and how exploiting the power of water might be
possible with big wheels such as this one.

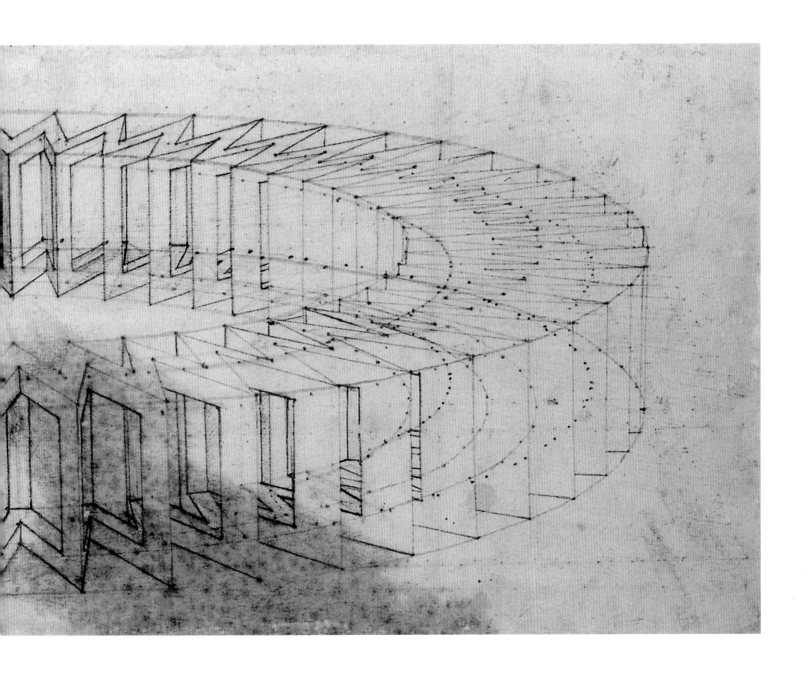

A Regnauld
drawings showing sectional views of steam boilers,
from *Modern Power Engineering*, 1924

THE FLYING STEAM ROLLER 50 Tons

3

COUNTER BALANCE

36 - 40 TON STEEL PLATES

12 TONS

STEAM ROLLER IS DRIVEN IN CIRCLE UNTIL MAXIMUM SPEED
THEN COUNTER BALANCE IS MOVED AWAY FROM PIVOT POINT (WORM GEAR)
STEAM ROLLER FLIES
and continues to spin in the air!

Chris Burden 1994

Chris Burden
The Flying Steam Roller
from *Dream Show at the MAK*, 1994
43 x 56 cm

As an artist, Chris Burden is preoccupied with machines—he has worked with planes, trains, and engines, creating works that subvert the emblems of the industrial age, addressing the power behind the city. His machines are easy to draw, but hard to realise. This is a drawing of a piece which he went on to construct; the simple line drawing becomes a large-scale, potentially dangerous installation which powers its way around the gallery space. The city, then, through Burden's work is a site of speculation and fantasy made manifest.

Experiment Nº.1.

Feby 13 1880
5-3

Chas Batchelor

small horseshoe

Thomas Edison
Experiment No. 1, February 13, 1880
pencil on paper

This simple pencil drawing records Edison's pioneering work with the incandescent light bulb. When he was born in 1847 electricity was thought of as a novelty, invented but not practical. By the time he died in 1931 entire cities were lit by electricity, largely due to his work.

Diana Cooper
Speedway, 2000-2002
foam-core and mixed media
196 x 177 x 37 cm

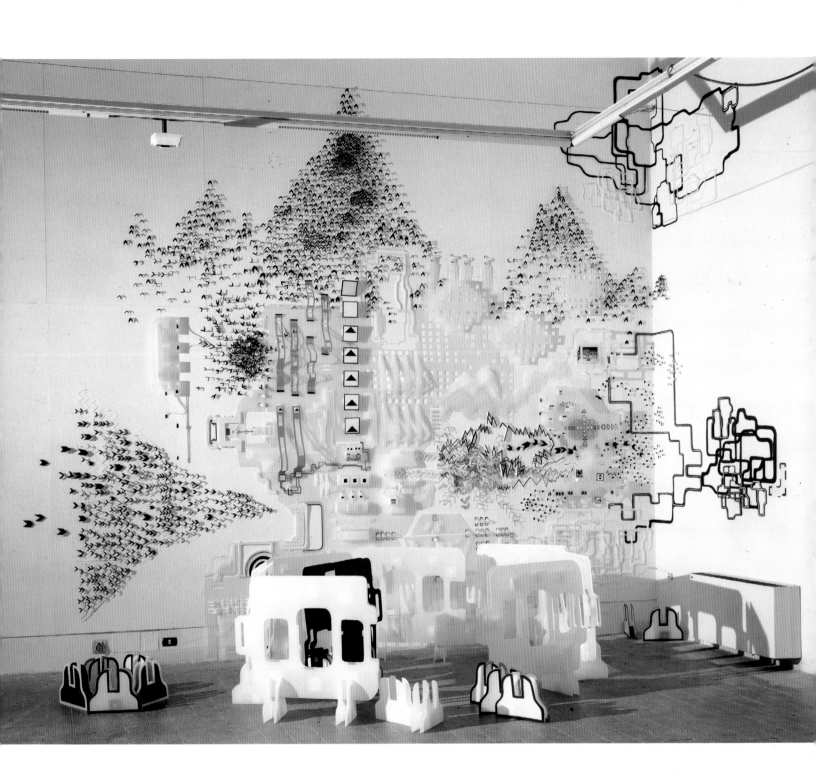

Diana Cooper
Swarm, 2003-2005
corrugated plastic, ink, acrylic, foam-core, photos,
velcro, map pins

TRANSAMAZONICA

Armando Andrade Tudela
Abstraccion Transamazonica, 2005
mixed media on paper
33 x 21 cm

Tudela is a contemporary artist who draws upon the precedents of South American Modernism, engaging with that tradition's relationship with the city and its development through the twentieth century. His compositionally rich works on notepaper show a painterly referencing and indexed relation to the past.

One sees drawings through the drawings one has seen.
They bind the past with the present.

Richard Serra

Armando Andrade Tudela
Neo—Huevo—Neo, 2004
mixed media on paper
33 x 21 cm

Armando Andrade Tudela
Untitled, 2004
mixed media on paper
33 x 21 cm

Ian Charlesworth
"Some of my friends are", 2004
carbon and resin on perspex
90 x 130 cm

Irish artist Ian Charlesworth engages with the mark-making practice of his urban and political environment; these works reference Protestant graffiti, using a cigarette lighter to burn a repeated "UVF" (Ulster Volunteer Force) on a ceiling. Related works take the trace of this act, reducing the mark-making to a patterned surface. His work emerges from a sense of the contested urban space, and the acts of marking territory which occur there. He has also created these drawings as installations, working directly onto the surface of the gallery space.

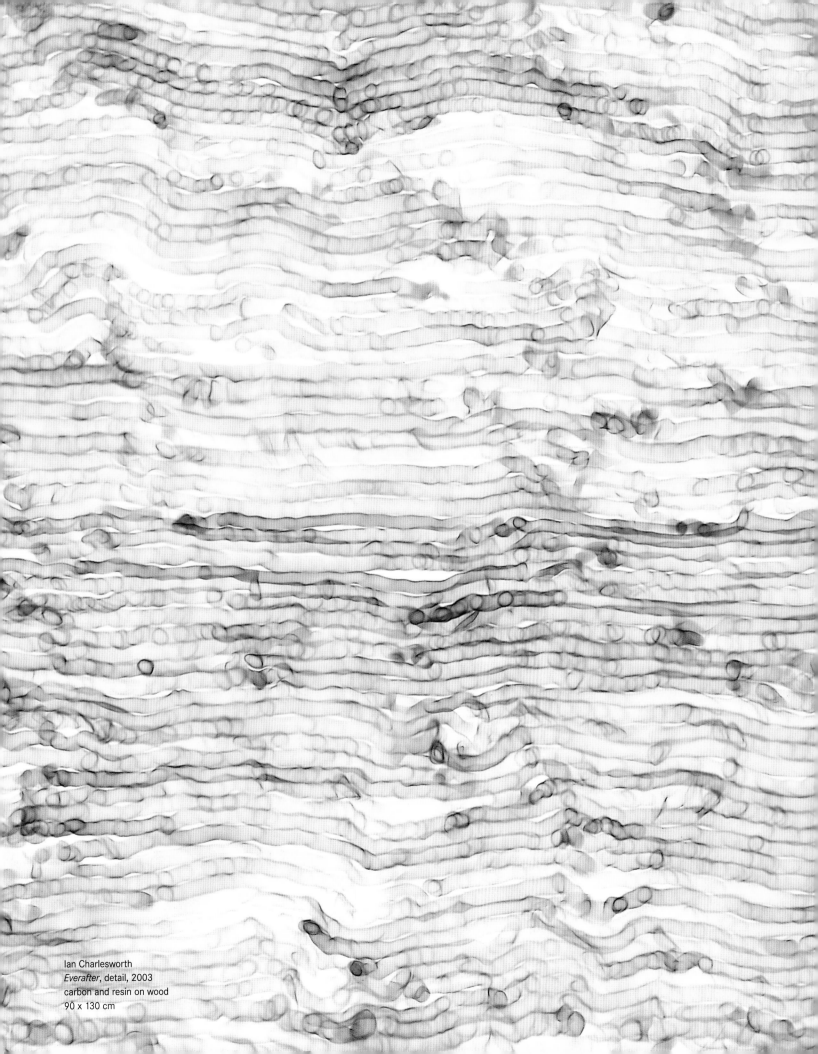

Ian Charlesworth
Everafter, detail, 2003
carbon and resin on wood
90 x 130 cm

Emma Stibbon
Autobahn, 2005
black prepared paper
56.5 x 41 cm

Emma Stibbon
Eichkamp, 2005
black prepared paper
56.5 x 41 cm

Sooner or later in the modern landscape every country road leads to a highway, and all highways whether we follow them or not, lead to the city.

John Brinckerhoff Jackson, *A Sense of Place, a Sense of Time*

Emma Stibbon
Fußgängertunnel Siegessaule, 2005
black prepared paper
56.5 x 41 cm

Emma Stibbon
Underpass Alexanderplatz, 2005
black prepared paper
56.5 x 41 cm

Robert Venturi and Denise Scott Brown
Map of Las Vegas Strip showing every
written word seen from the road, detail,
from *Learning from Las Vegas,* 1972

In this map of Las Vegas by architects Venturi Scott Brown, the city is shown
as a series of neon signs. Engaging with Postmodern discourse, the sign becomes
the signified; the building is not represented by the sign, but is replaced by it.

In the universe now there was no longer a container and
a thing contained, but only a general thickness of signs
superimposed and coagulated, occupying the whole volume
of space; it was constantly being dotted, minutely, a network
of lines and scratches and reliefs and engravings; the universe
scrawled over on all sides, along all its dimensions.

Italo Calvino, *A Sign In Space*

Mira Schindel
Sem Titulo (object grafico), 1968-1971
paint, letraset, transparent
acrylic sheets
51 x 51 cm

The Brazilian artist Mira Schindel's drawings of the 1960s use symbols and letters
in a free-floating space; the sign becomes an abstract form, without relation to a
specific. She addresses the attempt to communicate and negotiate through the
urban space as a site of information exchange.

Mira Schindel
Sem Titulo (object grafico), 1967-1968
ink and letraset on acrylic panel
97.5 x 97.5 cm

David Batchelor
Untitled, 2002
cellulose paint, ink
30 x 25 cm

David Batchelor
Lecture Notes, 1996
ink on paper
30 x 23 cm each

David Batchelor is perhaps best known for his work with stacked fluorescent light boxes, large-scale three-dimensional installations which take on an architectural quality, referencing the monumental structures of the city. The colour and form of his works on paper share these reference points. The artist sprays fluorescent paint onto graph paper and blocks out abstract black shapes, recalling the neon advertising of the cityscape at night. However, like his *Lecture Notes*, the works resemble signs or writing but are blank, empty of reference, addressing the urban experience of navigation among a proliferation of symbols.

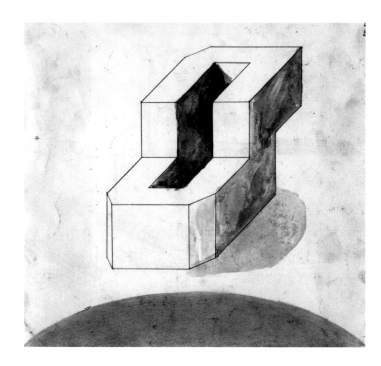

Paul Noble
"O" sketches, 2000
pencil on tracing paper
21 x 15 cm each

Noble's drawings on tracing paper can be laid on top of each other, showing the process of generation as a letter grows like a crystal. In this way, he explores the process of construction; like the city, a geometric form is subjected to an organic process. Modern cities may have their basis in grid structures but the process of growth is often incremental, buildings raised without accordance to an overarching plan.

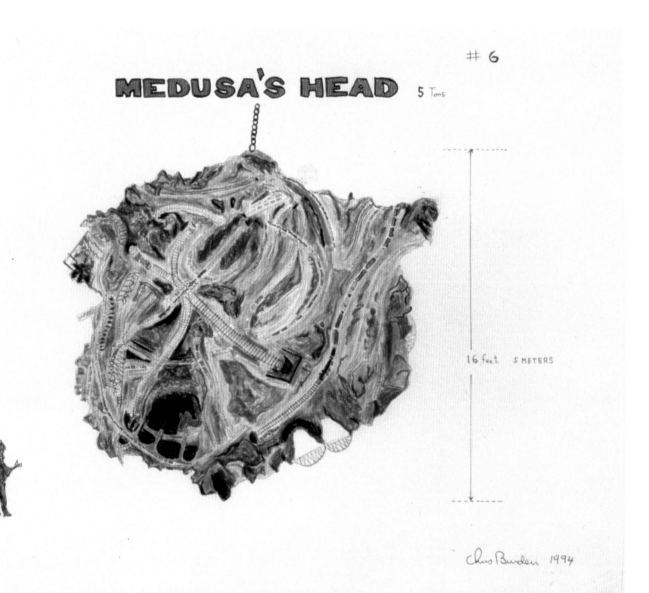

MEDUSA'S HEAD 5 Tons

6

16 feet. 5 METERS

Chris Burden 1994

Chris Burden
Medusa's Head
from *Dream Show at the MAK*, 1994
pen and ink on paper
43 x 56 cm

Chris Burden's work shows the artist engaging with the structures of the city,
treading a line between what can be realised and the realm of the speculative.
The roads and building structures that twist into his *Medusa's Head* become
the wrecking ball that will tear those structures down.

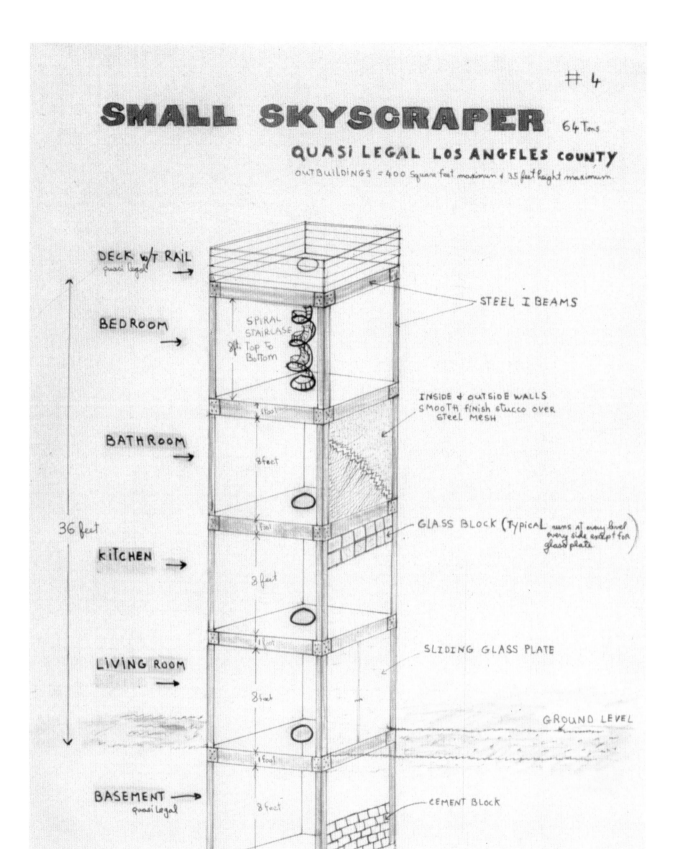

SMALL SKYSCRAPER 64 Tons

QUASI LEGAL LOS ANGELES COUNTY

OUTBUILDINGS = 400 Square feet maximum & 35 feet height maximum.

#4

DECK w/ RAIL
quasi legal →

BEDROOM →

BATHROOM →

KITCHEN →

LIVING ROOM →

BASEMENT →
quasi legal

36 feet

SPIRAL STAIRCASE
8ft. Top To Bottom

STEEL I BEAMS

INSIDE & OUTSIDE WALLS
SMOOTH finish stucco over
STEEL MESH

GLASS BLOCK (TYPICAL runs at every level every side except for glass plate)

SLIDING GLASS PLATE

GROUND LEVEL

CEMENT BLOCK

1 foot
8 feet
1 foot
8 feet
1 foot
8 feet
1 foot
8 feet

10 feet 10 feet

Chris Burden 1994

Chris Burden
Small Skyscraper
from *Dream Show at the MAK*, 1994
ink on paper
55 x 43 cm

Mies van der Rohe
Project for the Stanley Resor house, Jackson Hole, Wyoming,
view of the landscape from the interior, 1937-1938

Oliver Zwink
Blocks, 2000
mixed media on tracing paper
29 x 42 cm

Oliver Zwink works up his forms in bold
felt-tip colours to create his purely
imaginative buildings, an impossible and
vibrant vision of unrealised architecture.

Lake Union, Seattle, Wash. CO. 1972

172 Claes Oldenburg
 Giant Faucet, 1972
 photo-lithograph
 82 x 63 cm

Richard Wilson
20:50, 1986-1987
graphite/photograph ink on paper
85 x 60 cm

This drawing relates to Wilson's *20:50*, an installation using steel and sump oil housed in the Saatchi Collection, London. In this iconic piece, the viewer walks over a gangway above a lake of oil, which mirrors the space around it. The drawing reflects the artist's three-dimensional work, sharing the same processes of collaging, layering and cutting.

Paul Noble
Paul's Palace, the Architect's house
plate five from *Nobson Newtown*, 1996
pencil on paper
170 x 150 cm

Alex Hartley
Eames House and Studio, showing routes "Flip book" and "Leg splint" from *LA Climbs: Alternative Uses for Architecture*, 2003

These drawings are from *LA Climbs: Alternative Uses for Architecture*, an architectural climbing guide to iconic twentieth century Los Angeles buildings; the lines trace routes up these buildings. Of all modern cities, Los Angeles has become the archetype of the late twentieth century urban sprawl, a mass of signs and streets; Hartley's climbing guide suggests an alternative means of negotiating urban space, in the city of dreams.

There is no such thing as a line, only light and shade.

Alfred Hitchcock

Alfred Hitchcock
*Saboteur (Statue of Liberty
struggle sequence)*, 1942
pencil on paper
23 x 20 cm

Alfred Hitchcock's drawings form a vital record of his thinking process; constantly
sketching out ideas, drawing was for him a fundamental tool for creativity.
He allegedly claimed that it should be possible to draw a whole film on one side
of note paper. Here, his protagonists ascend the Statue of Liberty, in a sketch that
encapsulates the film's climactic moment.

John Huston
Moby Dick, sketchbook page, 1956
pen on yellow paper
20.5 x 33 cm

It is possible to envision a time when there wasn't oil painting
(before the fifteenth century), or video art (before 1964), but
drawing seems to have been with us always.

Laura Hoptman, *Drawing Now*

William Kentridge
Temple interior
from *Learning the Flute*, 2003
charcoal on paper
49 x 61 cm

William Kentridge
Birds
from *Learning the Flute*, 2003
charcoal on paper
57.5 x 59.5 cm

South African animator and filmmaker William Kentridge came to prominence by addressing issues around apartheid; his recent work has taken on a more personal, lyrical inflection. He films his drawings as he works, making or erasing a mark and filming the piece, so that the process of creation is animated and the drawing is perpetually re-presented in another medium.

Keir Smith
Angelo Raffaele II, 2004-2005
acrylic on paper
26 x 38 cm

This drawing reflects Keir Smith's preoccupation with decaying buildings.
The crumbling wall shows the city in dissolution; that which was built to last
and seemed unassailable is, like everything, subject to the passage of time.

E Challis, WH Bartlett
The Coliseum at Rome, c. 1850

The riots in Harlem last August left scenes like this after many violent nights. Police personnel, such as Captain Lloyd Sealy, were found to be heroes in helping maintain law and order in the strife-torn Harlem 28th Precinct.

THE MAN WHO KEPT HARLEM COOL

Ellen Gallagher
The Man Who Kept Harlem Cool, from *Deluxe*, 2004
edition of 20
photogravure, aquatint, spitbite and plasticine
33 x 25.5 cm

Adam Dant
Community Bed, detail, 2002
ink on paper
160 x 40 cm

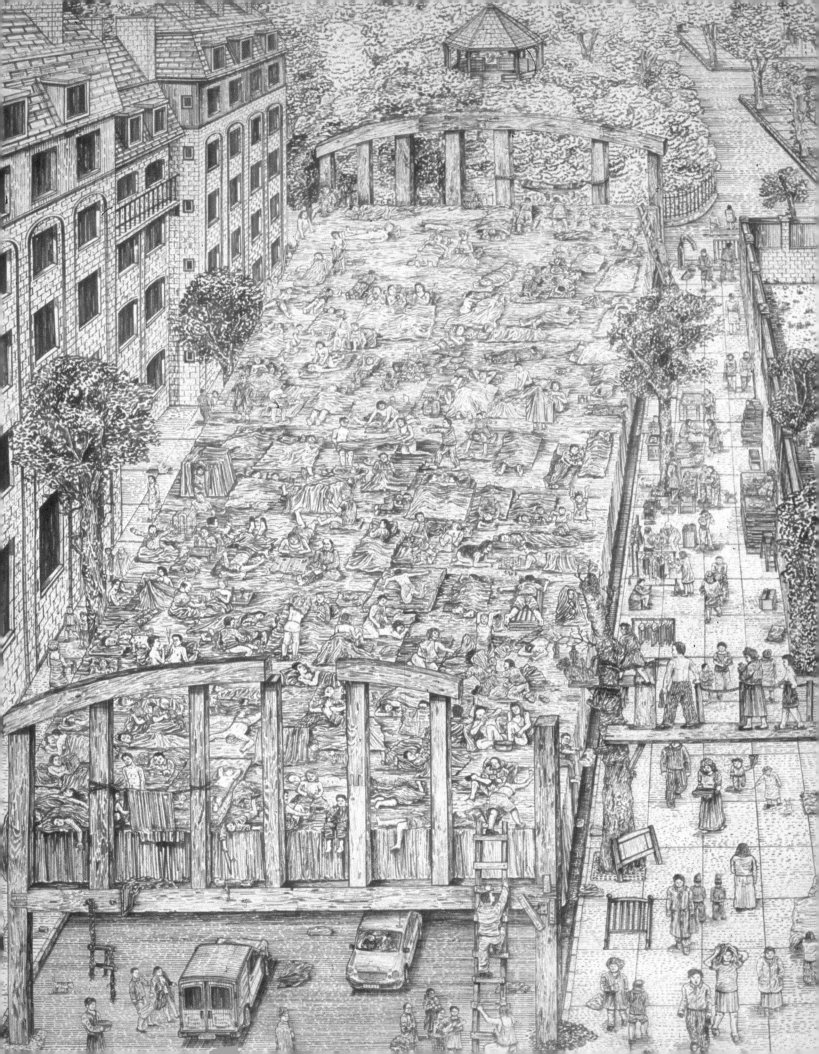

The studies here are selected from Prendergast's ongoing series of pencil drawings of cities. The fine, hairline marks which delineate the roads and waterways trace cobweb-like forms on the page. The contrast between each metropolis emerges. In these aerial views, the formation and limits of urban space, and the routes in and out of them, become apparent, and the disparate locations expose their differences. Their individual histories and geographies are reduced to the same visual language, and all are rendered with delicacy, a reminder of the fragility of what seems impervious.

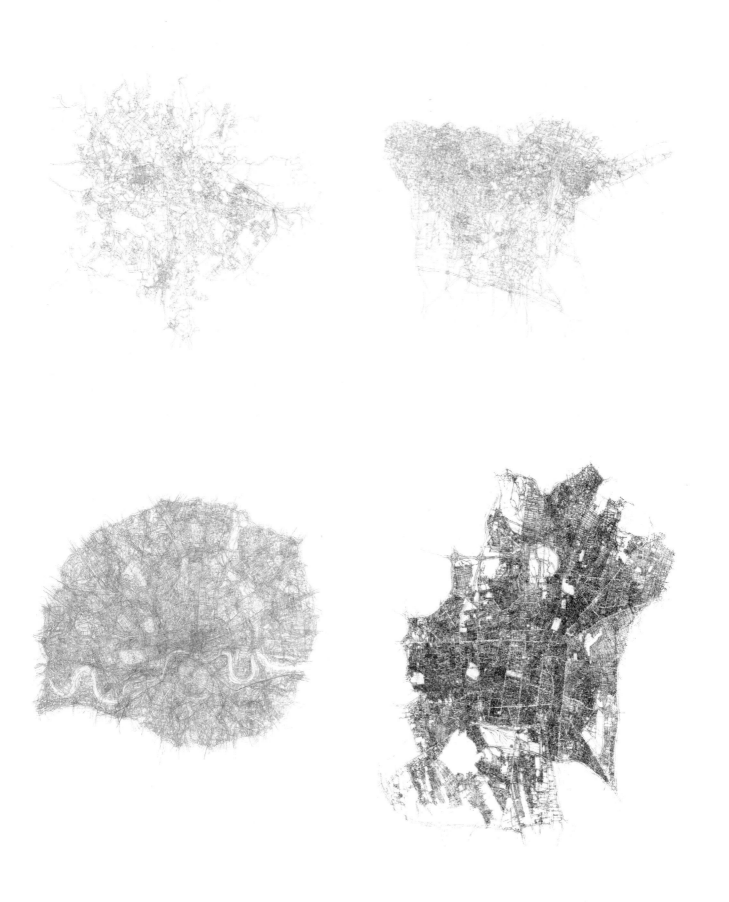

Kathy Prendergast
City Drawings, 1992
from ongoing series
all works pencil on paper
32 x 24 cm each

opposite: *Mexico City, Mexico*
above left: *Addis Ababa, Ethiopia*
above right: *Beirut, Lebanon*
below left: *London, Britain*
below right: *Jerusalem, Israel*

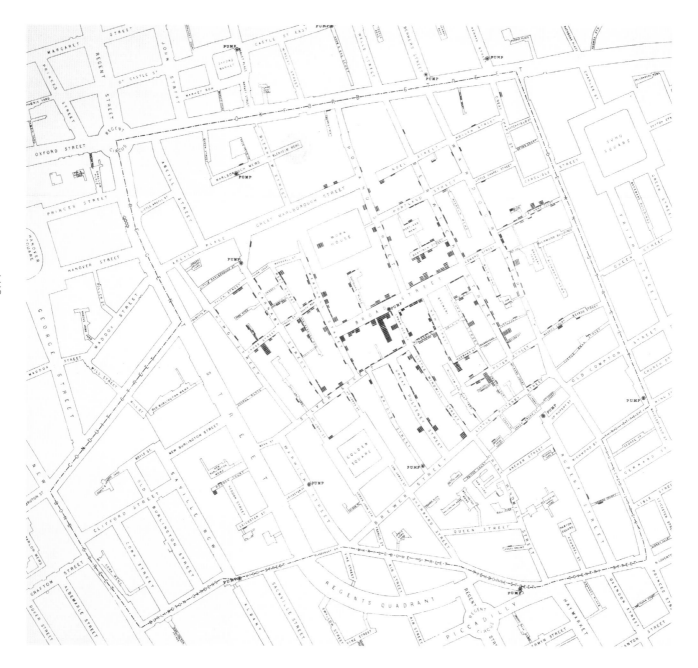

John Snow
map from *On the mode of
communication of Cholera*,
second edition, 1855

This map shows the distribution of cholera cases in the locality of the Broad Street
pump in Soho, London. The distribution and spread of disease was a specific theme
pursued in the urban cartography of the nineteenth century, and this map in
particular was hugely significant in the evolution of epidemiology.

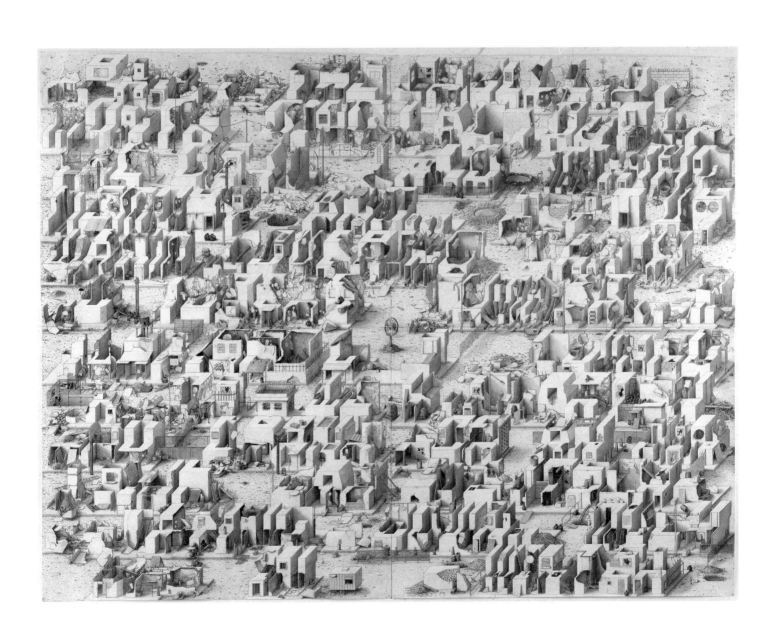

Paul Noble
Nobson Central, 1998-1999
pencil on paper
300 x 400 cm

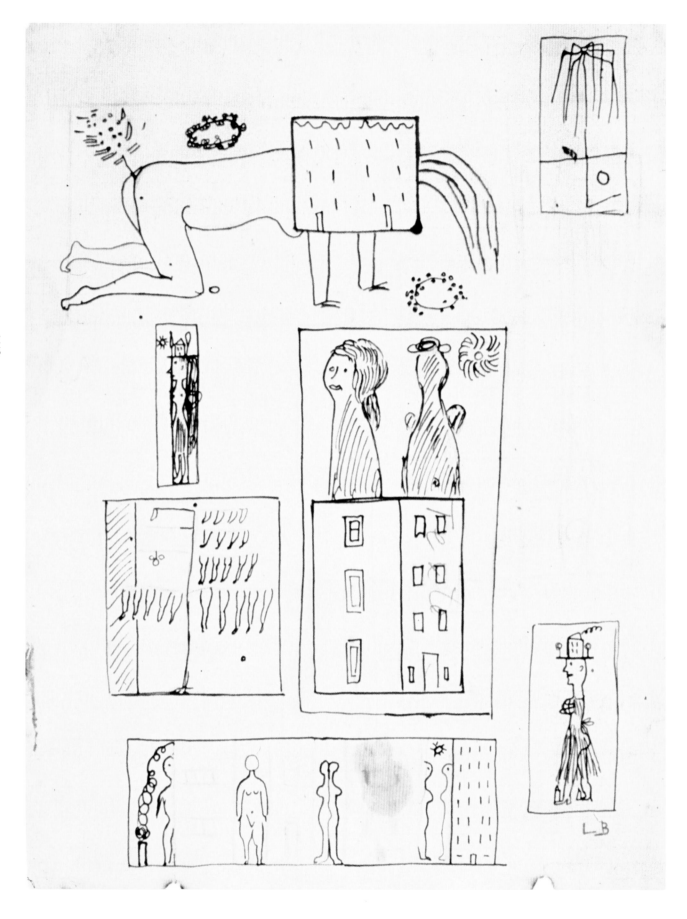

Louise Bourgeois
Untitled, 1947
charcoal and ink on paper
28 x 21 cm

Here, Bourgeois' concern with the body in space is apparent; we see the individual
in the urban environment, navigating and occupying the interior of the city, finding
a private space in a public realm.

Rachel Goodyear
Lost Dog, 2005
pencil on Rizla paper
actual size

Just as the child draws outward, pulling the trace away
from himself, the adult draws outward and pushes away
as he writes. In writing as in drawing, the 'throw-out'
gesture conjures up a trace, a line. This 'line' which
seems tied to his movement, is used by the inscriber
to pull back the thought that has been cast out in the
act of inscription.

Serge Tisseron, *All Writing is Drawing*

FDH, aged five
drawing of a game of chess, 2004
felt tip on paper

Chess is a game of finding a route and positioning the self within a grid. In this
drawing, we see the child learn to navigate the game, the grid, and the page.

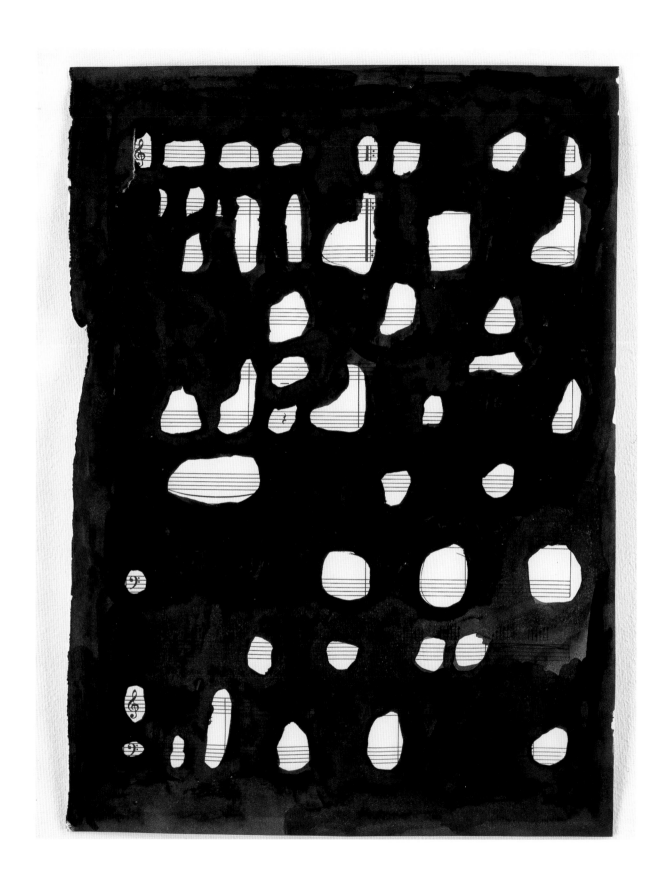

Louise Hopkins
Untitled (393), 2003
acrylic ink on sheet music
30 x 22 cm

Rachel Whiteread
Door, 1991
acrylic on graph paper
42 x 29.5 cm

Rachel Whiteread's work explores private, untouched and hidden spaces. Here, the artist presents a closed door behind which she might have retreated; doors and windows are the means of accessing the architectural volumes of the city, but are also the means of sealing the self off. The very architectural structures which, from the exterior, symbolise the urban landscape and experience, have internal spaces into which the individual can retreat, to find a private space within.

My drawings are a diary of my work.

They are a more discrete part of my practice. They help me work out what it is that I'm doing. The drawings are a way of finding my way through something. They are a way of thinking. If I get stuck in an uncomfortable place with a work, drawing lets me worry the work through, till the work is resolved or moved on.

There is a mobility to how I draw. When I was first at college I painted, but I was making paintings, rather than painting them. I make drawings—I stick things down and pull them off. I cut or perforate images. When I use something like the correction fluid over an image it's as if I'm casting the drawing.

My relationship changed with the drawings when I was in Berlin for 18 months. It was the first time I had had a drawing studio. The studio became an important thinking space. The studio became a composite picture of what was inside my head.

I try never to show the drawings with the sculpture. I want to keep them separate. They are an aspect of my work that I have a lot of control over. Maybe because they are my diary.

I retain the drawings as memories. With each drawing I have an ability to recall where I did that drawing and the circumstances of its making. It's as if the drawing absorbed the time of its making.

Rachel Whiteread, in conversation with Tania Kovats, April 2005

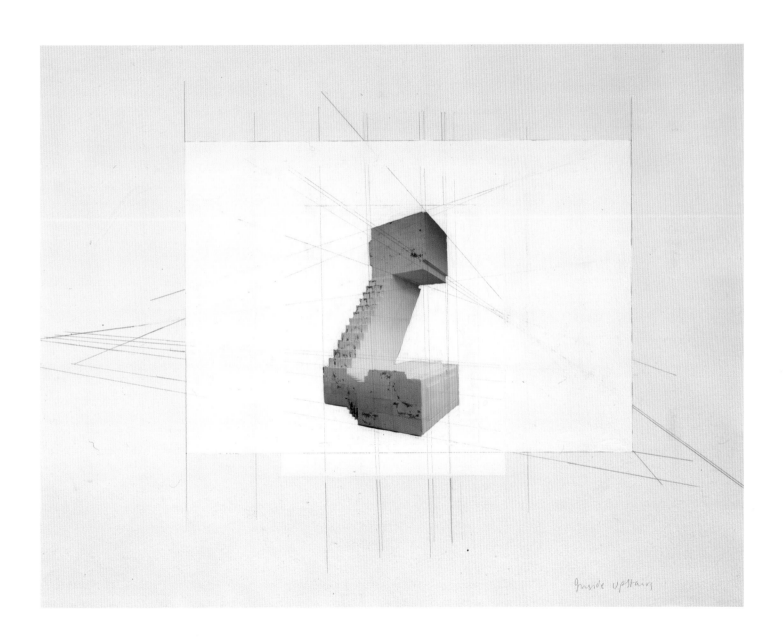

Rachel Whiteread
In-Out Stairway, detail, 2003
collage, gouache and pencil on paper
66.5 x 50.5 cm

Rachel Whiteread
Inside Upstairs, 2004
collage, gouache and pencil on paper
50 x 66 cm

Toba Khedoori
Untitled (House), detail, 1995
oil paint and wax on paper
335 x 488 cm

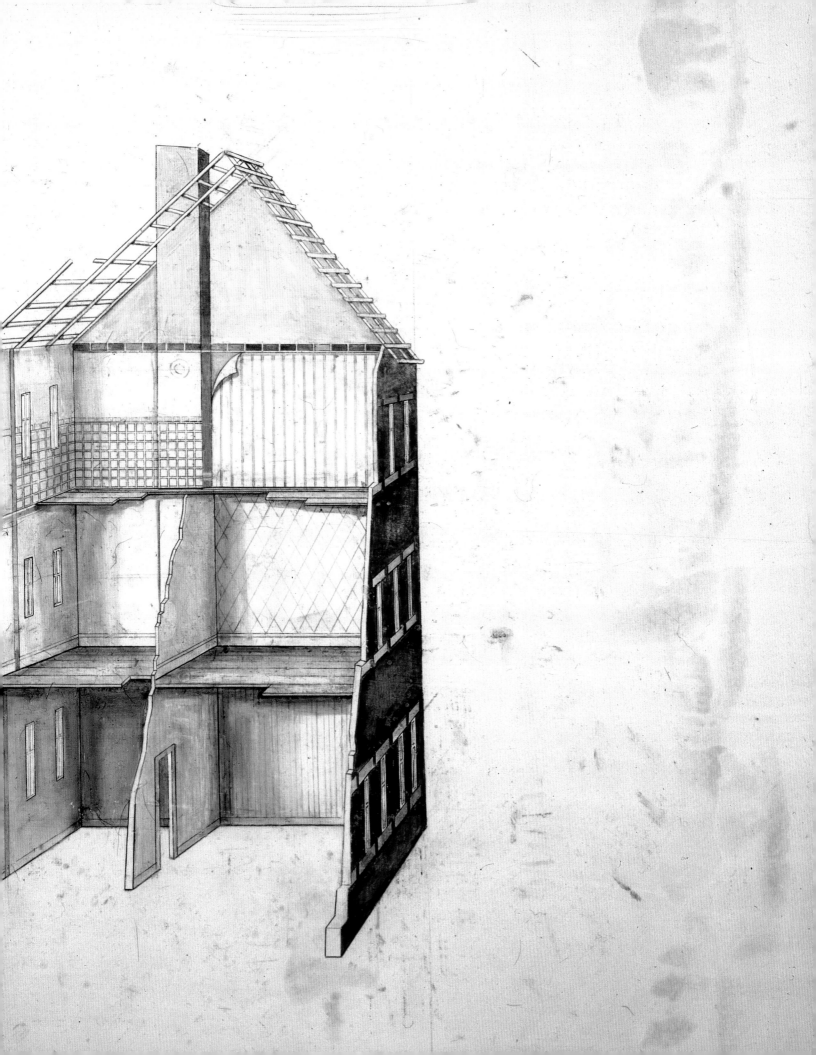

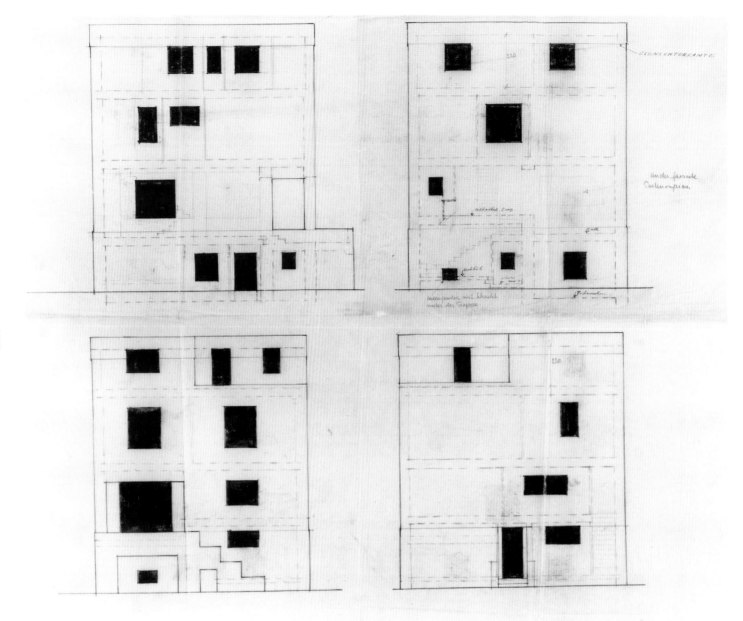

Each elevation shows not only the outlines of the facade but also, in dotted lines, the horizontal and vertical divisions of the interior, the position of the rooms, the thickness of the floors and the walls. The windows are represented as black squares, with no frames. These are drawings of neither the inside nor the outside but the membrane between them: between the representation of habitation and the mask is the wall.

Beatriz Colomina, *The Split Wall: Domestic Voyeurism*

Adolf Loos
Villa Josef und Marie Rufer, Wien XIII., Schliemanngasse 11,
Fassaden mit Fensteraufteilung, 1922
pen, pencil on transparent paper
60.5 x 67 cm

Toba Khedoori
Untitled (Window), detail, 1999
oil paint and wax on paper
366 x 610 cm

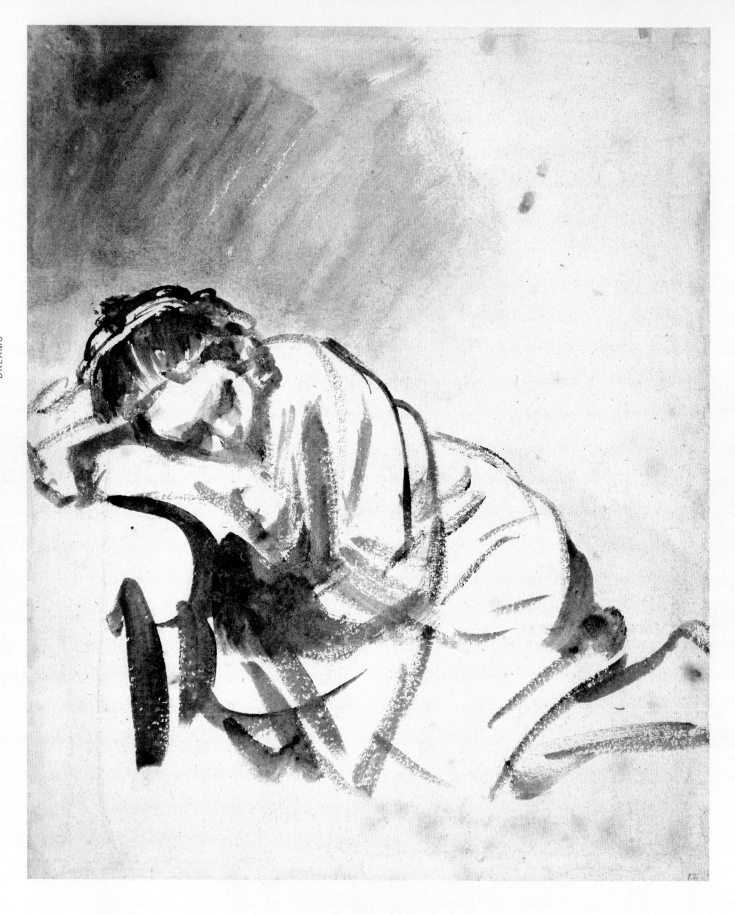

Rembrandt van Rijn
A Girl Sleeping, c. 1655
brown ink
24.5 x 20 cm

DREAMS

Drawing—all art—is about establishing a difference; setting up that other-thing which allows us to think in metaphor, to measure ourselves against a projection of ourselves. By and large, this projection is external, focussed on the sitter in front of us, the landscape around us. But there is an internal Other that fascinates us, too: the unconscious self we see in dreams, that rebels against measurement, cities and grids.

More than any other form of image-making, drawing negotiates between the rational and irrational minds, the intellectual and the instinctive, the head and the hand. This dialogue decides how we re-cast three dimensions as two, or render the dustiness of skin in powdered graphite; how we shrink a mountain down to paper-size, or imply a source of light. Rembrandt's lovely ink sketch, *A Girl Sleeping*, c. 1655, is about all of those things. Its quick, broad wash and intimate scale tell us everything we need to know about the artist: his urge to touch his subject's skin or hair, his fear of waking her. It's an oddly revealing image, because Rembrandt's view is one-sided. There's no enigmatic smile on the girl's face, no meeting of the artist's eye—nothing, in short, that we can read as a response, a conscious exchange. And that is because the girl is dreaming.

If drawing mediates between two states of mind, then this picture is the portrait of a process. One reason *A Girl Sleeping* is so powerful is that its subject's unconsciousness reminds us of Rembrandt's own unconscious; that what we're seeing played out on paper is a fantasy. In a sense, the subject of *A Girl Sleeping* isn't the girl at all but Rembrandt's desire to draw her, with all that implies.

One thing we can be fairly sure of is that Rembrandt would have viewed this interpretation with doubt. It's a Freudian view, and Rembrandt was pre-Freud. The simple, Dutch domesticity of his scene covers its tracks well: what you see, it says, is what you get. But is *A Girl Sleeping* really so different from Goya's *Mala Mujer*, drawn 150 years later in 1802? Is it any less fantastical, any more real?

On the face of it, the answer is yes. Although there are similarities of handling between the two works—Goya was an ardent admirer of Rembrandt—there's a question of intent. *A Girl Sleeping* sets out to prove the triumph of the conscious over the unconscious mind. While his dozing subject reminds us of Rembrandt's fantasy, there is no threat in his gaze. If anything, the air is of collusion rather than of exploitation; of a society in which civility has overcome sexual instinct. By contrast, Goya turns gender on its head, showing an unnatural Spain in which the "bad woman" eats babies rather than feeds them. And, unlike Rembrandt, you feel that was precisely his intention. Goya's drawings, he said, were "fantasy and

invention", intended to show "an imagination mortified by contemplation of my own suffering". If you'd presented him with a Freudian interpretation of his *Mala Mujer*, then—pre-Freudian or not—Goya would probably have agreed with it.

So there's a line in these drawings that runs between hiding the irrational and embracing it, between Rembrandt and Goya. It's a line that divides much drawing. The drapery in Daniele da Volterra's *Woman at the Foot of the Cross*, c. 1538, seems to fall on the first side of it, Botticelli's bizarrely precise drawing for his *Chart of Hell*, 1480-1495, on the second. Yet the first two works, like the last two, start from a position of impossibility.

Daniele's Mannerist folds tell us that they couldn't exist in real life: that the stories we're looking at go beyond human understanding; that they defy natural law and so the laws of naturalism. One of the marks of Renaissance rationalism was the way post-Quattrocento drapery articulated the body, hinting at the flesh below the cloth; by reverting to an older kind of mark-making, Daniele takes us back to a time before the rational. By contrast, Botticelli's fantasy map seems naturalistic, cartographic. The precision of his curves, the mechanical likeness of his tongues of flame, tells us that we are seeing some kind of truth-to-life—a New World as real as the one being explored by Botticelli's contemporary and fellow-Florentine, the explorer Amerigo Vespucci.

It's only after Freud that this oneiric back-and-forth becomes totally knowing: *The Interpretation of Dreams*, not the *First Surrealist Manifesto*, is the real founding text of Surrealism. Before Freud, dreams were ephemeral things; will o' the wisps that needed putting down on paper before they disappeared, whose flightiness was part of their magic. After Freud, dreams were cryptic messages of the id that could be decoded or made up or re-invented backwards. Duchamp's *With My Tongue in My Cheek*, 1959, is exactly what it says it is: a self-deconstructing slip of the tongue, a parapraxis-on-purpose. A plaster cast of the artist's face with his tongue, literally, in its cheek, Duchamp's multiple pun recreates the irrational in the most rational way possible. And yet it hints at a mind beyond Duchamp's knowing, at meaning outside his own. CD

All that we see or seem
Is but a dream within a dream

Edgar Allen Poe, *A Dream Within a Dream*

The artist is a receptacle for emotions that come from all
over the place: from the sky, from the earth, from a scrap
of paper, from a passing shape, from a spider's web.

Pablo Picasso

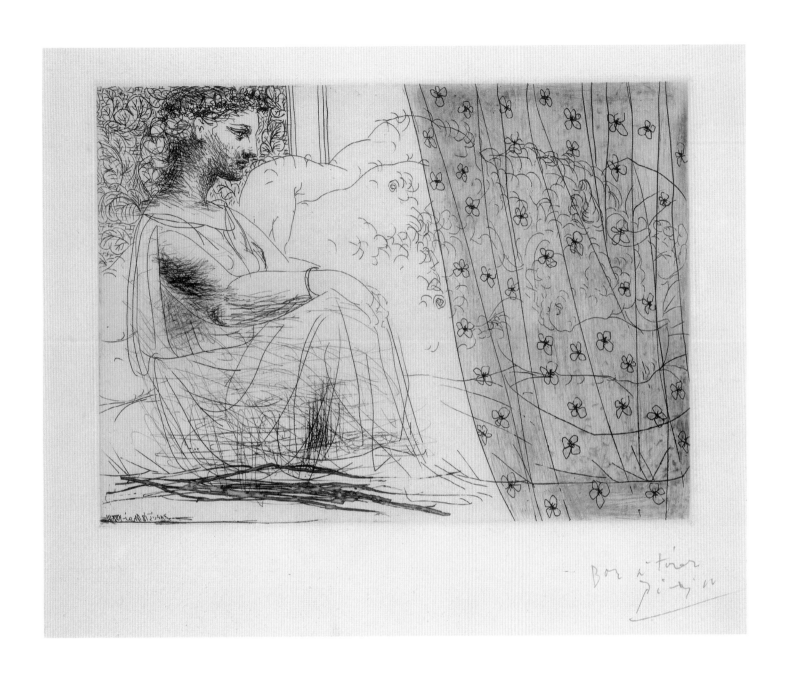

Pablo Picasso
Girl Seated by Sleeping Minotaur, 1933
combined technique, etching
19 x 26.5 cm

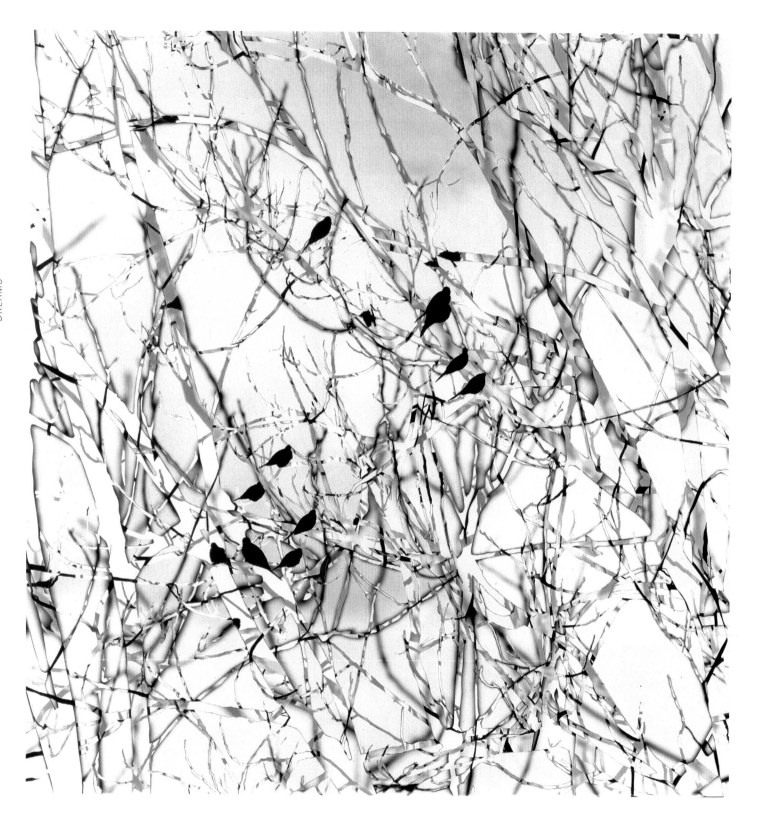

Soo Kim
He Bows to his Image in the Mirror, 2005
two layered hand-cut c-prints
61 x 61 cm

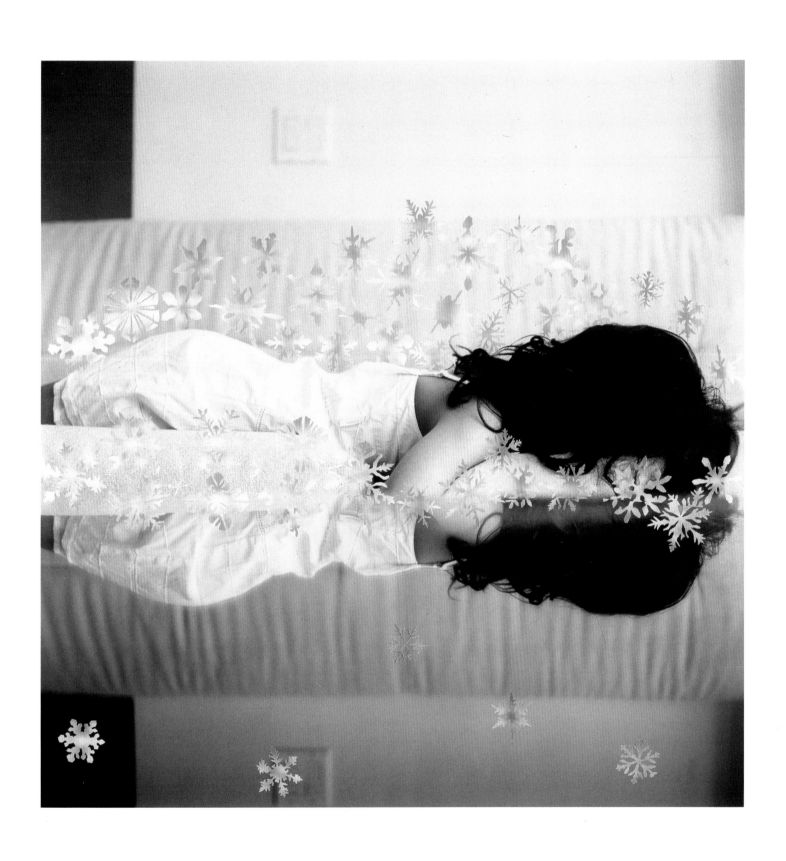

Soo Kim
Halla, 2005
hand cut c-print
91 x 91 cm

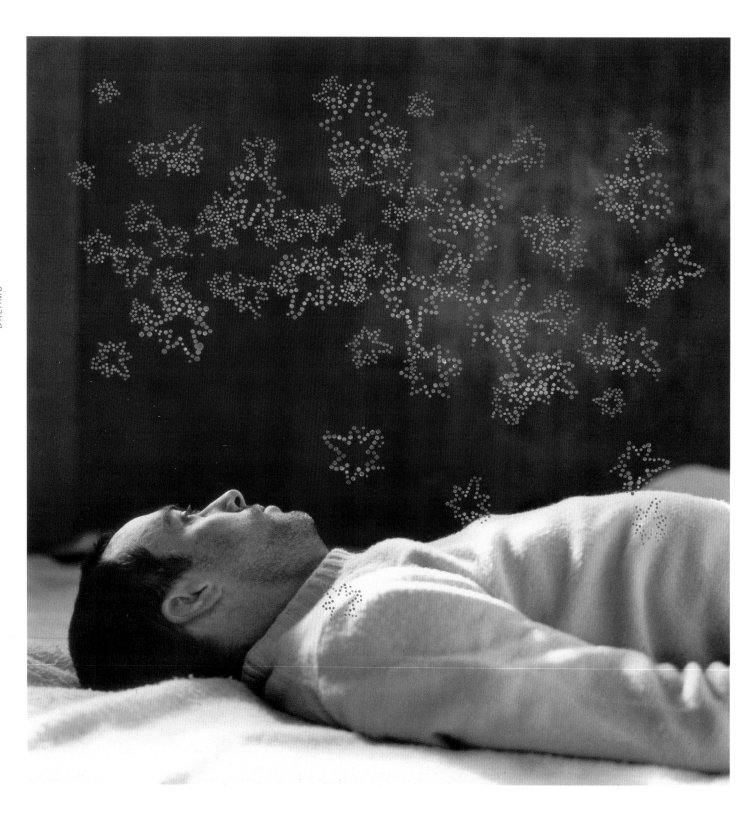

Soo Kim
Idyllwild (yon), 2005
hand cut c-print
91 x 91 cm

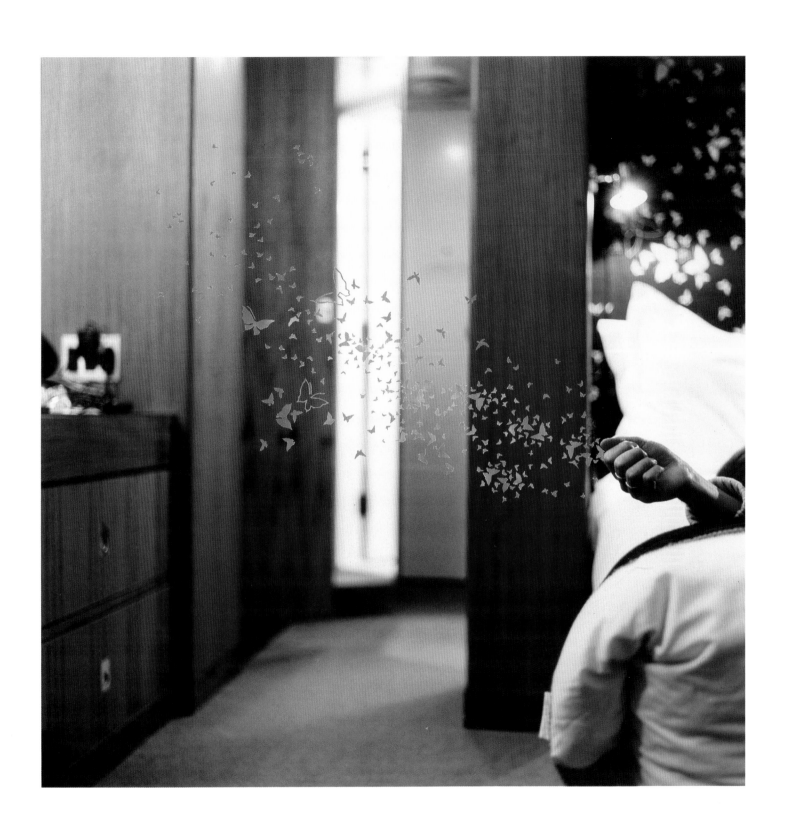

Soo Kim
Maritime, 2005
hand cut c-print
88 x 88 cm

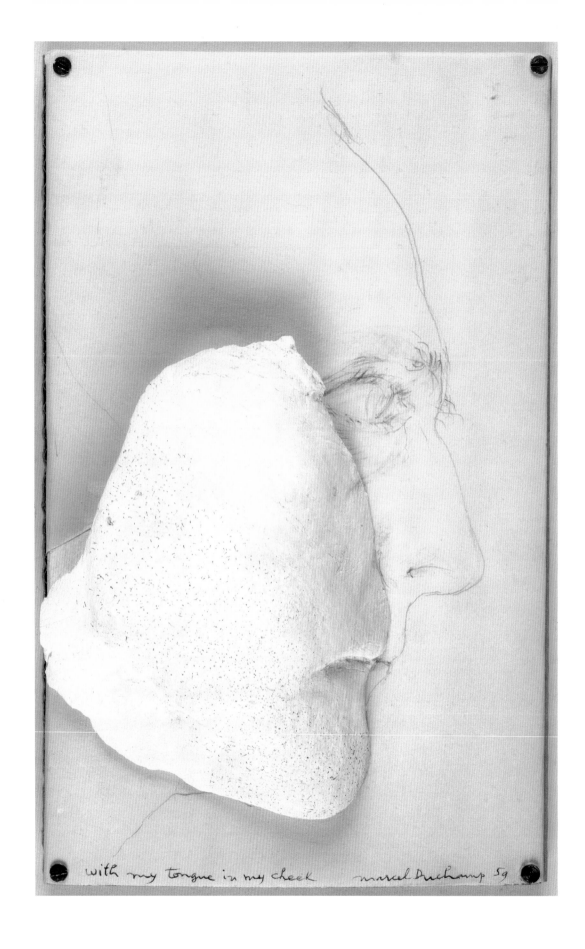

with my tongue in my cheek marcel Duchamp 59

Marcel Duchamp
With My Tongue in My Cheek, 1959
pencil, ink, plaster on paper

If the dust of drawing is alive, it is both because of its entanglement with language (it 'describes' something; there is a flash of energy from image to referent that doesn't result either in their coinciding or estrangement) and its ability to elicit something less easy to articulate in words, something that happens in the blind spots of representation.

David Musgrave, *Living Dust*

David Musgrave
Transparent Head, 2003
graphite on paper
29 x 24 cm

In the night between Wednesday and Thursday after Whitsunday 1525, I saw this appearance in my sleep—how many great waters fell from heaven. The first struck the earth about four miles away from me with terrific force and tremendous noise, and it broke up and drowned the whole land. I was so sore afraid that I awoke from it. The other waters fell and as they fell they were very powerful and there were many of them, some further away, some nearer. And they came down from so great a height that they all seemed to fall with equal slowness. But when the first water that touched the earth had very nearly reached it, it fell with such swiftness, with wind and roaring, and I was so sore afraid that when I awoke my whole body trembled and for a long while I could not recover myself. So when I arose in the morning I painted it above here as I saw it. God turn all things to the best.

Albrecht Dürer

Albrecht Dürer
Vision in a Dream, c. 1525
pen and watercolour
43 x 30 cm

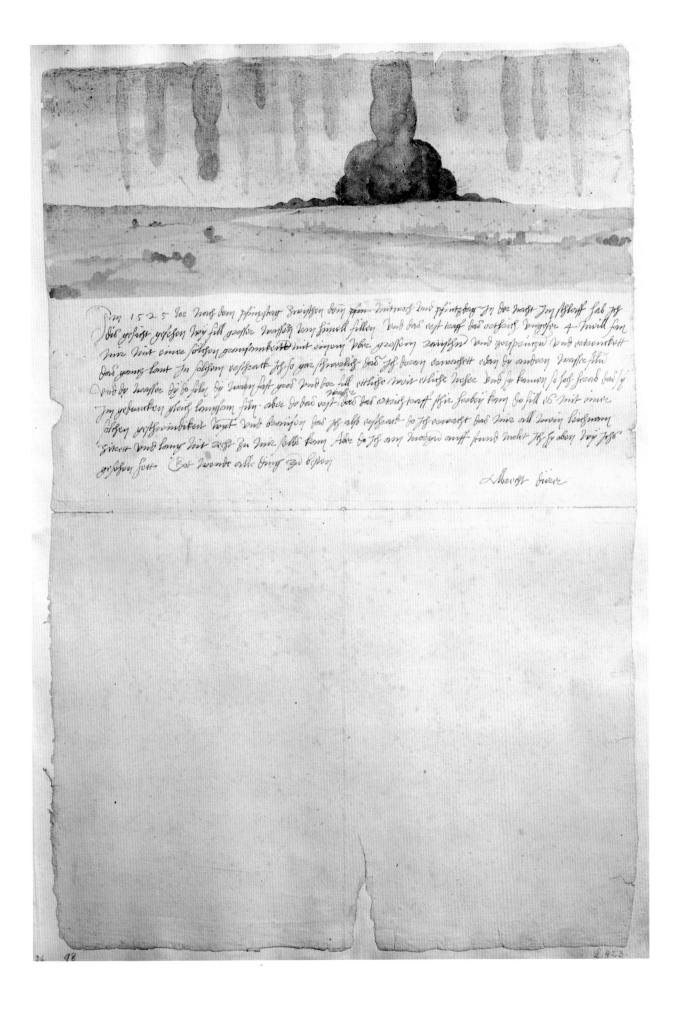

Im 1525 Jor noch dem pfingstag zwischen dem Mitwoch und pfintztag In der nacht Im schlaff hab Ich dis gesicht gesehen wy fill grosser wasser vom himel fillen Vnd das erst traff das ertrich ongfer 4 mill fon mir mit einer solchen grausamkeitt mit eynem überschwemmen zerischen vnd erztrencken das gantz lant In solchem erschrack Ich so gar schrocklich das Ich doran erwachet ehe dy andren wasser filen Vnd dy wasser dy do filen dy woren fast gros Vnd der fill ettliche weit ettliche neher vnd sy kamen so hoch herab das sy Im geduncken gleich lanksam filen aber do das erst wasser das das ertrich traff schier herbey kom do fill es mit einer solchen geschwindikeitt wint vnd braussen das Ich als erschrack do Ich erwacht das mir all mein leichnam zittert vnd lang nit recht zu mir selbs kom Aber do Ich am morgen auff stund molt Ich sy oben dey gestalt gesehen hett Got wende alle ding zu besten

Albrecht Dürer

OA
"She stood by the bedside for some moments
looking down upon her pityingly."
from *Little Saint Elizabeth* by Frances Burnett, 1890

Richard Lydekker
A Column of the Army Worm
from *The New Natural History*, vol. XI, c. 1880-1890

John Tenniel
illustration for *Alice's Adventures
in Wonderland*
by Lewis Carroll, 1898

John Tenniel
illustration for *Through the Looking Glass*
by Lewis Carroll, 1897

"And if he left off dreaming about you, where do you suppose you'd be?"
"Where I am now, of course," said Alice.
"Not you!" Tweedledee retorted contemptuously. "You'd be nowhere.
Why, you're only a sort of thing in his dream!"

Lewis Carroll, *Through the Looking Glass*

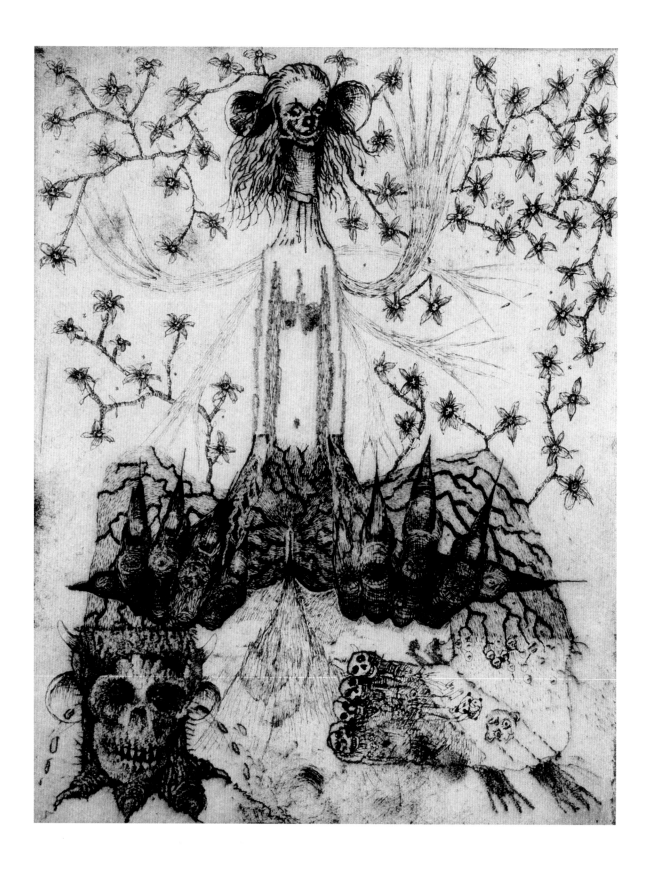

Jake and Dinos Chapman
etchings from *Exquisite Corpse*, 2000
20 etchings
46 x 38 cm each

These drawings play upon and foreground the Chapmans' collaborative approach, as they pass folded paper between them in a game of 'consequences'. The result is these figures, both monstrous and endearing, a meeting point of imaginations that produces amalgamations reminiscent of those that occur in dreams.

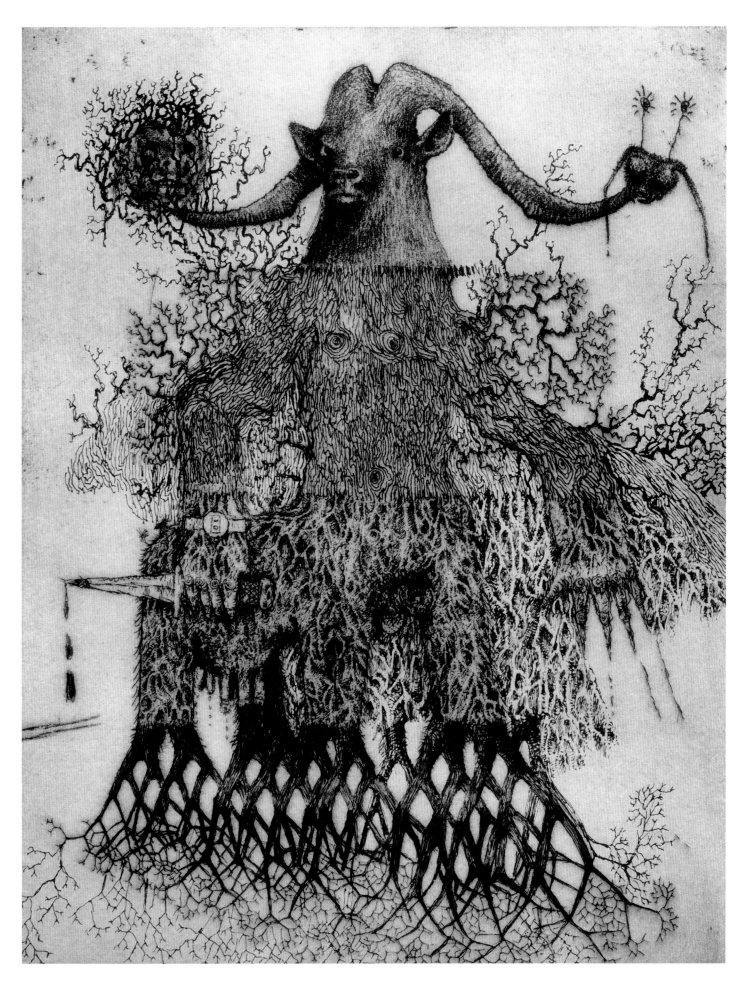

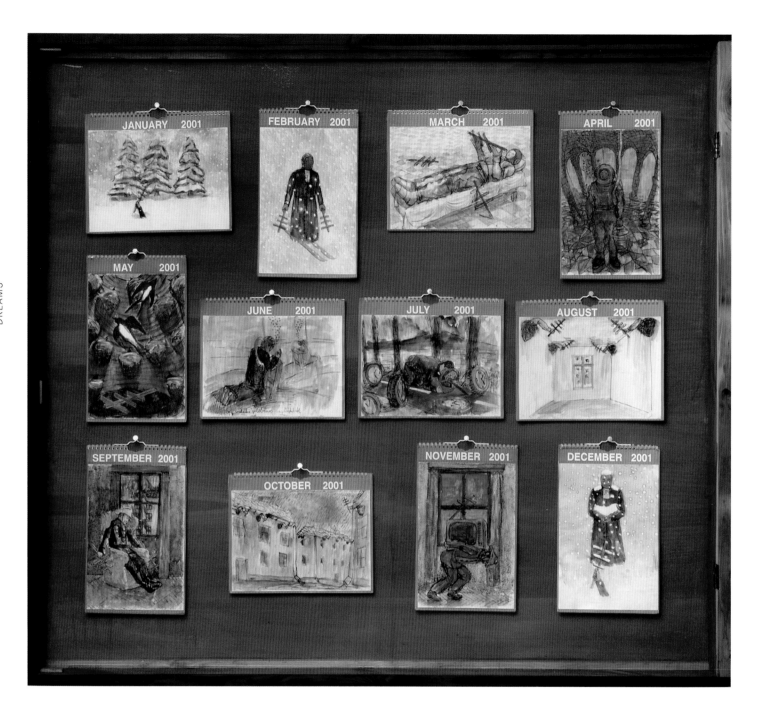

Balazs Kicsiny
Calendar, 2001
calendar pages, watercolour,
wood, glass
120 x 140 cm

Hungarian artist Balazs Kicsiny produces his works through performance, installation, sculpture, and drawing. His protagonists are conventional heroes, priests, sailors, and divers, identified by their dress to the extent that at times empty costumes take the place of the figure. They feature in scenarios stripped of a story, emerging from a narrative which is lost. The fragmentary nature of these works, the archetypal figures that feature in them, and the sense of time marked off and passing, night by night, all serve to invoke a dream-like quality.

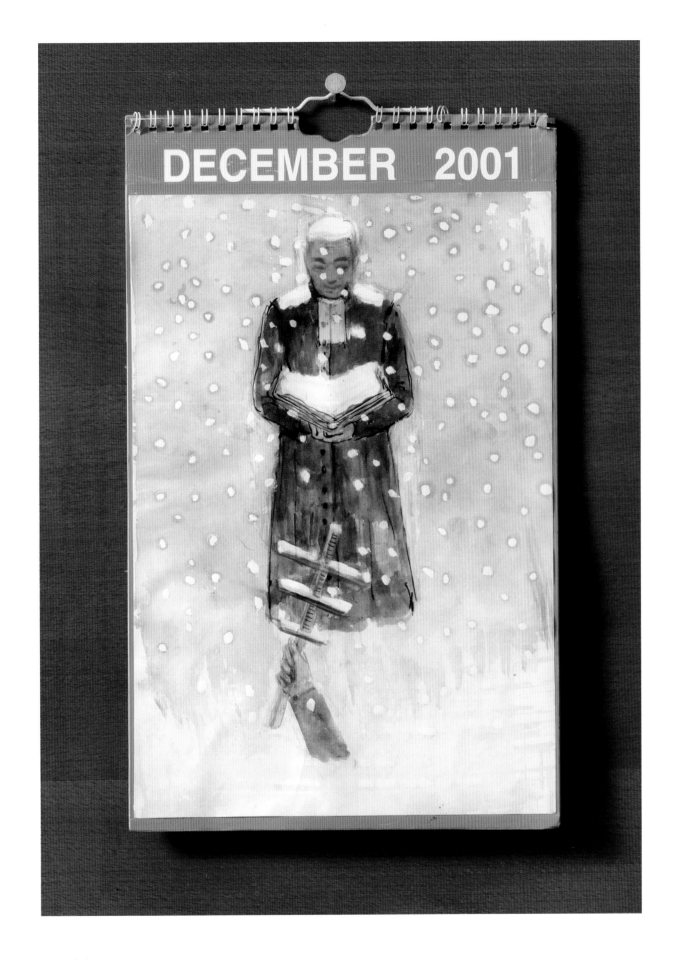

Balazs Kicsiny
Calendar, detail

Daniele da Volterra
Woman at the Foot of the Cross, c. 1538
red chalk
36 x 33 cm

Francisco de Goya
Mala Mujer (Wicked woman), 1801-1803
lead pencil, brush and Indian ink wash

Francisco de Goya
Giant, 1810-1818
mezzotint
28 x 21 cm

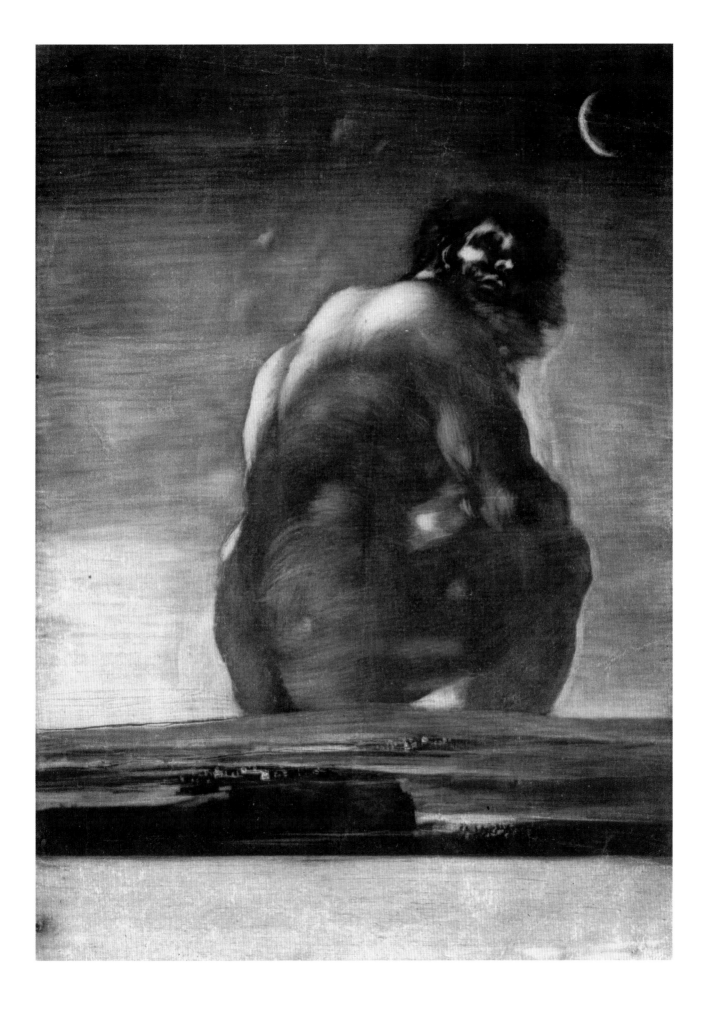

August Natterer (Neter)
Witch (trial sketch), before 1919
pencil on writing paper
20 x 16.5 cm

This is an exploration. Through words, signs, drawing.
Mescaline is the thing explored.... As for the drawings,
I began immediately after the third experiment, they
were done with a vibratory movement that stays in you
for days and days—automatic, blind, you might say, but
thus precisely reproducing the visions I had undergone,
going through them once again.

Raymond Pettibon
Untitled (self portrait on LSD), 1990
pen and ink on paper
28 x 22 cm

Adam Dant
500 Images et Paroles (B.I.S.I), 2003
ink and watercolour on paper
36 x 28 cm

Adam Dant
Encyclopaedia Subliminalia, 2003
ink and watercolour on paper
28 x 23 cm

14. The Notion of Subliminal Research:
The notional significance of the museum's collection of 'subliminal images' is widely researched. This research covers the history and practices of certain artists, the personages of the individuals who located the 'subliminal images' and the status of the images as a part of the museum's collection.

Adam Dant
The Notion of Subliminal Research, 2003
ink on paper
63.5 x 21 cm

Adam Dant
studies for *Natural Disaster*, 2003
ink on paper
36 x 28 cm

229

230

Lucia Nogueira
Untitled, 1997
graphite, watercolour, ink on paper
28 x 38 cm

Lucia Nogueira
Untitled, 1998
graphite and watercolour on paper
28 x 38 cm

Lucia Nogueira
Untitled, 1990
graphite and ink on paper
38 x 28 cm

Routine is ritual.

Lucia Nogueira

Antony Gormley
Untitled, 1985
oil and charcoal
137 x 101 cm

In this work, the artist has traced around himself and filled in the modified outline, creating a slightly larger-than-life, monstrous form. Emerging from a dark recess of the mind, this figure recalls the transformations and permutations of the self which the dreaming mind conjures.

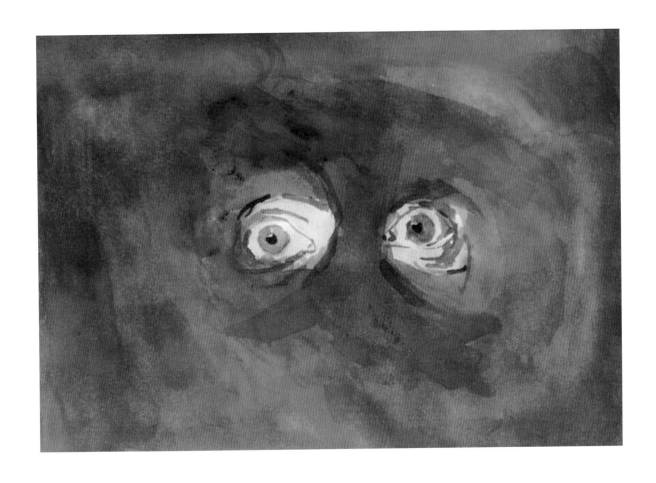

Anne-Marie Creamer
Locked, 2002
ink on paper
18 x 24 cm

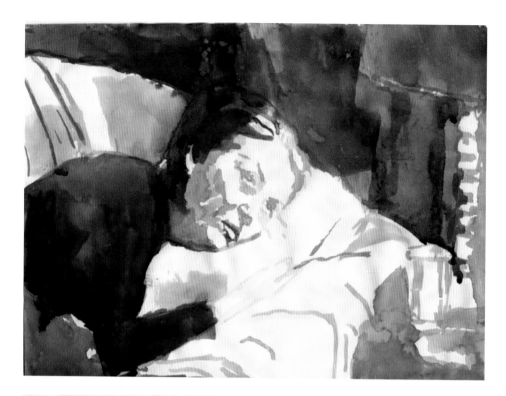

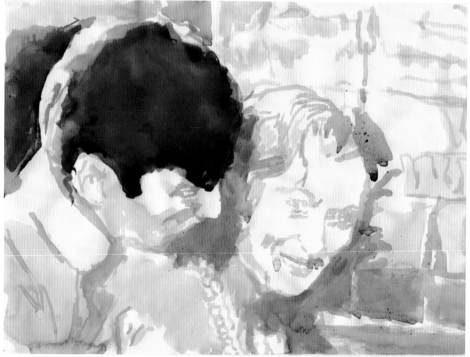

Anne-Marie Creamer
stills from *Amnesia*, 2001
video animation

Anne-Marie Creamer
stills from *Amnesia*, 2001
video animation

Heather Deedman
Doyley I, 2004
ink on paper
84 x 114 cm

Heather Deedman
18th Century Porcelain I, 2002
coloured ink on paper
84 x 114 cm

Heather Deedman's work engages with the decorative arts, evoking the delicacy
of lace and porcelain. These drawings of lace doilies seem to capture the reverie
of the maker, becoming a net into which thoughts are woven. There is also something
cell-like about these forms, grown through a process of accumulation.

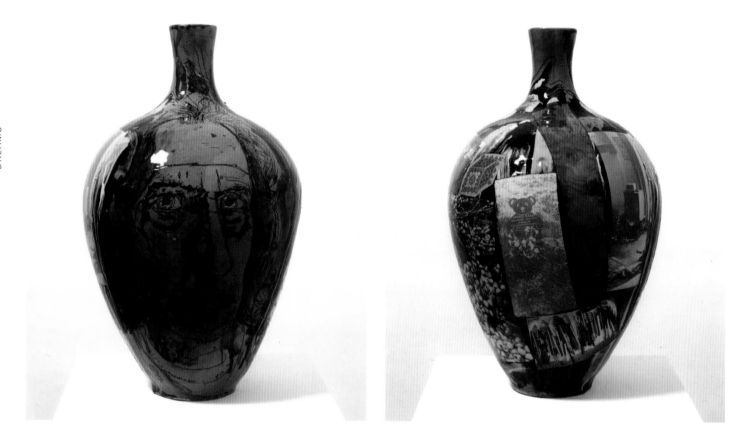

Grayson Perry
Self Portrait with Eyes Poked Out, 2004
glazed ceramic
55 x 34 cm

Grayson Perry
Self Portrait with Eyes Poked Out, 2004
glazed ceramic
55 x 34 cm

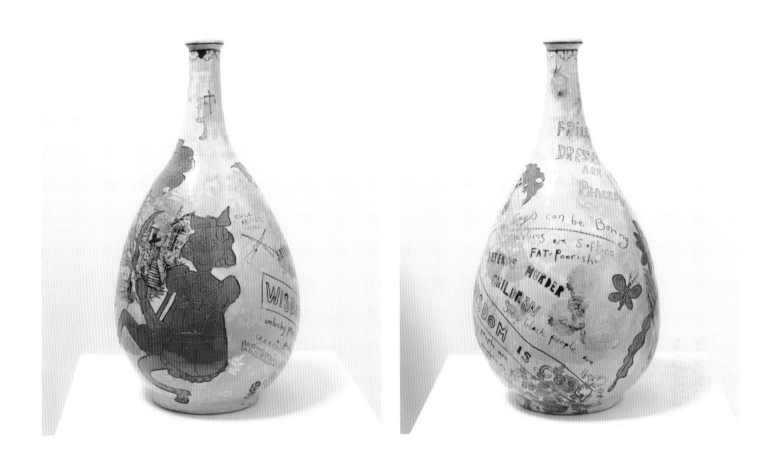

Grayson Perry
Wisdom is Cool, 2004
glazed ceramic
47 x 25 cm

Grayson Perry
Wisdom is Cool, 2004
glazed ceramic
47 x 25 cm

I make drawings to suppress the unspeakable. The unspeakable
is not a problem for me. It's even the beginning of the work.
It's the reason for the work; the motivation of the work is to
destroy the unspeakable.

Louise Bourgeois

Louise Bourgeois
Unconscious Compulsive Thoughts, 1998
pencil on paper
22 x 29 cm

Robert Overby
Living room wall, 1972
chalk on paper
188 x 73 cm

Overby made artworks from the residual traces left on surfaces; here, he has made a
chalk rubbing of a living room wall. Tracing the imperfections of the surface in
an elusive and subtle work, he engages with the skin of the house.

Neal Tait
O Zero verso, 2002
gouache on paper
39.5 x 29.5 cm

Neal Tait
Girl with Fishtails, detail, 2002
gouache on paper
29.5 x 21 cm

Neal Tait presents isolated incidents of narrative in which, as in a dream, unexplained foreign elements intrude. In them there is a sense of significance or meaning, but just beyond reach. The child-like simplicity of these drawings reinforces the impression that they have emerged from a subconscious source.

I knew a man who was prone to verbal outbursts. Our paths crossed on numerous occasions and he always offered me an insight into life, sex and death as he interpreted it. He was well aware of the way his mind dealt with information—all input would be processed at once, congealing it into a disjointed amalgamation of fact and fiction. My approach to drawing is not too dissimilar.

Rachel Goodyear

Rachel Goodyear
Man Eating Squirrel, 2004
biro on paper bag
15 x 15 cm

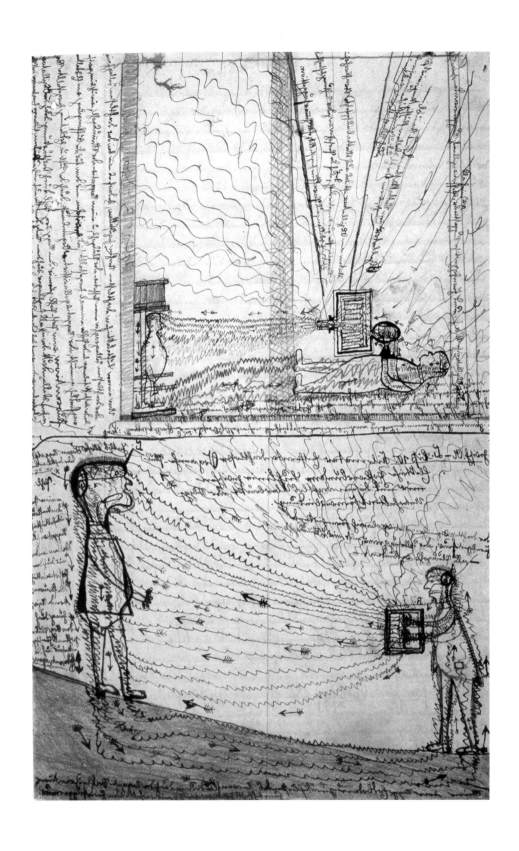

Jakob Mohr
Proofs, c. 1910
pencil, pen, on office paper
33 x 21 cm

246 Bethan Huws
Untitled, 1990-1991
watercolour
21 x 30 cm

Alison Wilding
Wolf Series I (226)

In this work from a series of wolf drawings, the necks of the creatures are suggested
in a landscape which is almost soundscape, recalling the forms of an oscilloscope.
The forms of the piece disappear off the edge of the page, eluding definition.

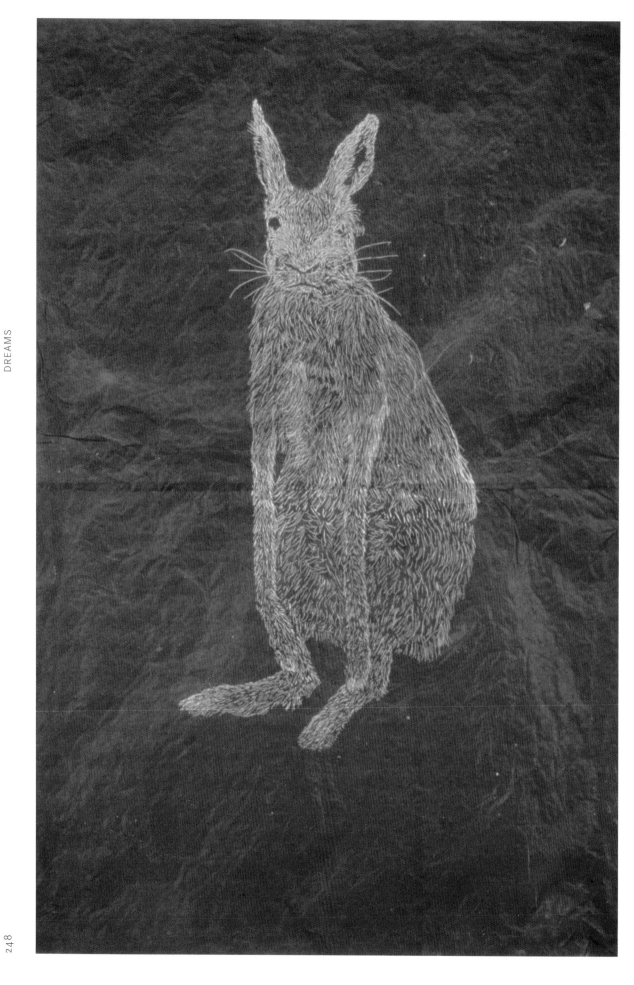

Kiki Smith
Bunny, 1997
ink on paper
90 x 60 cm

Kiki Smith
Double Animals, 1998
ink on paper with collage
and methyl cellulose
50 x 77 cm

Kiki Smith's work incorporates fairytale and folk material into a highly developed
visual language, charged with symbolism. Her creatures make reference to
a host of archetypal forms—wolves, crows, rabbits—worked into an intensely
personal mythology.

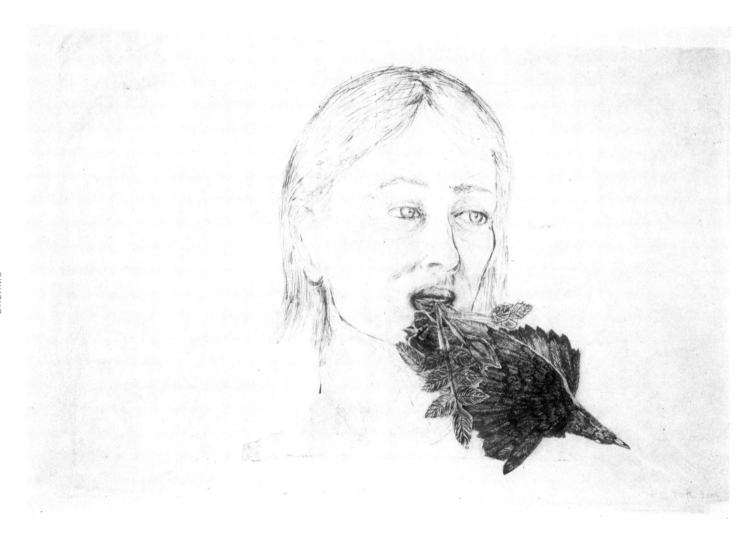

Drawing is something where you have a really direct,
immediate relationship with the material, with the paper and
pencil in front of you. So you make a mark, and then you make
another mark in relation to that mark, whereas with a lot of my
sculpture, I have a concept, and then it's labor. With drawing,
you're in the present. In drawing you take physical energy out
of your body and put it directly onto a page.

Kiki Smith

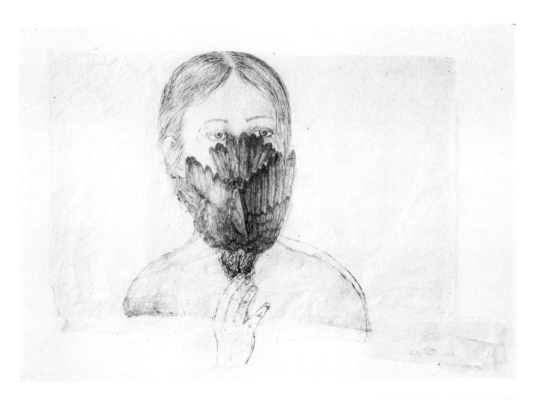

Kiki Smith
Untitled (Woman with Bird), 2003
ink on paper
51 x 76 cm

Kiki Smith
Untitled (Woman with Bird), 2003
ink on paper
51 x 76 cm

Kiki Smith
Untitled (Woman with Bird), 2003
ink on paper
51 x 76 cm

THE BODY

One of the ironies of art history is that the man who may have had the greatest influence on it wasn't an artist but an architect; a first century BC designer of amphitheatres, none of which now stand.

You could, without too much trouble, argue the presence of Vitruvius in every drawing in this book. It was he who codified bodily perfection and made that perfect body the measure of all things: of architecture first—the proportions of Roman buildings, the layout of city blocks—and then, by extension, of an entire solipsistic universe whose cosmology was rooted in the human form. Leonardo's famous *Vitruvian Man*, c. 1490, merely sums up, graphically, what Vitruvius had said all along: that the palm of a man's hand was four fingers wide; that the length of his outstretched arms equalled his height; that these proportions were divinely inspired and that all geometry derives from them.

You see this in Dürer's *Adam and Eve*, 1504, the whole of the human story compressed into a pair of Vitruvian figures. The father and mother of Man are based on the *Apollo Belvedere*, the Roman copy of a Greek sculpture excavated near Rome in the late 1400s. The *Apollo* was central to the Renaissance rediscovery of Classical values in art. Its antiquity would, in Dürer's view, have taken us back to that time nearer The Fall when everything (bodies included) was less debased, closer to God's creation. In this way, *Adam and Eve* stand for two overlapping histories: a moment in the life of Man when all was perfect; and the moment in men's lives when they are at their physical prime. And that equation of bodily perfection with morality is both interesting and iniquitous, because it suggests a link between bodily imperfection and immorality: makes cellulite or sagging muscles the wages not just of age but of sin; ugliness a crime.

Is it going too far to say that all subsequent treatments of the human body (and, by extension, of all systems deriving from that body) either affirm or deny this assumption, implicitly at least? Fashions in perfection may change—Michelangelo's *teste-divine* heads of the 1520s may not strike a twenty-first century audience as all that divine—but the impulse to seek it out does not. Even the celebration of imperfection suggests perfection of a kind. Rodin's doubly graphic fragment, *Nude Woman Face Down With Bent Legs*, isn't trying to undo Dürer, merely to shift his goalposts. Likewise, Matisse's delightful portrait of the heavy-browed Yvonne Landsberg, 1914, is precisely that: filled with delight.

In both drawings, it is the intimacy of the mark-making that gives the image its power. Rodin's lines don't just represent carnality: they are themselves carnal, invasive, sexy. By contrast, Matisse's caressing, curvaceous mark tries to reconcile the apparently conflicting halves of the French term, *jolie-laide*—pretty-ugly—to the artist's satisfaction. Landsberg, a shy teenager, is said to have reminded Matisse of the magnolia he was sketching when she arrived at his studio. The sweep of his pencil is both tender and bemused: parental, and yet interested in its own capacity to find loveliness in a girl so patently gauche and mono-browed. It doesn't set out to challenge ideas of beauty so much as to renegotiate them.

It is only in the past century or so that the understanding of art as a transaction, an exchange between suppliers and consumers, has led to the search for beauty being seen as politically charged. Who, we now ask, is looking at whom, and by what right do they do so? The body in particular has become an aesthetic battleground, its representation charged with the ethics of power: sexual, moral, political. Hans Bellmer's erotic dolls are a case in point.

Bellmer's drawing from the 1930s looks like the doodling of a dirty old man, an indecorous eliding of cause with effect. Actually, his Neo-expressionist lewdness is arguably as political as it is erotic, intended to challenge the Nazi cult of the body beautiful. Caught up in a world where muscular maleness and child-bearing femininity were state-ordained virtues, Bellmer hits back at Fascist aesthetics by inventing a body that was both male and female, intentionally degenerate.

Subversive politics are also at the heart of Paul McCarthy's *Keep 'em Chilled*, 1997, a work that bears unexpected similarities to Dürer's *Adam and Eve*. Where Dürer's was a before-and-after story, though, McCarthy's is set firmly post-Eden. The apple-heads are moral windfalls, genetically modified reminders of man's fall from grace. The vast, comic-book genitals of McCarthy's apple-folk—vaginas that gape like the mouths of caves, penises that drag along the ground—also hint at what it was in Man's nature that brought his Fall about. And yet *Delicious* and the rest are oddly lovable and rather funny; absurd in the fullest sense of the word, and all the more moving for it.

It's no coincidence that the body has been one of the most vivid subjects for drawing, the movement of a hand across paper being, before anything else, a bodily function. Uninterrupted by the space between a painter's hand and his canvas, a sculptor's and his stone, the line made by the drawing hand stands in for other haptic things: caressing, the judging of texture and volume, sexual gratification. The body is where drawing begins, and where it ends. **CD**

Henri Matisse
Yvonne Landsberg, 1914
pencil on tracing paper
28 x 21 cm

Looking at images does not lead us to the truth.
It leads us into temptation.

Marlene Dumas

Albrecht Dürer
Adam and Eve, 1504
engraving
25 x 19 cm

Paul McCarthy
Delicious, studies for the *Apple Heads*, 1997
pencil on vellum
60 x 45 cm

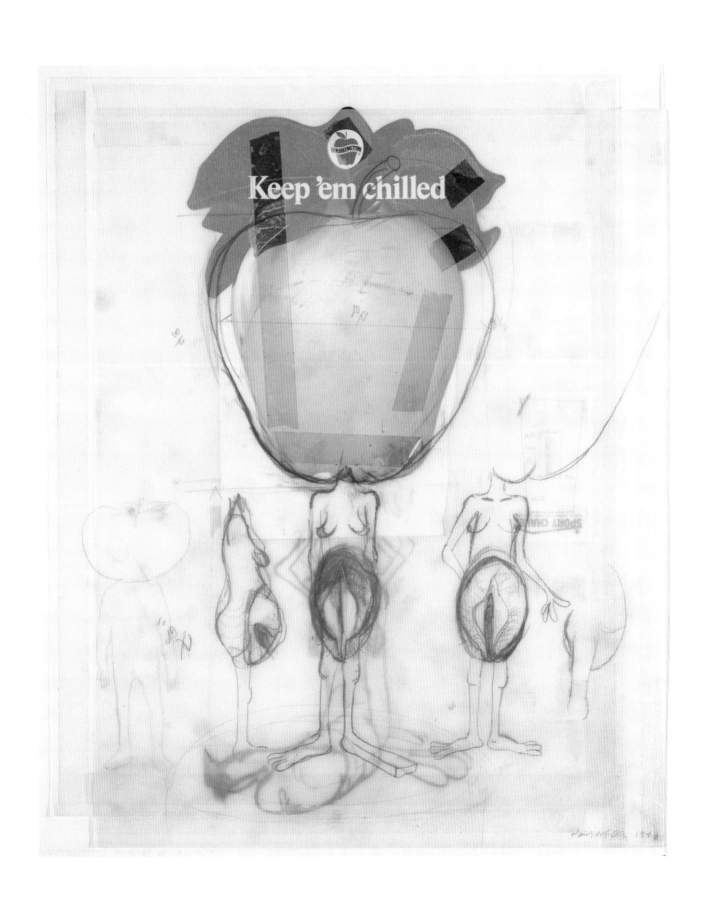

Paul McCarthy
Keep 'em Chilled, studies for the *Apple
Heads*, reverse side of *Delicious*, 1997
pencil on vellum
60 x 45 cm

Emma Hauck
Sweetheart come (letter to her husband), 1909
pencil on writing paper
20 x 16 cm

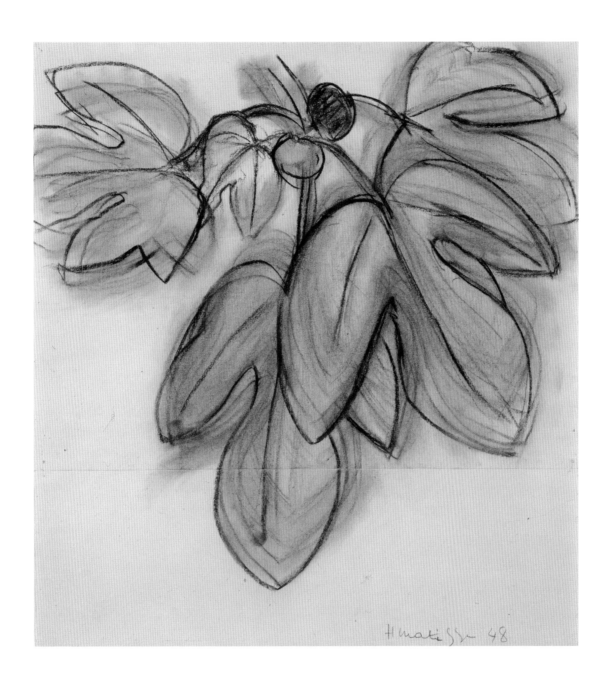

Drawing is like an expressive gesture with the advantage
of permanence.

Henri Matisse

Henri Matisse
Fig Leaves, 1948
charcoal on white paper
52 x 48 cm

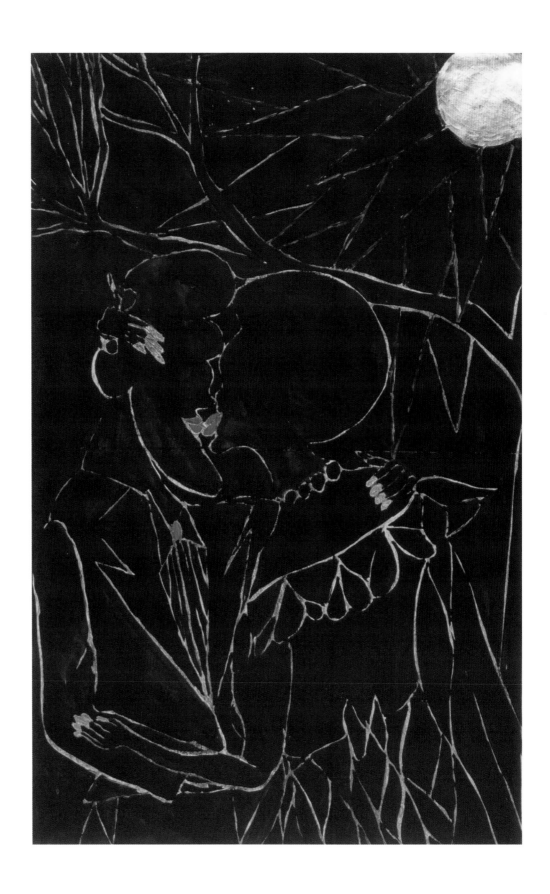

Chris Ofili
Within Reach 3, 2002
charcoal, gouache, gold leaf on paper
97 x 62.5 cm

Chris Ofili
Prince among Thieves with Flowers, 1999
pencil on paper
75.5 x 56.5 cm

Peter Peri
Death Mask, 2004
graphite on unbleached paper
53 x 47 cm

Peri works at a level of painstaking detail, using a large lens above the page to enable
him to make his hairline marks, a death mask executed with subtlety and sensitivity.

Michelangelo
Head of a Young Woman, c. 1533
black chalk
20 x 14 cm

Sometimes you would sit down with no idea at all, and at some point you'd see something in the doodling, scribbling... and from then on you could evolve the idea.... When one is young there are lots of possibilities that one hasn't tried out; drawing is a means of finding your way about things....

Henry Moore

Henry Moore
Idea for Sculpture: Pregnant Women, c. 1924
pencil, pen and Indian ink, chalk and wash
25.5 x 42 cm

Ellen Gallagher
Doe, from *Deluxe*, 2004
mixed media
33 x 25.5 cm

Ellen Gallagher works into the surface of her drawings, cutting, collaging, and obscuring with paint. These advertisements for beauty products, aimed at African American women, offer a new perspective on the feminine ideal; beauty becomes beautification, and the body is modified or imposed upon.

Ellen Gallagher
Negro A Day, 2004
photogravure, aquatint and gouache
33 x 25.5 cm

LET'S FUNGO.

NO HURRY TO GET HOME.

CROSSING THE EQUATOR THE FOUL LINES BLUR, THE RULES CHANGE. SKIPPER SAYS LATITUDE'S JUST AN ATTITUDE. AND THE GREEN LIGHT'S ALWAYS ON TO GO LONG-ITUDE, TOO.

AFTER TAKING 'BATTING PRACTICE' ON THE HOME TEAM, COACH HAS US SHAG-GING FLY BALLS AND GROUNDERS IN THE FIELD.

268

Raymond Pettibon
No Title (Let's fungo, No), diptych, 2003
pen and ink on paper
151 x 105 cm each

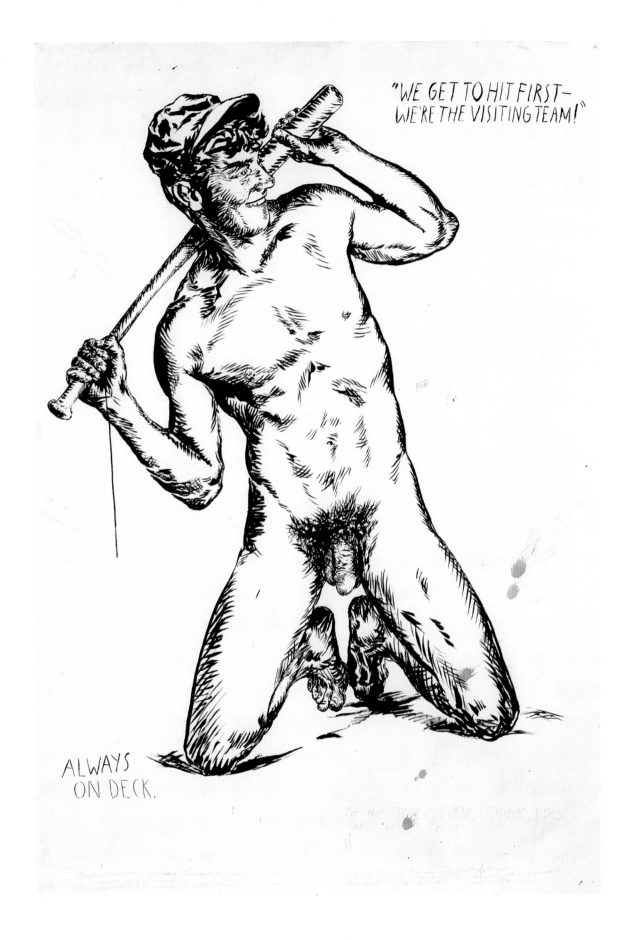

"WE GET TO HIT FIRST—
WE'RE THE VISITING TEAM!"

ALWAYS
ON DECK.

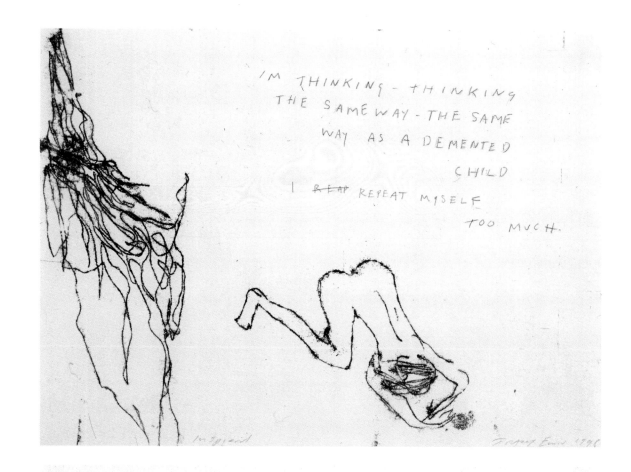

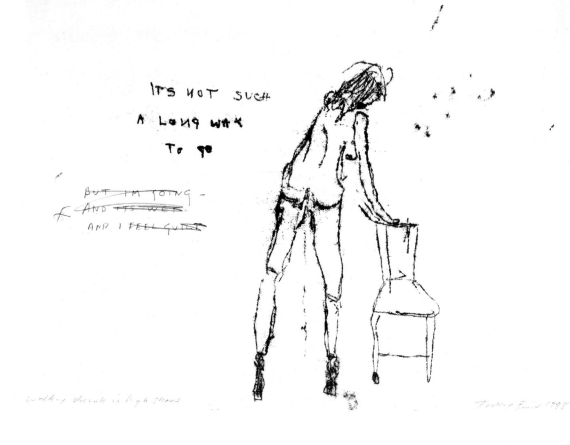

Tracey Emin
Inspired, 1998
monoprint
58 x 81 cm

Tracey Emin
Walking Drunk in High Shoes, 1998
monoprint
23 x 81 cm

Terribly wrong –

Tracey Emin 1997

Tracey Emin
Terribly Wrong, 1997
monoprint
58 x 81 cm

The body presents the paradox of contained and container
at once. Our attention is continually focused upon the
boundaries or limits of the body; known from an exterior,
the limits of the body as object; known from an interior,
the limits of its physical extension into space.

Susan Stewart, *On Longing, The Imaginary Body*

Hans Bellmer
Untitled, 1961
pencil and gouache on paper

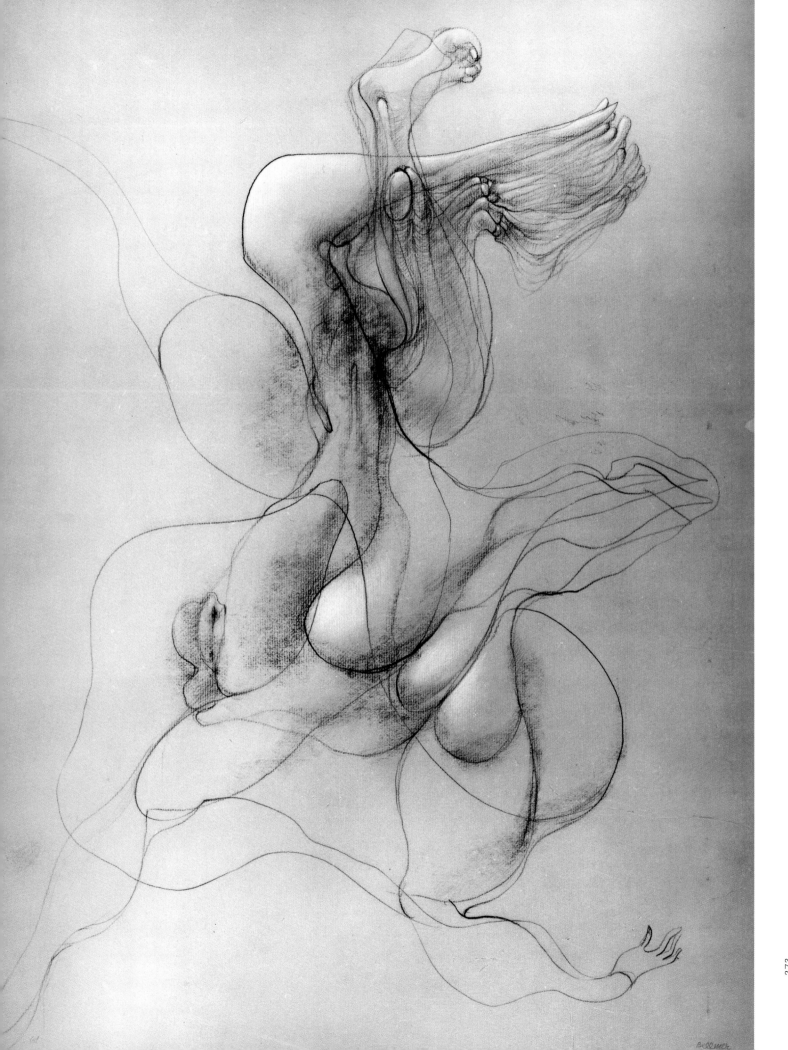

GH LIKE GIBLETS, STRETCHING THE
FACE LOOKS STRETCHED, EVEN THE E
H THEN HER HEAD FALLS FORWARDS,
N ONTO HER PEROXIDE CROWN. THE E
KE SHE'S GOT A BIG BRUISE DOWN ONE
WRINKLES UNDER HER EYES, SET IN D.
UGH TIPS OF HER ELBOWS QUIVERING, F
STRETCHING ON HER CHEST, DARK RED
NCIENT HOLE IN MIDDLE, GOING TO INSI.
E, JUST DARK IN THE SLASH, VERY DARK PIN
, CALVES, FLECKED WITH PORES, NO HAIRS,
ATCHING, QUIET HOPING THAT THEY'LL FORG
FUR CATCHING THE LIGHT, FINGERS BONY, DA
EKS STRETCHEDTOO, AND HER EYES TO SLITS
NG MOVES EXCEPT HER CHEST IN AND OUT.
KING FORWARD AND BACK FORWARD AND E
SEE SOMETHING, BUT SHE CANT, STRAINING FO
THE LIGHT MAKING IT WHITE OR SILVER, ALMOST
N THE INSIDE, STREAKED WITH SWEAT. THE BLUE
SSING AROUND, THE HER HANDS AND FINGERS DIS
ING DOWN, HER FACE SUCKS IN, SHE DOESNT LC
ULGING TITS LIFTING, AND FALLING, KIND OF UNEV
POURING WET FACE, VIOLET, ROUND BUTTOCKS
MARKS ON THE ARCHES OF HER FEET, BLUE VEIN

In the nude drawings I am describing a person, undressing on the page. These works address my limits, the problem of the magnificence of reality and how to put an image on a page. I am within a well-established pictorial convention but employing a vocabulary of words that I find more giving. There is no fixed viewpoint, I can move around the model, and the model can move.

Fiona Banner, in conversation with Tania Kovats, May 2005

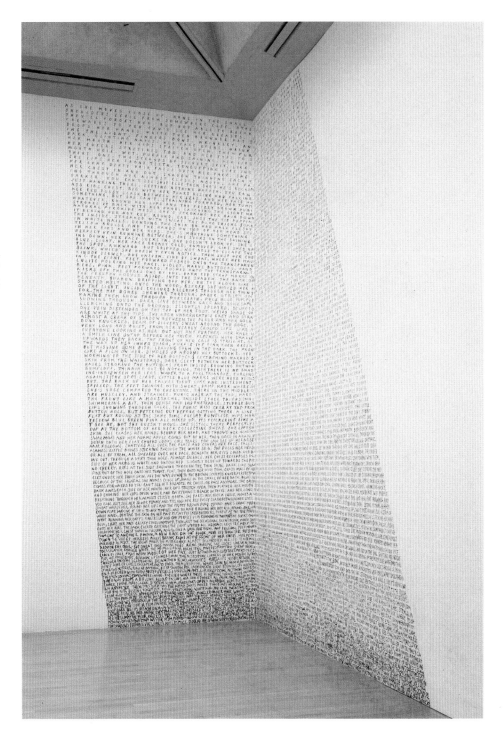

Fiona Banner
Nude, detail, 2002
Indian ink on wall

Fiona Banner
Nude, 2002
Indian ink on wall at Tate Britain

I never meant to stay
I suppose that's what they all say.

It was my first time in a peepshow
So when the girl smiled at me
I said, "Only looking", and she replied,
"That's how I got started here too."

Marlene Dumas, *Sweet Nothings*

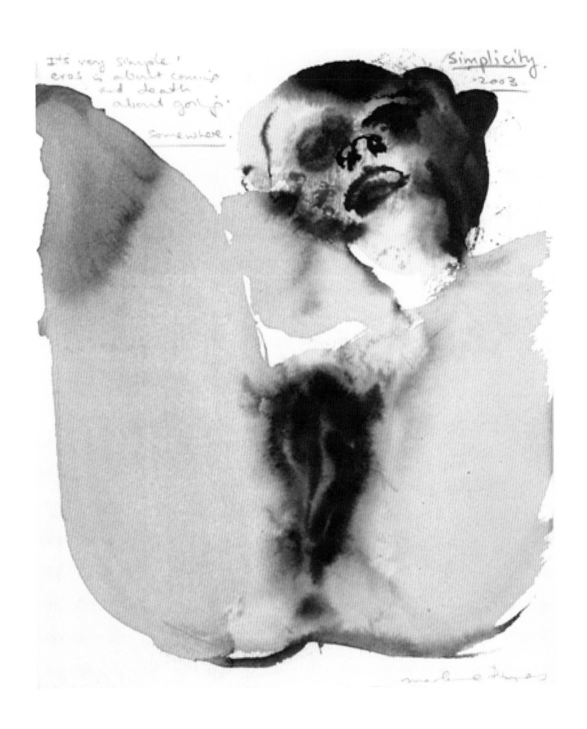

Marlene Dumas
Simplicity, 2003
ink on paper
29 x 24.5 cm

Auguste Rodin
Nude Woman Face Down with Bent Legs
pencil on paper

Auguste Rodin
Nude Woman Sitting under Water
pencil, watercolour, on cream paper
32 x 25 cm

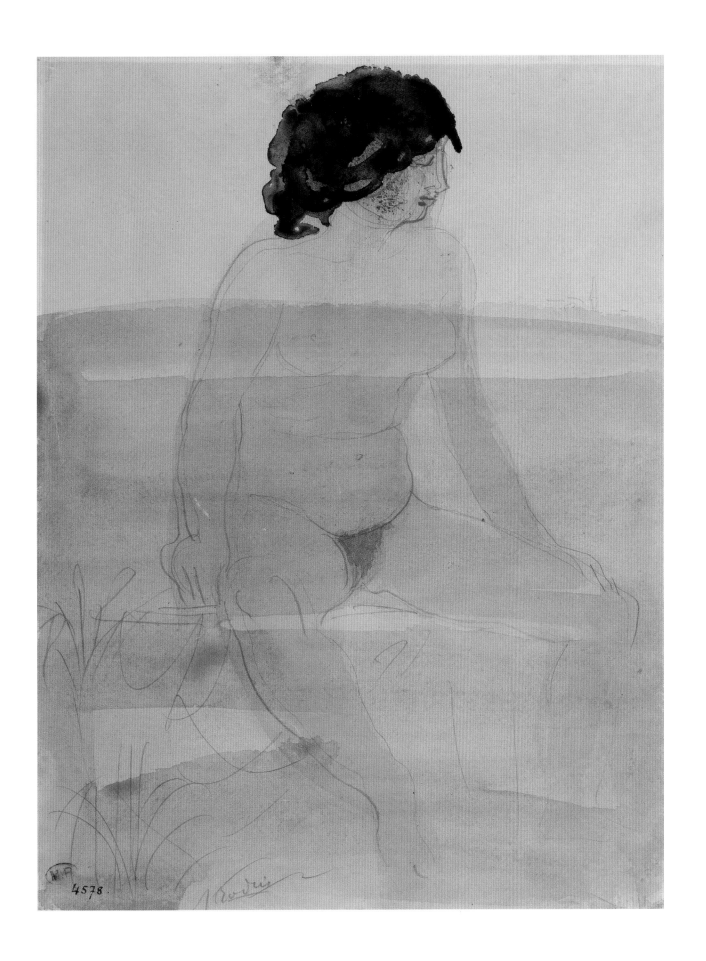

4578.

Anything you can project as expressive in terms of drawing—
ideas, metaphors, emotions, language structures—results from
the act of doing.... Drawing is a verb.

Richard Serra, *Richard Serra: Writings and Interviews*

Lucia Nogueira
Untitled, 1997
graphite, ink and watercolour on paper
38 x 28 cm

Lucia Nogueira
Untitled, 1991
gouache, ink and watercolour on paper
28 x 38.5 cm

These works by Brazilian artist Lucia Nogueira reference the body in their process, as much as their subject; there is a fluidity and viscerality to her line, the marks seeming to bleed out from, or hang like teeth upon the page.

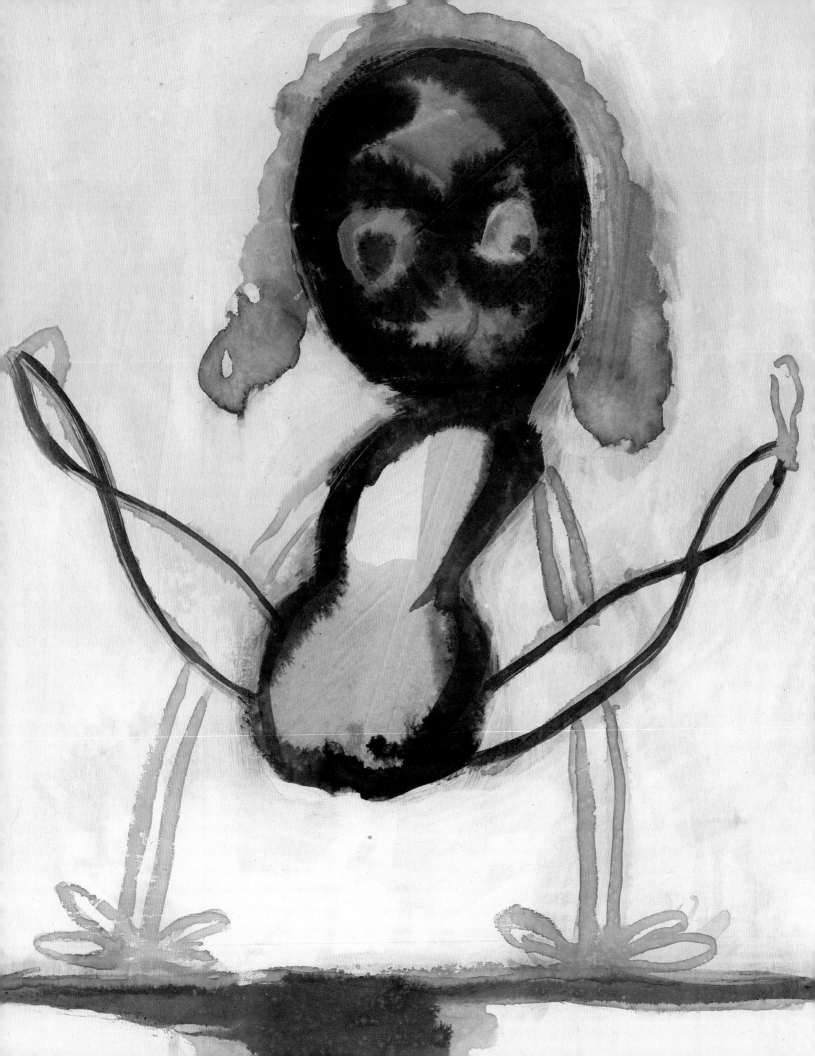

Ansel Krut
Bunny Hops, 2004
ink and acrylic on acrylic gesso prepared paper
34 x 25 cm

Ansel Krut
Insides Out, 2004
ink and acrylic on acrylic gesso prepared paper
33 x 25 cm

Barbara Hepworth 4/48

... from the moment when I entered the operating theatre I became completely absorbed by two things: first the extraordinary beauty of purpose and co-ordination between human beings all dedicated to the saving of life, the way that unity of idea and purpose dictated a perfection of concentration, movement, and gesture; and secondly by the way this special grace (grace of mind and body) induced a spontaneous space composition, an articulated and animated kind of abstract sculpture very close to what I have been seeking in my own work.

Barbara Hepworth, *Drawings from a Sculptor's Landscape*

Barbara Hepworth
Fenestration of the Ear—The Lamp, 1948
oil and pencil on board
35.5 x 46 cm

Eva Hesse
Untitled, 1965
ink on paper
45 x 61 cm

The clinical line of Hesse's drawings here convey a sense of something being dissected or diagrammed; the way in which the page is filled and cannot contain the abstract forms suggests that we are almost too close to discern what it is that is subject to analysis.

Nowhere does nature present our eyes with the lines and
the relationships between lines which are the raw material
of drawing.

Philip Rawson, *Drawing*

Eva Hesse
Untitled, 1965
ink on paper
32.5 x 50 cm

Melissa McGill
The Shadow of Ecstasy, detail, 2003
rubber wall drawing
dimensions variable

Black rubber paint has been applied directly to the wall of the gallery picking out the shadows in the folds of Bernini's *Ecstasy of Saint Teresa*.

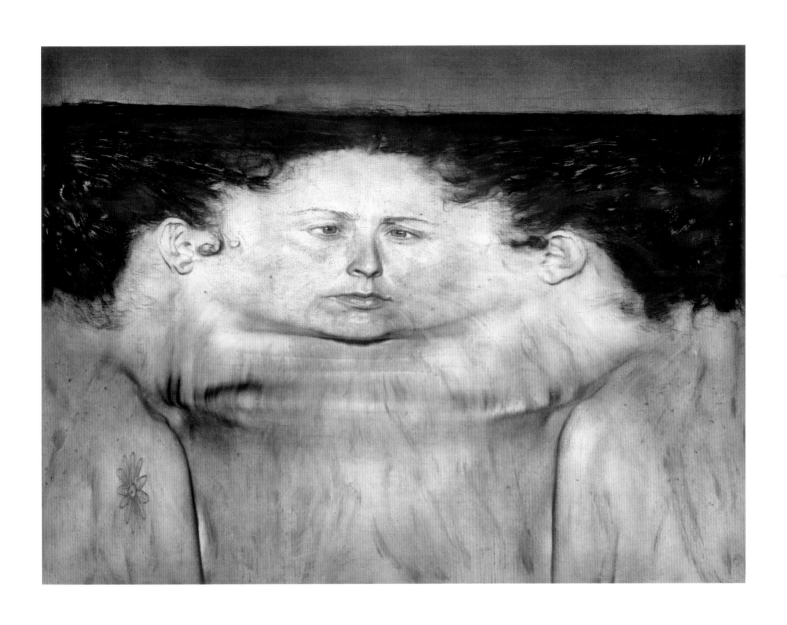

Kiki Smith
My Blue Lake, 1995
photogravure, à la poupée inking, and lithograph on mould-made En Tout Cas paper
plate: 85 x 117 cm, sheet: 111 x 139 cm

Marlene Dumas
After Painting, 2003
ink, acrylic and watercolour
23 x 62.5 cm

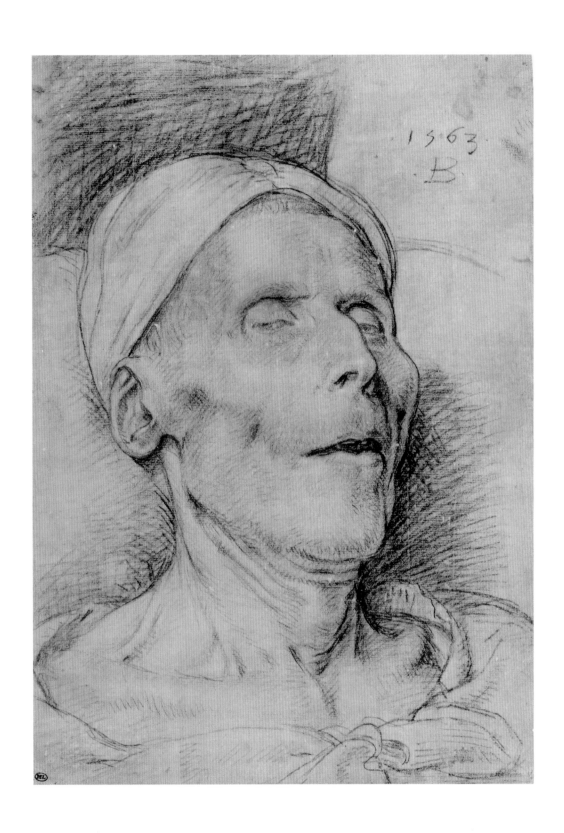

Bernard de Ryckere
Head of a Dying Man, 1563
black, red and white chalks

Henry Wood (active in Bristol 1801-1830)
eight designs for funerary monuments including one commemorating
Margaret Colston (died 2 December 1812)

Sacred to the Memory of
MARGARET COLSTON,
Daughter of CRISP MOLINEUX ESQ.ᵉ M.P.
and Wife of WILLIAM HUNGERFORD COLSTON, D.D.
Rector of this Parish.
Who departed this life
on the second of December 1812,
Aged 49.

Keir Smith
The Virgin's House, 1994-1995
watercolour on paper
56 x 76 cm

John Nost the Elder
design for funerary monument to William Douglas (1677-1710)
brown pen, ink and grey wash
49 x 34.5 cm

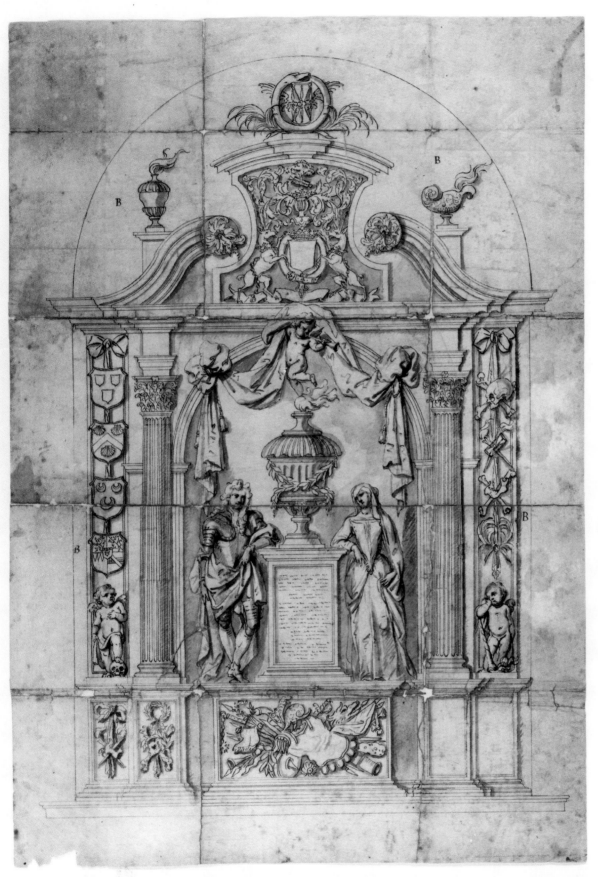

NOST, JOHN. DESIGN FOR MONUMENT TO 3RD DUKE OF HAMILTON
Ac No 49/84

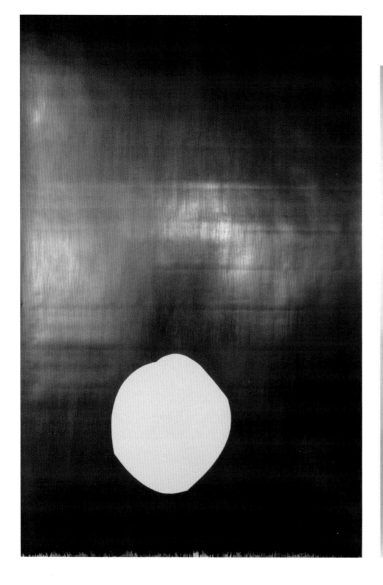

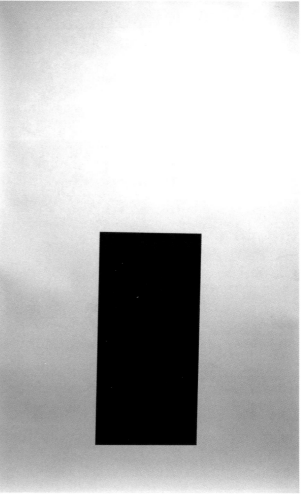

Fiona Banner
Dynamo (drop out font)
Full Stop Drawing, 1999
graphite on paper
150 x 100 cm

Fiona Banner
Avantgarde
Full Stop Drawing, 1999
graphite on paper
250 x 150 cm

Banner engages with language in her work. Here she engages with its cessation in a series of full stops. The flat sheen of her surfaces, their impenetrability, reflects the finality of the end point.

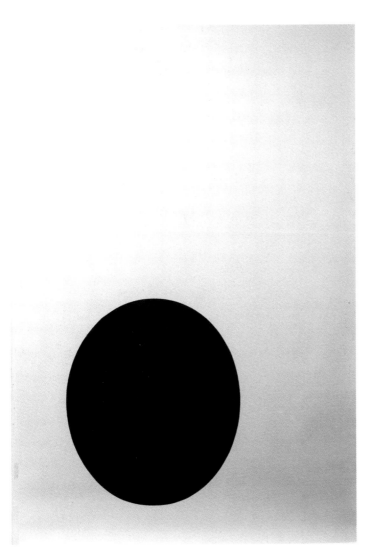

Language can also fail. This is what led me to the full stops.
They are another impasse, a loss of language. These positive
black holes represent another difficulty with trying to articulate
something, and a fall into an abstraction.

Fiona Banner, in conversation with Tania Kovats, May 2005

Fiona Banner
Nadienne
Full Stop Drawing, 1999
graphite on paper
250 x 150 cm

Fiona Banner
Stan Lee
Full Stop Drawing, 1999
graphite on paper
250 x 150 cm

some of the Ancients thought the World would
have an end, which is a kind of dying upon its
Nativity.

Raymond Pettibon
No Title (Some of the), 1999
pen and ink on paper
70 x 50 cm

Russell Crotty
Extinction, large version, 2003
ink and watercolour on paper on acrylic sphere
114 cm diameter

A wish upon the night of the falling light of day.
Love come out to play!

Out of a universe of signs, I'm Gemini; I, me, mine.
What's your sign?

Raymond Pettibon
No Title (A wish upon), 1991
pen and ink on paper
34 x 27 cm

... I would have liked to draw the moments that little by little make up life, to let people see the phrase within, the phrase without words, a rope indefinitely unrolling, winding, accompanying in its intimacy all that comes in from the outside, and the inside, too. I wanted to draw the consciousness of existing and the flow of time. As you might take your pulse.

Henri Michaux, *Drawing the Flow of Time*

ACKNOWLEDGEMENTS

I have been overwhelmed by the generosity and support I have had for this project. It would be impossible to thank all the artists, archivists, estates, and individuals at various galleries who have helped gather material ready for this publication but I know the book couldn't have taken form without the help I received, thanks again.

Several artists gave me their time to discuss the project in moredepth and I would like to thank Rachel Whiteread, Fiona Banner, Paul Noble, Anne-Marie Creamer, David Batchelor, Adam Dant, Ansel Krut, Louise Hopkins and Michael Landy for their insights.

Thank you also to BDP for inviting me to make this book. I have been supported by three very hard working and patient individuals, Sharon, Meena, and Chris. Thanks also for helping with the trees to Beryl Hartley.

I would like to express respect and gratitude to Deanna Petherbridge and Avis Newman for providing the inspiration that sustained my attention to drawing. Many thanks also to Tim Llewellyn and the Henry Moore Institute who have funded this thinking time, and UWE for housing me during it.

Thank you also to Alex and Frank, who have been very patient during the time the book has swallowed me up.

The Drawing Book is dedicated to my father, a former engineer, whose heart made drawings.

I looked at the screen and I could see my rotten old heart beating,
and it made a drawing like when the earth moves.
Sàndor Kovàts, 2005

Tania Kovats

SELECTED BIBLIOGRAPHY

Artaud, Antonin, *Works on Paper*, Margaret Rowell ed., New York: The Museum of Modern Art, 1996.

Bachelard, Gustave, *The Poetics of Space*, Boston: Beacon Press, 1969.

Bambach, Carmen, *Drawing and Painting in the Italian Renaissance Workshop: Theory and Practice 1300-1600*, Cambridge and New York: Cambridge University Press, 1999.

Barry Le Va, Accumulated Vision, Philadelphia: Institute of Contemporary Art, University of Pennsylvania, 2005.

Benjamin, Walter, *Reflections: Essays, Aphorisms, Autobiographical Writings*, New York: Harcourt Brace, 1979.

Benson, WAS, *Drawing: its History and Uses*, Oxford: Oxford University Press, 1925.

Bethan Huws, Watercolours, Bonn: VG BILD KUNST, 1998.

Beyond Reason: Art and Psychosis: Works from the Prinzhorn Collection, London: The Hayward Gallery, 1996.

Blaser, Werner, *Mies van der Rohe*, Basel; Boston; Berlin: Birkhauser, 1997.

Bourgeois, Louise with Robert Rinder, *Drawings & Observations*, Boston; New York: Bullfinch Press, Little, Brown and Company, 1996.

Bradford, William and Helen Braham eds, *Mantegna to Cezanne, Master Drawings from the Courtauld (A Fiftieth Anniversary Exhibition)*, London: British Museum Publications Limited, 1983.

Brinckerhoff, John, *A Sense of Place, A Sense of Time*, New Haven: Yale University Press, 1994.

Butler, Cornelia H, *Afterimage: Drawing Through Process*, Boston: The MIT Press, 1999.

Calvino, Italo, *Cosmicomics*, New York: Harcourt Brace, 1968.

Carroll, Lewis, *Alice's Adventures in Wonderland*, New York: Macmillan and Co., 1898.

Carroll, Lewis, *Through the Looking Glass*, New York: Macmillan and Co., 1897.

Carter, Peter ed., *Mies van der Rohe*, London: Phaidon, 1999.

Chapman, Jake and Dinos, *Unholy Libel*, New York: Gagosian Gallery, 1997.

Chapman, Jake and Dinos, *Hell*, London: Jonathan Cape in association with the Saatchi Gallery, 2003.

Chris Ofili, Within Reach, London: Victoria Miro Gallery, 2003.

Cianchi, Marco, *Leonardo's Machines*, Florence: Becocci Editore, 1988.

Colomina, Beatrice ed., *Sexuality and Space*, New Jersey: Princeton Papers on Architecture, 1992.

Craig-Martin, Michael, *Drawing the Line, Reappraising drawing past and present*, London: The South Bank Centre, 1995.

Dexter, Emma ed., *Vitamin D*, London: Phaidon, 2005.

Diana Cooper, Hew Locke, London: The Drawing Room, 2004.

Doyle, Mary, Kate Macfarlane, Katharine Stout and Grant Wilson, *Drawing on Space*, London: The Drawing Room, 2002.

Drawings, New York: Gagosian Gallery, 2004.

Dumas, Marlene, *Sweet Nothings: Notes and Texts*, Amsterdam: Galerie Paul Andriesse, 1998.

Dürer, Albrecht, *Albrecht Dürer, The Drawings*, Stanley Appelbaum trans., New York: Dover Publications, 1970.

Eisler, Georg, *From Naked to Nude, Life Drawing in the Twentieth Century*, London: Thames and Hudson, 1977.

Elderfield, John ed., *The Drawings of Henri Matisse*, London: Thames and Hudson, 1984.

Elliot, James, *The City in Maps: Urban Mapping to 1900*, London: The British Library, 1987.

Ellis, David A, *Drawing For Bricklayers and Plan Drawing*, London: Cassell, Petter and Galphin and Co., c.1860.

Eva Hesse, Gouaches 1960-1961, Paris: Renos Xippas and New York: Robert Miller, 1960.

Fiona Banner, The Nam, London: Frith Street Gallery, 1997.

Fiona Banner, Michael Archer, Patricia Ellis, Dundee: Dundee Contemporary Arts, July 2002.

Ford, Simon, *The Situationist International*, London: Black Dog Publishing Limited, 2005.

Foucault, Michel, *This is Not A Pipe*, Berkeley, CA: University of California, 1983.

Friedman, Terry, *Four Centuries of Sculptor's Drawings from the Collection of Leeds City Art Galleries*, Leeds: Henry Moore Foundation, 1993.

From Figure to Object, A Century of Sculptors' Drawings, London: Frith Street Gallery and Karsten Schubert Gallery, 1996.

Godfrey, Tony, *Drawing Today: Draughtsmen in the Eighties*, London: Phaidon, 1990.

Grayson Perry, London: Victoria Miro Gallery, 2004.

Haak, Bob, *Rembrandt Drawings*, London: Thames and Hudson, 1976.

Harmon, Katharine, *You are here, Personal Geographies and Other Maps of the Imagination*, New York: Princeton Architectural Press, 2004.

Hartley, Alex, *LA Climbs: Alternative Uses for Architecture*, London: Black Dog Publishing Limited, 2003.

Hepworth, Barbara, *Drawings From a Sculptor's Landscape*, New York: Praeger, 1967.

Hoptman, Laura, *Drawing Now: Eight Propositions*, New York: The Museum of Modern Art, 2002.

Ian Charlesworth, from dark passages, Belfast: Golden Thread Gallery, 2005.

Kandinsky, Wassily, *On the Spiritual in Art*, MTH Sadler trans., New York: Dover Publications, 1997.

Kantor, Jordan, *Drawing from the Modern 1975-2005*, New York: Museum of Modern Art, 2005.

Kathy Prendergast, The End and The Beginning, London: Merrell Publishers n association with the Irish Museum of Modern Art, 1999.

Kiki Smith, London; Trustees of the Whitechapel Art Gallery, 1995.

Kingston, Angela ed., *What is Drawing? Three practices explored: Lucy Gunning, Claude Heath, Rae Smith*, London: Black Dog Publishing Limited, 2003.

Klee, Paul, *Pedagogical Sketchbook*, London: Faber and Faber, 1968.

Kren, Alfred, *Drawing Distinctions: American Drawings of the Seventies*, Munich: Alfred Kren, 1981.

Le Corbusier, *Towards a New Architecture*, London: John Rodick, 1927.

Le Corbusier, *La Ville Radieuse*, Paris: Vincent, Freal and Cie, 1933.

LeWitt, Sol, "Paragraphs on Conceptual Art", *Artforum*, vol. 5, no. 10, June 1967.

Lingwood, James ed., *Vija Celmins, Obras 1964-96*, Karmelin Adams trans., Madrid: Museo Nacional Centro de Arte Reina Sofia, 1996.

Lucia Nogueira, Drawings, London: The Drawing Room, 2005.

Macfarlane, Robert, *Mountains of the Mind*, London: Granta Books, 2003.

Marlene Dumas, Suspect, Geneva and Milan: Skira, 2003.

Meschede, Friedrich ed., *Rachel Whiteread, Gouaches*, Berlin: Cantz Verlag, 1993.

Michael Landy, The Making of Scrapheap Services, London: Waddington Galleries, 1996.

Michelangelo, *Drawings by Michelangelo: In the collection of Her Majesty the Queen at Windsor Castle; The Ashmolean Museum; The British Museum; and other English collections*, London: British Museum Publications Limited, 1975.

Milner, Marion, *Eternity's Sunrise: A Way of Keeping A Diary*, London: Virago, 1987.

Moszynska, Anna, *Antony Gormley Drawing*, London: British Museum Press, 2002.

Musgrave, David, *Living Dust*, Norwich: Norwich Gallery, 2004.

Neri, Louise ed., *Looking Up, Rachel Whiteread's Water Tower*, Berlin and New York: Public Art Fund, New York and Scalo, 1999.

Paul Noble, London: Whitechapel Gallery, 2005.

Petherbridge, Deanna, *The Primacy of Drawing, An Artist's View*, London: South Bank Centre, 1991.

Philip Guston, Retrospective, London: Thames and Hudson, 2003.

Picasso, Pablo, *Je Suis Le Cahier: Sketchbooks of Picasso*, London: Thames and Hudson, 1996.

Picasso, Pablo, *Picasso's Vollard Suite*, Norbert Guterman trans., London: Thames and Hudson, 1985.

Poe, Edgar Allen, *The Complete Poems*, Richard Wilbur ed., New York: Dell, 1966.

Rawson, Philip, *Drawing* (second edition), Philadelphia: University of Pennsylvania Press, 1987.

Reid, Martine ed., *Boundaries: Writing and Drawing*, New Haven: Yale University Press, 1994.

Robert Overby, About When, guest curated by Terry R Myers, London: Haunch of Venison, 2004.

Robert Smithson, Los Angeles: The Museum of Contemporary Art, 2004.

Robin, Harry, *The Scientific Image, From Cave to Computer*, New York: Harry N Abrams, 1992.

Rose, Bernice, *Allegories of Modernism: Contemporary Drawing*, New York: Museum of Modern Art, 1992.

Rose, Bernice, *Drawing Now*, New York: The Museum of Modern Art, 1976.

Rose, Bernice, *Jackson Pollock—Drawing Into Painting*, Oxford: Museum of Modern Art, 1979.

Ruskin, John, *The Elements of Drawing*, New York: Dover Publications, 1971.

Serra, Richard, *Writings, Interviews*, Chicago: University of Chicago Press, 1994.

Shepheard, Paul, *The Cultivated Wilderness, Or What Is Landscape?*, Boston: MIT Press, 1997.

Sigmar Polke, Gemeinschaftswerk Aufschwung Ost, Berlin: Bruno Brunnet Fine Arts, 1993.

Spiller, Jurg ed., *Paul Klee: The Thinking Eye: The Notebooks of Paul Klee*, London: Lund Humphries, 1961.

Stetoff, Rebecca, *The British Library Companion to Maps and Mapmaking*, London: The British Library, 1995.

Stewart, Susan, *On Longing: Narratives of the Miniature, The Gigantic, The Souvenir, The Collection*, Durham: Duke University Press, 1993.

Strauss, Walter L, *Albrecht Dürer: The Complete Engravings, Etchings and Drypoints*, New York: Dover Publications, 1972.

Sussman, Elizabeth ed., *Eva Hesse*, New Haven: Yale University Press, 2002.

Thomson, Richard and Christopher Lloyd, *Impressionist Drawing*, Oxford and London: Phaidon and Arts Council of England, 1986.

Thrower, Norman JW, *Maps and Civilisation, Cartography in Culture and Society*, Chicago: University of Chicago Press, 1996.

Tufte, Edward R, *Envisioning Information*, Cheshire: Graphics Press, 1990.

Tufte, Edward R, *The Visual Display of Quantitative Information*, Cheshire: Graphics Press, 2001.

Tufte, Edward R, *Visual Explanations: Images and Quantitatives, Evidence and Narrative*, Cheshire: Graphics Press, 1997.

Van Den Boogerd, Dominic et al, *Marlene Dumas*, London: Phaidon, 1999.

Vasari, *On Technique*, New York: Dover Publications, 1960.

Venturi, Robert and Denise Scott Brown, *Learning From Las Vegas*, Boston: MIT Press, 1972.

da Vinci, Leonardo, *Leonardo: Drawings*, New York: Dover Publications, 1980.

da Vinci, Leonardo, *The Notebooks of Leonardo da Vinci: Selections*, Oxford: Oxford World's Classics, 1998.

Vija Celmins, Paris: Fondation Cartier pour l'Art Contemporain, 1995.

Wigley, Mark and Catherine de Zegher, *The Activist Drawing, Retracing Situationist Architectures from Constant's New Babylon to Beyond*, Boston: MIT Press, 1999.

de Zegher, Catherine, *The Stage of Drawing: Gesture and Act, Selected from the Tate Collection by Avis Newman*, London: Tate Publishing and New York: The Drawing Center, 2003.

CREDITS

cover: Michael Landy
Bristly Ox-tongue 2,
courtesy the artist and Thomas Dane
Gallery, London

p. 2: Leonardo da Vinci
Plan for Casting the Sforza Monument,
courtesy Biblioteca National, Madrid
ref no Cod. Madrid Ms. II folio 157r.

p. 19: Louise Hopkins
Untitled (the,of,the),
courtesy the artist

p. 22: Diana Cooper
Swarm, detail,
courtesy the artist

p. 27: Rachel Whiteread
Floor Study, detail,
courtesy the artist

p. 31: Lucia Nogueira
Untitled,
courtesy Anthony Reynolds Gallery,
London

p. 33: Adam Dant
Musée du Louvre (B.I.S.I),
courtesy the artist

p. 37: Louise Bourgeois
Untitled
photo: Christopher Burke
collection of the artist
courtesy Cheim and Read, New York

p.41: Ellen Gallagher
Watery Ecstatic Series,
courtesy Gagosian Gallery, New York

MEASUREMENT

p. 47: William Blake
Sir Isaac Newton,
courtesy Tate, London 2005

p. 49: William Blake
Elisha in the Chamber on the Wall,
courtesy Tate, London 2005

pp. 50-53: Eva Hesse
Untitled,
Untitled,
courtesy the Estate of Eva Hesse,
Hauser & Wirth, Zurich/London
Untitled,
courtesy The Baltimore Museum of Art
Untitled,
courtesy the Estate of Eva Hesse,
Hauser & Wirth, Zurich/London

p. 55: Sol LeWitt
Folded Drawing,
courtesy Marc Selwyn Fine Art, Los
Angeles
© ARS, NY and DACS, London 2005

p. 56: Jan Vredeman de Vries
plate from *Book of Perspective*,
courtesy British Library

p. 57: David Musgrave
Form in a Bag,
courtesy greengrassi, London

pp. 58-59: Paul McCarthy
Face Painting—Floor, White line,
Face, Head, Shoulder Painting Wall,
Black Line,
courtesy Hauser & Wirth,
Zurich/London

pp. 60-61: Antony Gormley
Immersion,
Field,
Through,
photo: Stephen White
courtesy White Cube Gallery, London

pp. 62-63: Louise Bourgeois
Untitled (C.I.A),
Untitled (C.I.A),
photo: Christopher Burke
collection of the artist
courtesy Cheim and Read, New York

pp. 64-65: Armando Andrade Tudela
Peru Abstracto,
Luz Y Mar,
Untitled,
courtesy Counter Gallery, London

p. 66: Alison Wilding
Untitled,
courtesy Karsten Schubert, London

p. 67: Peter Peri
Crystal 2,
courtesy Counter Gallery, London

p. 68: Tania Kovats
Untitled, from *Minerology* Series,
courtesy the artist

p.69: Abbe Rene Just Hauy
from *Traite de Mineralogie*,
Rome de l'Isle
The Domain of Crystals, from
Cristallographie,
Tania Kovats
Basalt, detail,
courtesy the artist

pp. 70-71: Jonathan Lasker
Untitled,
courtesy Sperone Westwater, New York
Untitled,
Untitled,
private collection
courtesy Sperone Westwater, New York

pp. 72-73: Susan Collis
No. 2 (in series),
Work on it, detail,
courtesy Mag Collection

p. 74: Sylvia Plimack Mangold
study for *Hallway*,
photo: Bill Orcutt
courtesy Alexander and Bonin,
New York

p. 75: Toba Khedoori
Untitled (Doors),
courtesy David Zwirner, New York and
Regen Projects, Los Angeles

pp. 76-77: Rachel Whiteread
Herringbone Floor Study,
courtesy Gagosian Gallery, London
Floor Study,
courtesy Luhring Augustine Gallery,
New York

pp. 78-79: Ellen Gallagher
Purgatorium,
courtesy Gagosian Gallery, London
Bubbel,
courtesy Gagosian Gallery/Albright-
Knox Art Gallery, London

p. 80: Rachel Whiteread
Untitled (Torso), detail,
courtesy Gagosian Gallery

p. 81: Jacob Epstein
*Study for the Arms and Hands
of Maternity*,
courtesy Leeds City Art Gallery, Leeds

p. 82: Jean-Auguste-Dominique Ingres
*Nude Study for the Portrait of Baronne
de Rothschild*,
courtesy Musée Bonnat, Bayonne
© Photo RMN/René-Gabriel Ojéda

p. 83: Bruce Nauman
Double size head and hand,
courtesy Sperone Westwater, New York

pp. 84-85: Claude Heath
Head Drawing,
Epstein's Hands,
courtesy CRG Gallery, New York

pp. 86-87: Louise Hopkins
Grid (476),
Untitled (0100), detail,
courtesy Andrew Mummery Gallery,
London

NATURE

p. 88: Charles Darwin
Sketch for an Evolutionary Tree,
First Notebook, p. 36,
courtesy syndics of Cambridge
University Library, Cambridge

p. 91: Galileo Galilei
Six Phases of the Moon,
ref no Gal 48, f 28r
courtesy Biblioteca Nazionale, Florence

pp. 92-95: Russell Crotty
Globe Drawings, installation view,
courtesy Miami Art Museum, Miami
*Notable Observations, Summer Milky
Way* (page two),
*Notable Observations, Summer Milky
Way* (page seven),
courtesy CRG Gallery, New York

p. 96: Alfred Wegener
diagrams from *The Origins of the
Continents*

p. 97: Leonardo da Vinci
Deluge,
courtesy The Royal Collection, Windsor
© 2005 Her Majesty Queen Elizabeth II

p. 98: R Scott
eighteenth century geological
engravings

p. 99: Seismograph
from Cal Tech Institute, editor's
own collection

pp. 100-101: John Clerk
drawings for James Hutton's *Theory of
the Earth*,
courtesy Special Collections, University
of Edinburgh Library, Edinburgh

p. 102: Tania Kovats
Crust,
courtesy the artist

pp. 103-105: Louise Bourgeois
*Dissymetrie is Tolerated if not
Encouraged*,
photo: Christopher Burke
courtesy collection Louisiana Museum
of Modern Art
Untitled,
photo: Christopher Burke
collection of the artist
courtesy Cheim and Read, New York

pp. 106-107: Sandro Botticelli
Chart of Hell,
© Biblioteca Apostolica Vaticana

p. 108: Robert Louis Stevenson
Map of Treasure Island

p. 109: Robert Smithson
Heap of Language,
The Overholland Collection
courtesy James Cohan Gallery,
New York
© estate of Robert Smithson/VAGA
New York/DACS London 2005

p. 110: Richard Long
Untitled,
courtesy Sperone Westwater, New York

p. 111: Andy Goldsworthy
Hill and Valley,
courtesy Leeds Art Gallery, Leeds

pp. 112-113: Paul Noble
The Sea III,
courtesy Interim Art, London

pp. 114-115: Tania Kovats
British isles,
British isles, detail,
courtesy the artist

p. 116: Alison Wilding
Boulder II,
photo: Steve White
courtesy Karsten Schubert, London

p. 117: Richard Long
Five Stones,
courtesy Leeds Art Gallery, Leeds

p. 118: Malc Baxter
Tower Face Original from *Stanage:
the definitive guidebook*

p. 119: Henry Moore
page one of a ten page letter to
Jocelyn Horner,
courtesy Leeds Art Gallery, Leeds

p. 120: Claude Heath
Ben Nevis,
courtesy the artist

p. 121: John Ruskin
Aiguilles de Chamonix,
© Fitzwilliam Museum, Cambridge
University, Cambridge/The Bridgeman
Art Library, London

p. 122: Vincent Van Gogh
*Peasant Woman, Gleaming, Seen from
Behind*,
courtesy Kroller-Muller Museum, Otterlo

pp. 124-125: JD Harding
drawings from *Lessons on Trees*

p. 126-127: Paul Morrison
Cryptophyte,
Panorama,
courtesy Alison Jacques Gallery, London

pp. 128-129: Richard Lydekker
Typical Butterflies, from *The New Natural
History*, vol. XI

pp. 130-131: Michael Landy
Fever Few,
Greater Plantain,
courtesy the artist and Thomas Dane
Gallery, London

pp. 132-133: Bethan Huws
Untitled,
courtesy Fonds National d'art
Contemporain, Paris
Untitled,
private collection, Germany
Untitled,
courtesy Galerie Karlheinz, Karlsruhe
Untitled
private collection, Wales

pp. 134-135: Ellen Gallagher
Watery Ecstatic Series,
Watery Ecstatic Series,
photo: Tom Powel
courtesy Gagosian Gallery, New York

pp. 136-137: Richard Lydekker
Glass Sponges, from *The New Natural
History*, vol. XII
Radiolarians, from *The New Natural
History*, vol. XII

CITY

p. 139: Guy Debord
The Naked City

p. 141: Umberto Boccioni
Study for States of Mind (Those Who Go),
ref no 0122814
courtesy Museum of Modern Art, New
York, gift of Vico Baer

pp. 142-143: Leonardo da Vinci
Study of Water Wheel
ref no Cod. Atl. F. 263r –a. Codex
Atlanticus
© Biblioteca Ambrosiana –
Auth. No INT 31/05

pp. 144-145: A Regnauld
drawings showing sectional views
of steam boilers, from *Modern Power
Engineering*

p. 146: Chris Burden
The Flying Steam Roller, from *Dream
Show at the MAK*,
courtesy the artist

p. 147: Thomas Edison
Experiment No. 1, February 13, 1880,
courtesy of US Dept of the Interior
National Park Service, Edison National
Historic Site, New Jersey

pp. 148-149: Diana Cooper
Speedway,
Swarm,
courtesy Postmasters Gallery, New York

pp. 150-151: Armando Andrade Tudela
Abstraccion Transamazonica,
Neo—Huevo—Neo,
Untitled,
courtesy Counter Gallery, London

pp. 152-153: Ian Charlesworth
"Some of my friends are",
Everafter, detail,
courtesy the artist

pp. 154-157: Emma Stibbon
Autobahn,
Eichkamp,
Fußgängertunnel Siegessaule,
Underpass Alexanderplatz,
courtesy Upstairs, Berlin

pp. 158-159: Robert Venturi and Denise
Scott Brown
*Map of Las Vegas Strip showing every
written word seen from the road*, detail,
courtesy the architects

pp. 160-161: Mira Schindel
Sem Titulo (object grafico),
Sem Titulo (object grafico)
courtesy Millan Antonio, Brazil

pp. 162-163: David Batchelor
Untitled,
Lecture Notes,
courtesy Anthony Wilkinson Gallery,
London

pp. 164-165: Paul Noble
"O" sketches,
courtesy Interim Art, London

pp. 166-167: Chris Burden
Medusa's Head, from *Dream Show at
the MAK*,
Small Skyscraper, from *Dream Show at
the MAK*,
courtesy the artist

pp. 168-169: Mies van der Rohe
*Project for the Stanley Resor house,
Jackson Hole, Wyoming, view of the
landscape from the interior*,
courtesy Museum of Modern Art, New
York: Mies van der Rohe Archive
© DACS 2005 ref no 0121183

pp. 170-171: Oliver Zwink
Blocks,
courtesy fa projects, London

p. 172: Claes Oldenburg
Giant Faucet,
courtesy Leeds Art Gallery, Leeds

p. 173: Richard Wilson
20:50,
courtesy Leeds Art Gallery, Leeds

p. 174: Paul Noble
Paul's Palace, the Architect's house,
plate five from *Nobson Newtown*,
courtesy Interim Art, London

p. 175: Alex Hartley
*Eames House and Studio, showing
routes "Flip book" and "Leg splint"*,
courtesy the artist

p. 176: Alfred Hitchcock
*Saboteur (statue of Liberty struggle
sequence)*,
courtesy Margaret Herrick Library,
Academy of Motion Picture Arts and
Sciences Foundation, Beverley Hills
© Alfred Hitchcock Collection

p. 177: John Huston
Moby Dick, sketchbook page,
courtesy Margaret Herrick Library,
Academy of Motion Picture Arts and
Sciences Foundation, Beverley Hills
© John Huston Collection

pp. 178-179: William Kentridge
Temple interior, from *Learning the Flute*,
Birds, from *Learning the Flute*,
courtesy Marian Goodman Gallery,
New York

p. 180: Keir Smith
Angelo Raffaele II,
courtesy the artist

p. 181: E Challis, WH Bartlett
The Coliseum at Rome

p. 182: Ellen Gallagher
The Man Who Kept Harlem Cool, from
Deluxe,
photo: Tom Powel
courtesy Gagosian Gallery, New York

p. 183: Adam Dant
Community Bed, detail,
courtesy Adam Baumgold Gallery,
New York

pp. 184-185: Kathy Prendergast
Mexico City, Mexico, from *City Drawings*,
Addis Ababa, Ethiopia, from *City
Drawings*,
Beirut, Lebanon, from *City Drawings*,
London, Britain, from *City Drawings*,
Jerusalem, Israel, from *City Drawings*,
courtesy collection Irish Museum of
Modern Art, Dublin

p. 186: John Snow
map from *On the mode of
communication of Cholera*,
second edition,
ref no BL 7560.e.67
courtesy British Library, London

p. 187: Paul Noble
Nobson Central,
courtesy Interim Art, London

p. 188: Louise Bourgeois
Untitled,
photo: Eeva Inkeri
courtesy collection Kroller-Muller
Museum, Otterlo

p. 189: Rachel Goodyear
Lost Dog,
courtesy the artist

p. 190: FDH, aged five
drawing of a game of chess,
courtesy the artist

p. 191: Louise Hopkins
Untitled (393),
courtesy doggerfisher, Edinburgh

pp. 192-195: Rachel Whiteread
Door,
In-Out Stairway, detail,
Inside Upstairs,
courtesy Luhring Augustine, New York

pp. 196-197: Toba Khedoori
Untitled (House), detail,
courtesy David Zwirner, New York and
Hauser & Wirth, London

p. 198: Adolf Loos
*Villa Josef und Marie Rufer, Wien XIII.,
Schliemanngasse 11, Fassaden mit
Fensteraufteilung*,
courtesy Adolf Loos Archive
© Albertina 2005

p. 199: Toba Khedoori
Untitled (Window), detail,
courtesy David Zwirner, New York

DREAMS

p. 200: Rembrandt van Rijn
A Girl Sleeping,
courtesy British Museum, London

p. 203: Pablo Picasso
Girl Seated by Sleeping Minotaur,
ref no Plate 86
courtesy Photo RMN
© Photo RMN/Franck Raux

pp. 204-207: Soo Kim
He Bows to his Image in the Mirror,
Halla,
Idyllwild (yon),
Maritime,
courtesy Sandroni Ray, Los Angeles

p. 208: Marcel Duchamp
With My Tongue in My Cheek,
courtesy Musée National d'Art Moderne,
Centre Georges Pompidou, Photo
CNAC/MNAM Dist. RMN
© Photo RMN/Jacques Faujour

p. 209: David Musgrave
Transparent Head,
courtesy the artist and greengrassi,
London

p. 211: Albrecht Dürer
Vision in a Dream,
courtesy Kunsthistoriches Museum,
Vienna

p. 212: OA
"She stood by the bedside for some
moments looking down upon her
pityingly", from *Little Saint Elizabeth* by
Frances Burnett

p. 213: Richard Lydekker
A Column of the Army Worm, from *The
New Natural History*, vol. XI

pp. 214-215: John Tenniel
illustration for *Alice's Adventures in
Wonderland* by Lewis Carroll,
illustration for *Through the Looking Glass*
by Lewis Carroll

pp. 216-217: Jake and Dinos Chapman
etchings from *Exquisite Corpse*,
courtesy the artists and White Cube
Gallery, London

pp. 218-219: Balazs Kicsiny
Calendar,
Calendar, detail,
courtesy the artist

p. 220: Daniele da Volterra
Woman at the Foot of the Cross,
courtesy Louvre Museum, Paris
© Photo RMN/Michele Bellot

pp. 221-223: Francisco de Goya
Mala Mujer (Wicked woman),
ref (6910)-GW 1379
courtesy Louvre Museum, Paris
Giant,
courtesy Biblioteca National, Madrid

p. 224: August Natterer (Neter)
Witch (trial sketch),
courtesy Prinzhorn Collection,
Heidelberg

p. 225: Raymond Pettibon
Untitled (self portrait on LSD),
courtesy Regen Projects, Los Angeles

pp. 226-229: Adam Dant
500 Images et Paroles (B.I.S.I),
Encyclopaedia Subliminalia,
The Notion of Subliminal Reaearch,
studies for *Natural Disaster*,
courtesy Adam Baumgold Gallery,
New York

pp. 230-231: Lucia Nogueira
Untitled,
Untitled,
Untitled,
courtesy Anthony Reynolds Gallery,
London

p. 232: Antony Gormley
Untitled,
courtesy Leeds Art Gallery, Leeds

p. 233-235: Anne-Marie Creamer
Locked,
stills from *Amnesia*,
courtesy the artist

pp. 236-237: Heather Deedman
Doyley I,
18th Century Porcelain I,
courtesy the artist

pp. 238-239: Grayson Perry
Self Portrait with Eyes Poked Out,
Wisdom is Cool,
courtesy Victoria Miro Gallery, London

p. 240: Louise Bourgeois
Unconscious Compulsive Thoughts,
photo: Christopher Burke
collection of the artist
courtesy Cheim and Reid, New York

p. 241: Robert Overby
Living room wall,
courtesy Overby Estate, Haunch of
Venison, London

pp. 242-243: Neal Tait
O Zero verso,
Girl with Fishtails, detail,
courtesy White Cube Gallery, London

p. 244: Rachel Goodyear
Man Eating Squirrel,
courtesy the artist

p. 245: Jakob Mohr
Proofs,
ref no Inv 627/1. 1988 recto
courtesy Prinzhorn Collection,
Heidelberg

p. 246: Bethan Huws
Untitled,
courtesy collection B Steingenberger,
Frankfurt

p. 247: Alison Wilding
Wolf Series I (226),
photo: Prudence Cuming
courtesy Karsten Schubert

INDEX

References within the text are in italic

© 2005 Black Dog Publishing Limited, the artists and authors
All rights reserved

Edited by Tania Kovats

Designed by Studio AS

Black Dog Publishing Limited
Unit 4.4 Tea Building
56 Shoreditch High Street
London E1 6JJ

Tel: +44 (0)20 7613 1922
Fax: +44 (0)20 7613 1944
Email: info@bdp.demon.co.uk

www.bdpworld.com

British Library Cataloguing-in-Publication Data.

A CIP record for this book is available from the British Library.

The Drawing Book
a survey of drawing: the primary means of expression
ISBN 1 904772 33 1

Black Dog Publishing
Architecture Art Design Fashion History
Photography Theory and Things